D —
Something to help on those
"take you away" evenings, which you
3 AM evenings, which more of
will no doubt have
as you become a CEO!
Always Smiling —
B

June 4 2008

HITCHCOCK STYLE

© 2004 Assouline Publishing
601 West 26th Street, 18th Floor
New York, NY 10001 USA
Tel.: 212 989-6810 Fax: 212 647-0005
www.assouline.com

Translated from the French by
Simon Pleasance and Fronza Woods

ISBN: 2 84323 514 6

Color separation: Gravor (Switzerland)
Printed by Grafiche Milani (Italy)

JEAN-PIERRE DUFREIGNE

HITCHCOCK STYLE

ASSOULINE

To Noëlle,

One remembers a handbag, a key in the palm of a hand, a crime reflected in a pair of glasses, a windmill with the sails turning the wrong way. One no longer remembers why Janet Leigh stopped at the "Bates Motel," nor does one remember the story of Notorious. *Neither Ingrid Bergman nor Cary Grant, but only a bottle of wine. This does not happen with Griffith or Welles or me. Hitchcock really was the master of the universe… He had a control over the audience that nobody else has ever had. Through objects.*

JEAN-LUC GODARD, HISTOIRE(S) DU CINÉMA

[CONTENTS]

[A STYLE NAMED DESIRE]

Even though Alfred Hitchcock's world may have once conquered the planet, it is static and can grow no further. It is a closed world, confined within a round, almost bald head. A head that contains a brain, which itself contains another world with unfathomable twists and turns, whatever Freud might have believed he could decipher. A piece of furniture with secret drawers, the sort kings of yore were fond of.

What we see on the screen when we look at a Hitchcock film has been sifted through these secret places. The laughter that wells up in us turns into anxiety, a sentimental scene becomes a murder, and everything that appears before us—from the dress of an invariably endangered heroine to the murderer's car (or vice versa, for there is at least one killer decked out in his mother's dress)—has its unique and obligatory place in this world. And in this watchmaker's brain. Hitchcock always saw himself as a craftsman, an artisan rather than an artist, and he described himself as a technician. A technician of fear, and suspense? Such simplistic verdicts brought a smile to his lips. His driving force was desire.

"Suspense is like a woman," he told Bernard Parkin. "The more room she leaves to the imagination, the greater the emotion and the expectation. The audience is much more frightened by what it imagines than by what it actually sees. There's nothing terrifying about an explosion, only the expectation of it."

And the same goes for sexual expectation. In the published book of interviews between Hitchcock and François Truffaut, titled simply *Hitchcock*, Hitchcock admitted: "What calls the shots, when I deal with matters of sex on screen: the choice of sophisticated, blonde actresses? Suspense! We're all looking for worldly women, real ladies, and just when you're least expecting it, they turn into whores in the bedroom. An English girl is quite capable of getting into a taxi with you and, much to your surprise, ripping open your fly." Which is pure fantasy, of course, because Hitchcock never participated in that sort of occurrence. But Hitchcock saw desire as the sole driving force behind creation, the sole motive for crimes, and the sole exhibit. And quite probably, for a man who until he was in his forties was the

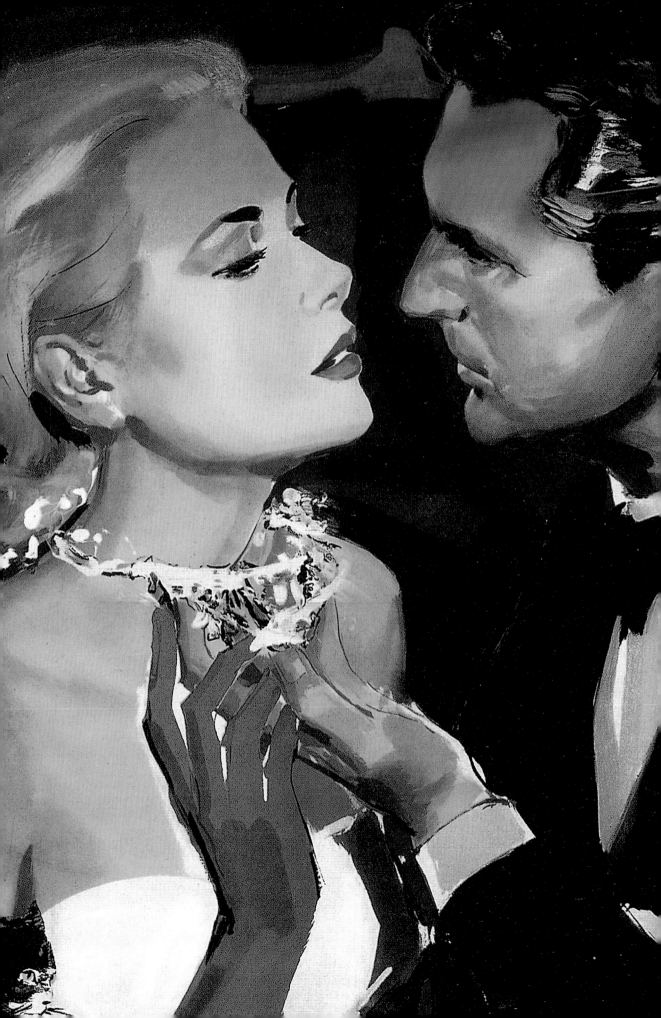

contemporary of Freud (1856-1939), desire was the sole key to his personality. It is a key that opens a cellar where the agents of Evil (Nazis) are hiding a dangerous secret, and it is hidden not in the palm of Ingrid Bergman's hand, in *Notorious*, clammy with fear, but in the very depths of his own psyche.

Another cellar where other unseemly secrets prowl: Hitchcock the Hollywood maestro was like the brazen girl in the taxi—profoundly English. So he, too, was capable of the worst "improprieties," by being simply outside life, in its representation alone, in its unfolding, which depended solely on him, sitting squeezed into his director's chair, directing.

Directing what? Beautiful people and very bad people, you can't have one without the other, or else you flounder about in cliché, elegant, fairly well-off, but not in a showy way, and with nice digs.

His most seductive bad guy (Hitchcock's bad guys are more than bastards: they invariably have a sentimental flaw, unless they are henchmen), James Mason in *North by Northwest*, owns a magnificent house near Mount Rushmore—where the busts of four great American presidents are carved in the rock, symbols of the morality of the "founding fathers." The house was designed by no less of a figure than Frank Lloyd Wright (1867-1959), the greatest architect of Hitchcock's day, and Hitchcock had Henry Grace and Frank McKelvey rebuild it as a Hollywood set.

This Frank Lloyd Wright house in America, with its dangerous beauty and its funereal elegance befitting deceased genius, is the counterpart of Manderley, the manor house haunted by the ghost of the first Mrs. de Winter in *Rebecca*. This is the estate where the elegant and aristocratic Max de Winter (Laurence Olivier) invites and proceeds to confine the fragile Joan Fontaine (the sister—and rival—of Olivia de Havilland). Fontaine, who plays the unnamed Mrs. de Winter, first appears at the beginning of the film as the paid companion of an extremely American and extremely snobbish shrew. Manderley is English down to the last detail, except for the fact that the house would never be anything other than a studio set, concocted from Hitchcock's English memory. It is significant that in that year, 1939, for his first American film, Hitchcock re-created a British manor house. *Rebecca* went on to win the Oscar for best film. But Hitch did not get the chance to wrap his hands around a statue: the Oscar went to his producer.

Hitchcock's world is as much rooted in time as it is in space: in effect, it is always his exact contemporary. He created it from what he saw and from what he experienced: both wars; the depression; the United Nations's attempts at world peace; the women's liberation movement, beginning with their attire, and later moving to their heads, words, and desires; the love of

money, and its ensuing transformation into beauty by the game of spending it. In the auction room in *North by Northwest*, James Mason lays his hand on Eva Marie Saint's shoulder—just when she is in the middle of bidding. Is he buying the woman or the pre-Columbian statue of a Tarascan warrior, which he eyes with mysterious insistence? And that also holds a secret: microfilm. Eva Marie is a spy—he does not know it as yet, but doubt is creeping in—living with him so that she may trap him. The statue is a centuries-old work of art, the woman is wearing the latest fashion; both are desirable, and—in the mind of the man who desires them—they are both works of art.

Hitchcock was a keen and most enlightened collector, and at his death, as we shall see, his coffers, rather than his walls, offered a perfect overview of the art of his day.

Owning the object of desire is the fabric of life: a State secret or a blonde who is already dead (*Vertigo*); a diamond (*Family Plot*); a suitcase with $40,000 pinched by the star of the moment (Janet Leigh in *Psycho*); luxurious clothes and embroidered linen kept by a ghost-like and ill-tempered housekeeper in a forbidden bedroom (*Rebecca*); a little tune played on a mandolin, which must not fall into the hands of a foreigner (*The Lady Vanishes*).

To still further perfect this world he lived in, to better enclose it like an egg in that skull (which was bald as an egg) that locks up secrets, fantasies, impulses, and desires, he needed accomplices—just like his best bad guys. Accomplices obeying his voice alone, and only his desires: costumes by Edith Head; music by Bernard Herrmann; scripts by Charles Bennett and later Ben Hecht—but always closely watched, reworked, re-stitched, "supervised" by his female double (she was born the same day as he, but two hours later), his wife Alma Reville; sets designed by George Milo. And for his independence, and the freedom of dreams and organized nightmares, without risking the censorship of the producer, too keen on verisimilitude, an agent: Lew Wasserman, the man to whom he owed his total freedom with regard to those tyrannical things called the major studios. Gang or family? A planet, his planet with its denizens placed under the authority of the master of the premises.

What did that planet look like? From a deserted road in Texas (*North by Northwest*) to a Cuban prison (*Topaz*), from a Moroccan market place to the great auditorium in London's Royal Albert Hall (*The Man Who Knew Too Much*), from Dutch windmills (*Foreign Correspondent*) to the Statue of Liberty (*Sabotage*), from a bay in northern California infested by *Birds* to a small Siberian village (*Torn Curtain*), his planet offers just one mooring: the maze of a brain (one better organized than his would be hard to find) with twists and turns more complex than the meanders of the Thames—from where England's fleets once held sway over all the world's seas (and through them all the world) from London. It was in

London that this brain, so well structured and brimming with every manner of desire, started to whir one Sunday in 1899, a date straddling two centuries, and two worlds.

London was the cradle of his very first films, and his very last also. A London steeped in the poverty of his early boyhood, as well as the spoils from his early success. London, a city whose geography is as complicated as a map of the world, where, as you change neighborhoods, you change social class, not to say cast, as they used to say in the old chunk of Empire called India.

London was also where his family—mother, brother, sister—stayed when Hitchcock the conqueror headed west to that America that was still known as the New World.

He was not homesick for London, he kept London within him, and in the wild America, which he conquered the way the red-coated troops of King James I did, the houses in far-flung little towns in Northern California had bay windows and porticos (see *Shadow of a Doubt*) worthy of the patrician residences in London's Holland Park, and of his own home, Turner House, which he managed to purchase in a chic neighborhood with the proceeds of his first real earnings. Killers and bad guys would be decked out like lords, arrogant and seductive beauties would never go out ungloved—a crucial detail that hid hands and fingerprints while also signaling membership in the enviable company of ladies. And when those ladies took their gloves off... the rest was history.

Perhaps, after all, Alfred did one day take a cab with an "English girl"—and what followed? Expectation? Something explosive?

Only in make-believe. Only in fifty-three fiction films.

London, here shown in 1960, appeared 24 times in Hitchcock's films. Big Ben can be seen in *Stage Fright*, *Blackmail* and *Sabotage*.

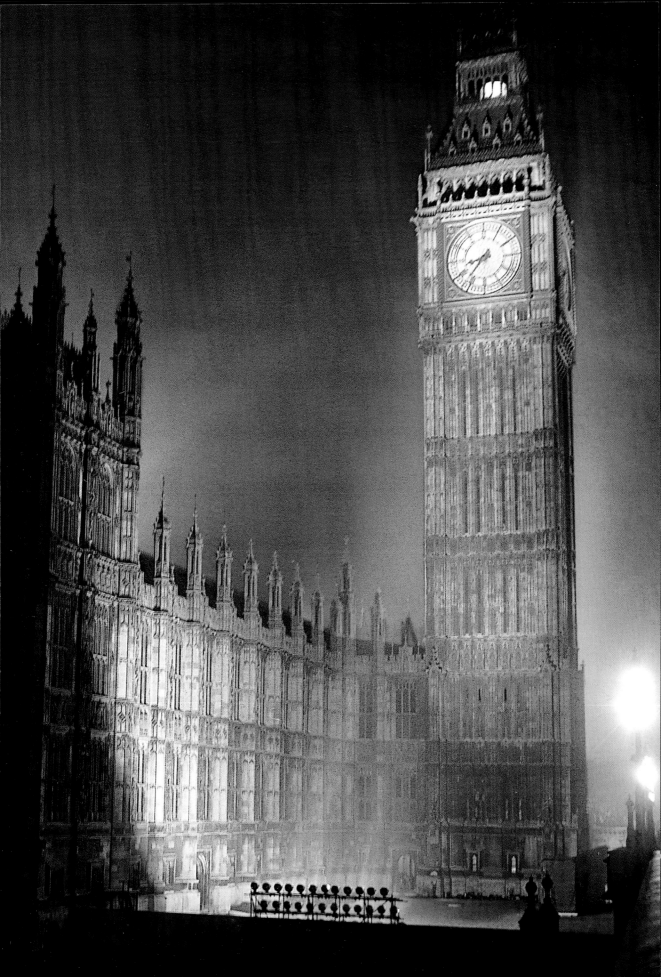

[AND THE LITTLE "COCK" BECAME "HITCH"]

Everyone either lies or keeps mum about their childhood. It is our longest bad memory. Those "green paradises," etc., are the invention of poets who have either become amnesiac, or have drunk too much. Childhood is the land of fear. Children make the best of it and grow up. But there remains in the fruit the worm that stops it from ripening. That worm of fear will turn us into a ladies' tailor, a secret agent, a singer, a serial killer, a gold-digger, an inspector of weights and measures, and, from time to time, a genius.

A future genius was born bawling with fright on Sunday, August 13, 1899 at no. 517 High Road, in Leystonstone, a borough in London's East End, the heart of Cockney country, on the first floor of an unprepossessing house, above a fruit and vegetable shop.

Seventy-five years before the concept was even invented, Leystonstone encapsulated already the look of a depressed, crumbling suburb, as sad as any childhood, and as boring as any Sunday afternoon.

The infant was a boy. So on that particular Sunday, Emma Hitchcock, the daughter of an illiterate working man and his illiterate Irish wife; her moustached husband, thirty-seven-year-old William Hitchcock, son of a "master market-gardener" (a potato merchant), who was also an immigrant from that emerald isle to England's west; and their first two offspring, William, Jr., aged nine, and Eileen, known as "Nellie," aged seven, saw Alfred Joseph Hitchcock emerge into the world all purplish-blue, slimy, and wailing.

To judge by his screams, we can presume that Alfred was not exactly overjoyed. Nor was the assembled company: they had missed mass at the church of St. Francis in Stratford (not far from Deptford, where the Elizabethan poet and playwright Christopher Marlowe had been murdered, in a sleazy tavern) because of his birth. This was a major omission for practicing Catholics—the sole eccentricity that this family allowed itself, ill at ease as they were in an Anglican land. They also had a marked soft spot for the theatre.

Alfred's presumed non-enchantment was bolstered as time passed. He kept quiet about his childhood spent amid pineapples and Chinese cabbages. This ragtag group of produce can

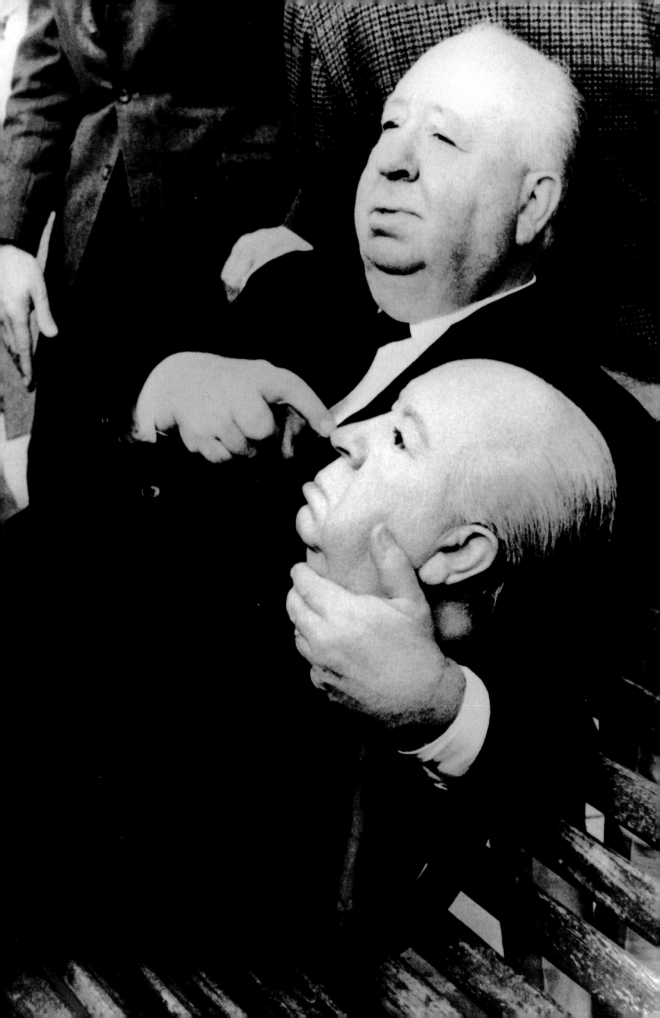

clearly be made out in a photo taken of Alfred and his father in the grocer's shop in which William Hitchcock is photographed in uniform (the Boer War, which had broken out the year Alfred was born, had just come to a close). Hitchcock kept a courteous indifference toward his brother and sister, and remained scared to death of his father. This fear would manifest itself in the gigantic granite effigy of Theodore Roosevelt hewn onto Mount Rushmore—and on whose surface Cary Grant and Eva Marie Saint have a brush with death in *North by Northwest*—and who bears a startling resemblance to William. But he loved his mother dearly, and of her there are many whimsical and nicely scatter-brained portraits gracing his films (in particular Patricia Collinge, mother of Teresa Wright in *Shadow of a Doubt*, and Jessie Joyce Landis, Cary Grant's mother in *North by Northwest*). She died at the height of the Second World War, with an ocean and a whole continent keeping her apart from her wee Fred, not counting his fame. And those millions of dollars already amassed. Alfred hated it when his family called him "Fred." At the St. Ignatius Jesuit school in Stamford Hill, which he attended aged eleven, he also hated being called "Cockie" (a nickname with sexual overtones that did little to enhance his life), so he called himself "Hitch."

It was a good move. This nickname, no bigger than a sneeze, would be his name of fame on the other side of the Atlantic, his trademark, his guarantee of authenticity. And so it was that the book that was "talked" with Truffaut and called *Hitchcock* would swiftly become the "Hitchbook."

The queen would in due course knight Alfred, making him Sir Alfred, and Hollywood would make him a millionaire many times over. There was something of Stroheim about Hitch. Stroheim, son of a Viennese hatter, and Jewish, claimed to be the son of an officer in the Imperial Guard, and assumed a "von"; Hitch, conversely, shortened his name, and was quick to camouflage his Cockney accent behind a diction that was too slow, too pompous, and priceless, but he dutifully remained grouchy and yellow-bellied, qualities illuminated by a shopkeeper's penny-pinching stinginess. In all of his films Hitchcock's wife, Alma Reville, appeared in the credits: first for the screenplay, and then as an advisor—a neat way of doubling the family's wages.

And Hitch took the world by storm. So what did it matter if you stayed as small as Peter Pan (born in the choicest of chic neighborhoods: the princely confines of Kensington, in London's West End), complete with portly paunch and somewhat unsightly, when you were the first—and only!—director to merit his full-length portrait outside auditoriums in order to attract the waiting queues and thumb your nose at the sublime stars you employed? Well, such things do matter. They make you repress your desires, and raise your own ante.

Ad style: Graphic and macabre in Poland for *Stage Fright* (Polish poster, 1950).

MARLENA
DIETRICH W
SENSACYJNYM DRAMACIE

ALFREDA
HITCHCOCKA

TREMA

W

PO ZOSTALYCH
ROLACH
JANE
WYMAN MICHAEL WILDIN
RICHARD TODD I INNI
PRODUKCJA WARNER BRO

Compared to Hitch, Orson Welles and even Erich (von) Stroheim had all the modesty of extras. What sweet revenge for Cockie! The little "Cock" turned into one great big megalomaniac! We can put up with megalomania when it is clad in wit (and Hitch had a surfeit of wit, weighing as much as his surplus pounds) and elegance in the creation of extraordinarily illustrated forms and fears. With Hitch, you forget about the megalomania, and if it rears its head again, it is fun—and funny.

The pride of poor children tends to enhance their works by way of an arrogant concern for perfection. Alfred Hitchcock did achieve such perfection, needless to say—not in all his fifty-three films, but often enough. Perfection in whole movies, and in hundreds of shots. Because he did not want to film like other people, he invented, like nobody else, what his great precursors were forever in pursuit of: style.

Hitchcock is all in an angle, a light, a sound, a background, a close-up, a cigarette lighter, a strangled woman's face reflected in a pair of eyeglasses, a phony studio landscape, an exaggerated color or a shadow, that flood the world with their artificiality in order to make it more real and true. And more pitiless. A Hitchcock film and a Hitchcock character (good guy and bad guy alike) are invariably merciless. Yes, the "good guys" too.

Hitch turned his back on all manner of sentimentality, and focused on pure sensation. In public he came across as a cynic; in private, he was vulnerable. To protect himself, he constructed a world of artifice and tricks that was built solely on the art of film, a popular art, albeit respected by intellectuals. At times nothing actually comes to pass, but we shiver and shudder at the lack of action; at times, a chase turns to farce, or triggers a string of fantasies. What was important to him was to hold our—the audience's—attention; and fill us with phenomenal fear. "With *Psycho*, I think I managed to do what I like best in the world: controlling the audience," he would—quite rightly—boast toward the end of his life.

Hitch tamed his own innate fear by playing, in a delightful way, with our own fears. Also, by grabbing power so as to protect himself from actors and producers.

Hitch rarely confided in others, the letters he wrote were few and far between, but what he kept to himself burst onto the screen in his films. His privacy was confined within a little fortress of silence and imagery. He liked the silent cinema, it satisfied him with its absence of words. The spoken word unsettled him, but, without nostalgia, he managed to adapt to it, because talking images opened up the fast track to money. Not money for its own sake, or money as such, but money as proof of success and box-office numbers. Money as an apotheosis—money, that freedom boat of his creation. He never penned a dialogue, never wrote a screenplay for himself; he hired pens, fired them, replaced them, dictated his corrections and

put everything into images and pictures. Images and pictures that came before words and went beyond them.

Did we say fear? He was born with it. When Hitchcock came into the world, the books that were all the rage were Robert Louis Stevenson's *Doctor Jekyll and Mister Hyde* (1885), Oscar Wilde's *The Picture of Dorian Gray* (1891), and Bram Stoker's still very young *Dracula (1897)*. Sophisticated and seductive gentlemen hiding monsters within themselves. At night, every little English child reveled in them, in the depths of their beds, often unbeknownst to their parents. For the pleasure of being scared. And outside there still prowled—for was he really dead?—the ghost of Jack the Ripper.

Whenever you laugh at your own fear while watching one of Hitchcock's films it is because he is winking at you, acknowledging the absurd masochistic joy of suspense. But the joy is always proceeded by fear.

"Fear is something that runs very deep. It got a firm footing in me when I was with the Jesuits," he told George Belmont in 1960. "Moral fear: fear of evil, fear of being linked with anything that's 'nasty': I always kept myself to myself. Because of another fear, probably: physical fear. I was terrified of corporal punishment. It encouraged a certain sense of drama in me. Because the Jesuits had the rod. It was made out of very hard rubber. It wasn't applied any old way, oh no! It was a sentence that was being executed. You would get an "invitation," an order, to go and see a priest at the end of the day. That priest would solemnly write your name in a register, plus your punishment: the number of strokes. All day long, in class, as you waited for the fateful moment, you lived with the feeling that you have been condemned to death. I can still see the little huddles in the corridor outside the executioner-priest's door, waiting for the culprit to emerge, to see by his face how he had taken his beating. It was like the crowd at a prison gate, ears pricked for the echo of the guillotine blade, or the thud of the counterweight at a hanging."

Or a lynching. That crowd often crops up in his English period—*The Lodger, Young and Innocent, The 39 Steps*—and he was quite happy making his traditional appearance in such films. This was how Hitch learnt that crime does not pay: in a London still awash in the memory of Jack the Ripper. So there was a fascination with crime as a child and later as a man who would always be afraid of punishment, ever since that damned rod. Yes. The fear and the crimes that he would pass on to us in fifty-three films out of fifty-six also hailed from that London of his boyhood.

"Crime is a typically English thing. The English are weirder murderers than in any other country," he told Richard Schickel in *The Men who Make Films*. "As a result, English literature has

the habit of tackling crime fiction at a high level, unlike other countries, even America, where crime literature is regarded as second-rate B-literature. But what a tremendous literary source!"

And what a thrill when, in 1910, he discovered in the newspaper the case of Dr. Hawley Harvey Crippen, the doctor who poisoned his wife Cora, cut her body into pieces, burnt them, and buried the charred remains in the basement of his house, before setting sail for the United States on board the *S.S. Monrose* with his mistress Ethel Le Neve disguised as a boy. Hitch pinched the paper from his father so that he could feast on the tale. He would remember it in several of his films. As he would the mistress disguised as a boy. In other words, slim, rather flat-chested, daringly coiffed and resolute.

And if she refuses your advances… the Crippen method! Everything was a mish-mash—priests, killers, and bothersome women—and clearly a source of inspiration.

If a blonde was too glossy to agree to slip into your bed, let her be attacked by a seagull (*The Birds*); hire the sexiest star, Janet Leigh, and kill her just twenty minutes into the film in a shower, and leave the rest of the film in the hands of a supporting cast grappling with a psychopath *(Psycho)*; ruin an attorney's career by getting him to defend a murderess he falls in love with (*The Paradine Case*); make a priest the suspect in a crime he has not committed (*I Confess*), because before he took the cloth he was in love; shatter the peace and quiet of Vermont with its hills as red as Shirley MacLaine's hair in *The Trouble with Harry*. You think you are an elegant advertising executive who's made it, already twice divorced, and, just because you want to call your mama on the phone, you will become the man who never was, whom everyone wants to get rid of, by the name of Kaplan. Once more, *The Wrong Man* has to flee from the truth with death at his heels, like in *North by Northwest*.

Life is made up of traps, nothing else. Stranglers prowl in fairgrounds, spies perch in the Statue of Liberty or communicate using windmill sails, music-loving gun-toting killers hide in the Albert Hall, kids ride London buses with bombs, your favorite uncle murders old ladies, the girl you fancy is a frigid burglar who is afraid of the color red, or, alternatively, a false corpse hired by your best friend… Life is wonderful when its great organizer makes it unbearable.

There is a word missing, is there not? Suspense. "The latest film by the master of suspense." With each new production, this slogan would appear writ large at the top of the posters. Just as Stroheim was "the man you love to hate," so Hitch would be "the master of suspense." Period. Which is not quite the whole thing. If you look at his films—and heaven knows they are nice to look at—you realize that Hitch is first and foremost the master of elegance. The little *frisson* he is after comes from this, and this above all. The only film he made that is terrifying, in the modern gory sense of the word, the only one that can be listed in the

Opposite page: Ad style: The shadow from *Topaz* in Belgium (Belgian poster, 1969).

TOPAZ
L'ETAU

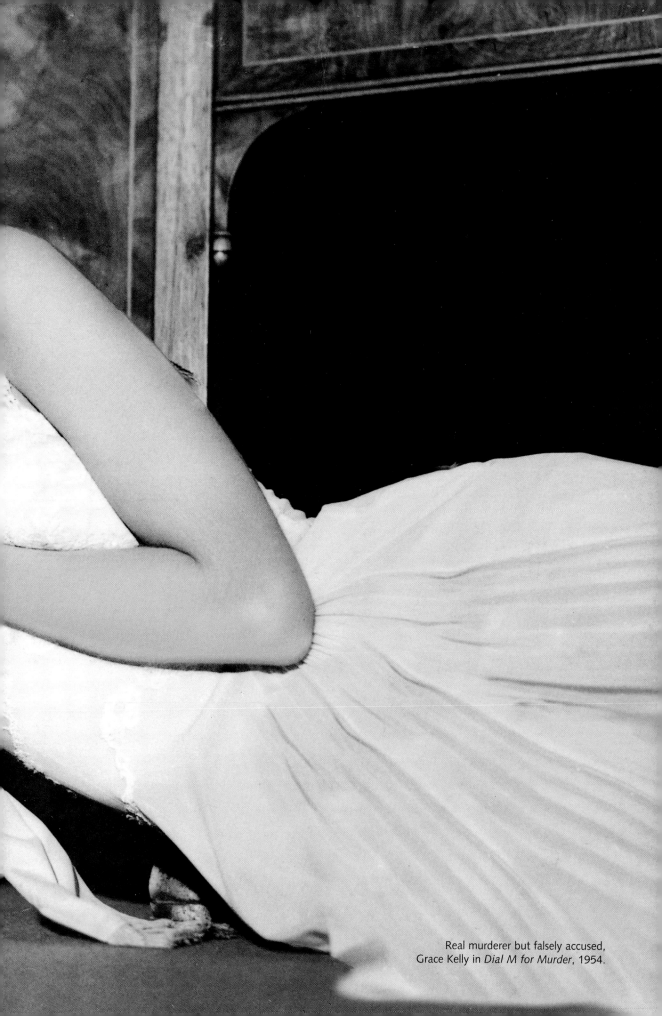

Real murderer but falsely accused,
Grace Kelly in *Dial M for Murder*, 1954.

"terror" genre is *Psycho*, which relies on the elegance of Anthony Perkins, a slim and hand-some young man with the face of a tormented kid. All the other films can be included in the category of fashionable society comedies, a wonderful American invention (where his only foray, *Mr. & Mrs. Smith*, with Carole Lombard and Robert Montgomery, was a flop), with, to spice them up, the Machiavellianism of incidents and a murder thrown in as a bonus. And a carefully thought out, macabre source of inspiration.

Hitchcock's oeuvre lends itself to wild simplification. People call *Rear Window*, a voyeur's film. Except for the fact that all the ingredients are there to justify the "voyeurism" of the hero (James Stewart): his profession, he is a photographer; his accident, he is housebound with a leg in a cast; his apartment, which looks out on to the back of a building; the weather, it is hot, so the injured hero is not sleeping well. What is he supposed to do? He observes things that are not his business: a curvaceous dancer, a failed musician determined to be successful, a tireless newlywed couple, an elderly, childless couple who foist their affection on a little dog who comes to a sticky end, a lonely-hearted woman, a strapping man and his sick wife. And he starts imagining that the husband of the sick woman, who suddenly vanishes overnight, has—like Dr. Crippen—killed his suffering and tyrannical other half, and cut her into pieces. Does he call the police? No. He keeps watch. Why? Because it relaxes him. Relaxes him from what? From his anxiety. What is this anxiety about? Finding a solution to something inevitable: avoiding marrying Grace Kelly, who pays him daily visits, wearing a different dress or suit each day, has seductive suppers delivered to him, scolds him, and bends over him as he finally rests, just like a vampire—in a real horror film—bending over a sleeping victim. In Stewart's mind, the avoidance of marriage takes precedence over finding out about the crime, a simple intellectual game as sterile as solving a crossword in a magazine. Stewart's life is frozen like those magazines—*Vogue, Harper's Bazaar*—that Grace Kelly endlessly reads by his side, keeping a close and watchful eye on her hobbled prey.

But the crime is established, and then the film suddenly takes a turn. Stewart is tipped out of the window, ends up with both legs in casts, and the ravishing ghoul watching over him has him at her mercy. The murderer? He just asks his tormentor one dumbfounded question: "Why?" How do you answer a man you're sending to the electric chair by saying, "to kill time"?

Herein lies Hitchcock's art, the smile of amorality. Suspense is just one ingredient, a smokescreen, not to say a con. Hitch the food-lover could not stand seeing a soufflé being cooked. Especially in an oven with a glass door. Seeing the soufflé rise and risk sinking was more than he could bear. He loathed that kind of suspense. But he let people talk about it. He loved publicity.

He preferred the manipulation of appearances to suspense. *Blackmail* (his first talking movie), *The Wrong Man, Shadow of a Doubt, Stage Fright, Family Plot, Vertigo, The Man Who Knew Too Much, The Lady Vanishes, Suspicion*—his titles spell out the danger of all manner of truth and fear of undeserved punishment. A child's fear if ever there was. Hitch was always bragging— though it is unproven—that as little Fred, he spent five minutes locked up in a cell in a police station at his father's request. Like the all too unpredictable baking of the soufflé, this would shape his soul and make him deeply suspicious of his fellow man. The scamp was very much alone. In his room he read railway and boat timetables, because he liked precision and had a desire to be somewhere else.

Somewhere else—he would wait until he was forty before he crossed the Atlantic. For the time being, it was as much as he could do to go across London. The Hitchcock family left Leystonstone for Poplar, still in the East End, in 1907. The following year they left Poplar for Stepney, near Whitechapel (which, coincidentally, was Jack the Ripper's stomping ground).

At the age of fifteen, he attended classes at a navigation school; he knew the tide tables by heart, as well as the movements of the fleet. He also read Edgar Allen Poe. Technology was one thing, creating was better. He attended night school at the university.

He did not make any friends there. "At family reunions, I stayed sitting in my corner and observed," he told François Truffaut. "Let me go on. I don't remember having any friends. I played on my own and invented my entertainments."

In reading *Dr. Jekyll and Mr. Hyde* and *The Picture of Dorian Gray*, he amused himself by seeking out what everyone hid behind a respectable facade. Then he would proceed to his city and its own facades.

For it was definitely London, his cradle, which would define his all too recognizable style, a style built on an obvious fact: something dark lurks behind appearances. He was leagues away from those stylized, painstakingly represented Londons that appear in his films.

That London he would move through in his youth and in his marriage, as success and money came his way, from the working-class neighborhoods of the East End to the fashionable areas of South Kensington and Earl's Court. An itinerary that had all the appearance of success.

It was appearances that Hitch tried to get away from. Where Covent Garden was concerned, in *Frenzy*, he left out the concert halls and instead focused on the market where his father had a stand sixty years earlier. There he housed his tie killer—the woman strangler— on Henrietta Street. Victoria Embankment was no longer a place to stroll beside the Thames, but the place where the victims were discovered in *The Lodger* and again in *Frenzy*. Spies met

Following pages: Hitchcock and his funny birds: Actors, technicians and winged creatures.
The filming of *The Birds*, 1963.

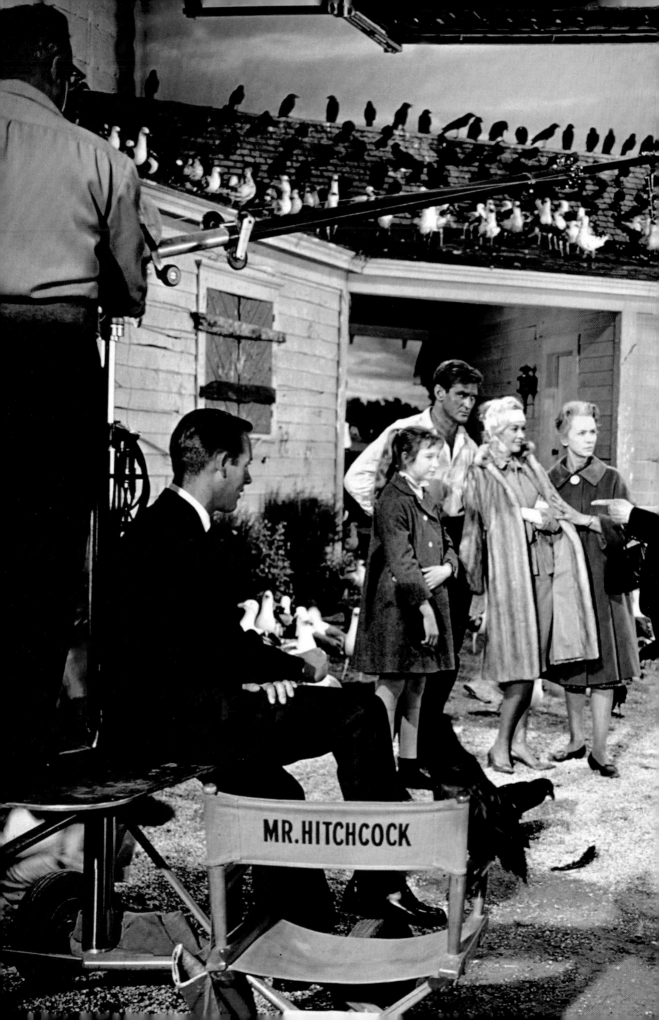

MR. HITCHCOCK

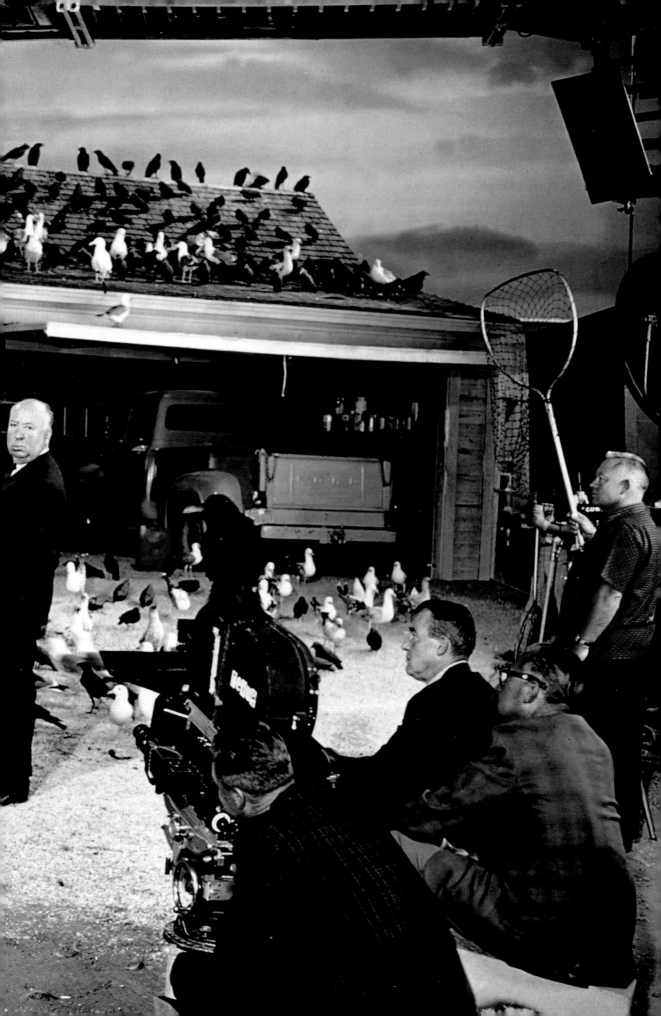

at the zoo, in the British Museum, in Westminster, at Trafalgar Square and Piccadilly Circus, under Big Ben, and by New Scotland Yard. The Royal Albert Hall offered the backdrop for the attempted assassination of an ambassador and allowed Doris Day to sing that corny old favorite, "Que Sera, Sera." *Dial M for Murder* was prepared in and around Maida Vale. The quiet residents of Bloomsbury, dear to Virginia Woolf, were ready to lynch *The* (innocent) *Lodger*, a beautiful Dietrich suspected of murder haunted St. Paul's Cathedral (*Stage Fright*).

What London contributed to film is all there. And London also brought film to Hitchcock and Hitchcock to film. They say film is teamwork.

He was invariably on his own, barely socializing with the merry troupes of the Players-Lasky British Producers, Ltd., where, in 1920, he painted flowers and candles on the titles of silent movies. He was sufficiently alone to nurture dreams, fantasies, and dark thoughts. He became a scriptwriter and assistant director in 1923, aged 24. That same year he married Alma Reville, who was born two hours after his own birth, on the same day, in the same year, and in the same neighborhood.

The studio management sent Hitch to Germany to study expressionism in films being made across the Rhine, on the hunch that English cinema was lacking in inventiveness and quality. In Germany he met Murnau on the shoot of *The Last Laugh*, and saw Fritz Lang's *Nibelungen*. Another viewpoint another way of looking at things, another camera angle. And he read the great masters of fantasy literature: Hoffmann and Grimm. He returned to England and became a director: he made *The Pleasure Garden* and *The Mountain Eagle*, before the success of *The Lodger* in 1926.

Hitchcock was one hell of a director, and father: his daughter Patricia Alma was born on July 7, 1928. She would have a typically British upbringing, and was only allowed to speak when spoken to. Her father meted out to her the same upbringing that his father had meted out to him.

In film, on the other hand, he was more than inventive and revolutionary; he was a practicing Catholic who was afraid of doing wrong, and therefore he behaved well.

In Germany he discovered what English cinema turned a blind eye to, and which he introduced way back in *The Lodger*: the middle class. The class from which he hailed. What he would film from then on was what he knew best.

He published an article in *Kinematograph Weekly*, which was not so much a manifesto as a criticism of traditional London film production: "More cabbages, fewer kings." In it he observed: "People who make films completely ignore this social stratum that is vitally important for England, the middle class. They ignore the people who jump on to moving buses, the

women squeezed together in the underground, traveling salesmen, journalists, manicurists, composers who write dance music, the City employee with his afternoon rugby match, the stockbroker and his golf clubs, the typist and her boyfriend. Queues outside cinemas, music hall girls, doctors, car salesmen, traffic cops and school masters. It is in them that the spirit of England lies." It was there among these people that he would choose the professions of his heroes and supporting actors. Hitchcock continued by saying, "If our sole source of information in this country were the cinema, we would know more about the life of a middle-class American than about the life of the English people who fill our trains and trams at rush hour. If you venture higher up the British social ladder, everything becomes bland. The veneer of civilization is so thick among the wealthy that individual qualities vanish. There is nothing to film, nothing worth bothering to put on the screen. The intonations are the same, expressions are reduced to nothing, and personalities are done away with. But get down into the much more colorful world of the middle class, look at their ways, and their relaxed attitudes. Here at last are people who smile, with smiles that mean something. Here are expressions that surface quickly onto faces without duress, a natural language, freer feelings, a sharper instinct. This is ideal material for the film industry."

And ideal for making a (small) fortune and taking your leave of that same middle class to arrive at that "veneer of civilization [that is] so thick among the wealthy." He will manage to do just that. In the United States, where that hallowed middle class was as triumphant as the most wealthy.

Therein lies his entire story, from there on out, from the 1930s on. A story that would be perfected, polished, and expanded across the Atlantic, in America.

It is also the story of a triumph that came too late. Preceded quite simply by celebrity. The story of a life without happiness, the stuff of creativity. The story of a man embalmed during his lifetime, but at the wrong moment—i.e., the moment when, from *Torn Curtain* on, things started to turn bad. Yes, *Topaz, Frenzy, Family Plot*, they all veered toward pure mechanics, dipped well below the average, and the rape scene that he had written and rewritten for the film that he would never make, *The Short Night*, wallowed in its vulgarity.

The bawling baby who came into the world on an August Sunday in 1899, who turned into the wizened, almost stuffed old man whose life was celebrated on March 7, 1979, at the Beverly Hilton in Hollywood could not stop himself from shaking. Oh, he had had a glorious life: *Rebecca*, his first American movie, with its cast of English stars, had won the Oscar for best film in 1940 (Hitchcock was nominated for best director), but it was the producer David O. Selznick who had walked off with the award.

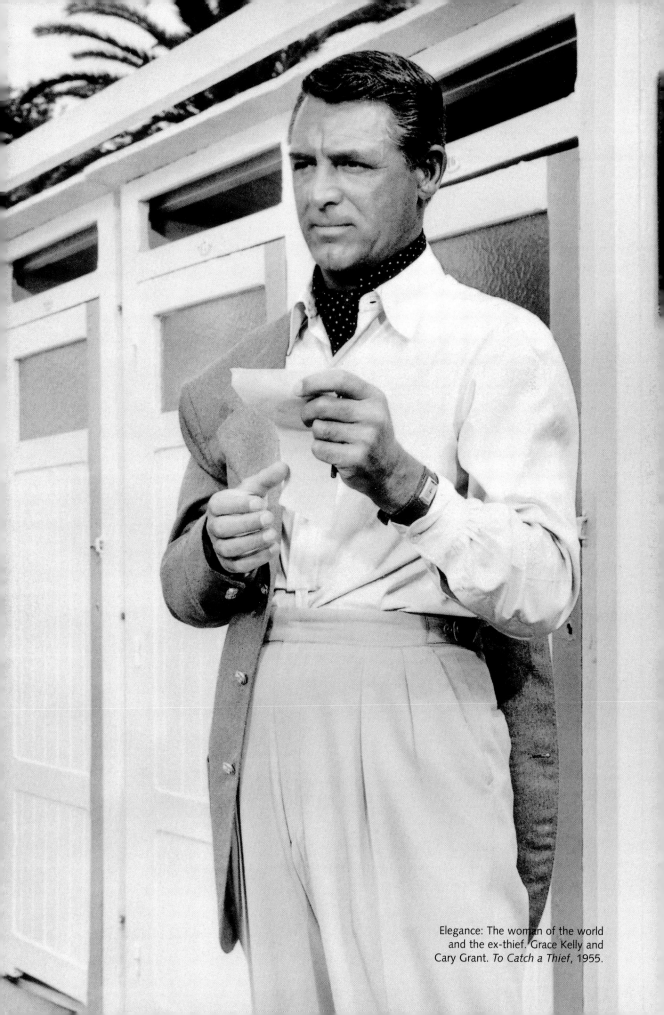

Elegance: The woman of the world
and the ex-thief. Grace Kelly and
Cary Grant. *To Catch a Thief*, 1955.

In that spring of 1979, his jubilee was being celebrated, but he could barely move.

But he had finally won some friends. Grace Kelly—Princess Grace—was dead, and Tippi Hedren (of *The Birds*) had fled film in disgust. But there were still Cary (Grant), Jimmy (Stewart), and Janet (Leigh), who all attended the ceremony. Ingrid (Bergman) presided over the ceremony. Though she had aged, Janet was still the prettiest there. People paid "homage" and "tribute," and passed congratulations around; Truffaut spoke English, film extracts were screened, and subtle jokes were bandied about, the work of handpicked gagmen. Just like in the good old days, Hitchcock's meticulous method dictated the action.

It was his turn. But he could not stand up. As meticulous as ever, he had foreseen his own catatonia that would attack him out of the blue, like a slayer of old ladies in a train. The day before, he had recorded and filmed his speech. Just like his introductions for his television series *Alfred Hitchcock Presents* (361 episodes). The text was perfect, recited in that artificial voice, solemn and hammered-out, mixed with the cockney of his long-lost youth:

"Ladies and gentlemen, good evening. Welcome to the darkest depths of Hollywood. A sudden calm has descended on the jungle, together with the night. The silence is so great that you could hear a pig fly. The wild creatures have already started to gather around their usual watering-holes. It is the hour when you must be on your guard, the hour when the fierce gate-crasher prowls everywhere in the shadows…"

Everyone stood and applauded a silhouette on a screen. Hitch stayed motionless at his table, staring at a forbidden vodka. He was waiting for "The End," and trying to hasten its arrival with strong liquor.

The end kept its appointment the following spring, on April 29, 1980. But he had been eulogized already at that perfect and sad party at the Beverly Hilton, referred to in Hollywood babble as the Lifetime Achievement Award.

But life sometimes ends on a touch of irony—life also plays at being the Hitchcockian heroine, the Hitchcoquette, the Hitchcocktease: mistreated, she takes her revenge. When beautiful, life is a bitch. When fragile, it triumphs.

Life laid Alfred low in an ugly manner. His wife, Alma, was in hospital. Alfred consoled himself with the cognac he kept in a drawer, and the vodka he kept in the medicine chest in the bathroom. Hitch—or what was left of him at the age of eighty—was trying to build and dictate a script. He was hiring secretaries from Universal who fled pale and at their wits' end before his requests for intimate services. He launched into murderous fits of wrath and then burst into tears. His sister Nellie died. His brother William only came to see him to drink his fine wines. Dull and dreary youth returned.

"I am an ocean of solitude," he told Ingrid Bergman, who was loyal like a good Lutheran. Don't let the priests get close to me, they're chasing me and they loathe me," he begged he who had directed her and so hopelessly desired her. She had turned him down for a Latin lover, Rossellini. Then Hitchcock confessed to her with a sob: "Ingrid, I'm going to die." She replied: "We're all going to die, Hitch." And that calmed him down for a while. Finally, at Christmas 1979, life, ever teasing, got two women to make him a last—or a first?—gift, a nose-thumbing gift. At the request of then Prime Minister Margaret Thatcher, her Gracious Majesty Queen Elizabeth II appointed Alfred Hitchcock Grand Knight of the British Empire, a decoration published under the heading: "Diplomatic and overseas services."

The British consul awarded the decoration and the title of "Sir" to the brand new Sir Alfred, in his office at Universal Studios, an office that was in the throes of being moved. The TV stations filmed an unruffled, grumpy recipient amid a setting resembling total chaos.

"I'm glad they finally thought of me" was his sole comment. Reckoning that he had been a tad abrupt, and that he had lacked wit—he who was so well acquainted with the media, by having made use of them so much—he added, exhausted: "And now perhaps Alma will mind her own business."

A loving thought for his bedridden spouse. All alone.

The only—and final—face that bent over him was the face of a nurse, on April 29, 1980, at 9:17 am. Behind his head, through the window, a cloudless California skyline. No gulls, and no birds.

When his will was unsealed, the executors discovered oil wells in Canada, 150,000 shares, 2,250 head of cattle, 66 cases of vintage wines from the best years of the 20th century, and 29 works of art by Rouault, Dubuffet, Dufy, Vlaminck, Klee, Dali, Rodin, and more. The initial taxes payable on his estate rose above the million-dollar mark. The press emphasized that not a single codicil mentioned so much as a dollar in aid of charitable works. Society doesn't like crime, and fear isn't distilled for charity's sake.

[FIRST YOU NEED A CRIME, A PLACE, A WEAPON...]

When and where are we really afraid of dying, or being killed—and which is deemed to be worse? In a gloomy house on a moonless night? But it is in bright sunlight, in the most open of places, on a dead straight, boring Texan highway that the murderer lies in wait for you in a Hitchcock film. Invisible in the desert in a crop-spraying airplane that actually sprays bullets, alongside vast expanses of corn, not genetically modified in those days. Or alternatively on a merry-go-round, beneath a sea of umbrellas, in an auction room, at the top of the Statue of Liberty, in Royal Albert Hall during a concert, in the shower, at the top of a belfry, or in the oven of your gas stove. It doesn't matter, actually, in life when you die, you die. But in films? Eek! And then the film gets going again.

Hitchcock prided himself in making "films with no dramatic holes or blemishes of boredom"—a delightful formula—and paid close attention to death, for he had no confidence in life.

Where life was concerned—and as a Catholic he nurtured the moral fear of being associated with what is evil—Hitch observed its moments of disquiet, its lack of stability and security, and its ambiguities, and imagined for it ends as brutal as capital executions. Hitch was an "avenger" (the nickname given by the press to the killer—also invisible—in *The Lodger*, the film that would be the matrix for his entire body of work), a righter of wrongs, a vigilante of sorts. He confessed one day, as he helped Norma, wife of his accredited composer Bernard Herrmann, with the washing-up after dinner, that if he had not become a filmmaker, he would have liked to have been a hanging judge, doling out death sentences.

He was a Zorro-like figure, who was far too overweight. And he always took note—in his childhood, in his profession, and through two world wars, not forgetting day-to-day life in Hollywood—of what men are capable of doing in order to destroy or manhandle purity and beauty. He did not make declarations or draw up petitions: he made movies. Lucid, thus scary, cruel, and cynical, as befits the works of an anxious artist.

Men kill and betray. Women, too. But is this a crime? Killing one's fellow man may be comforting. An act of relief for an irked aesthete. Therefore the crime needs to be well organized. In

Reconstruction: The crows from *The Birds*.
'Hitchcock and Art: Fatal Coincidences', Paris, Centre Georges Pompidou, 2001.

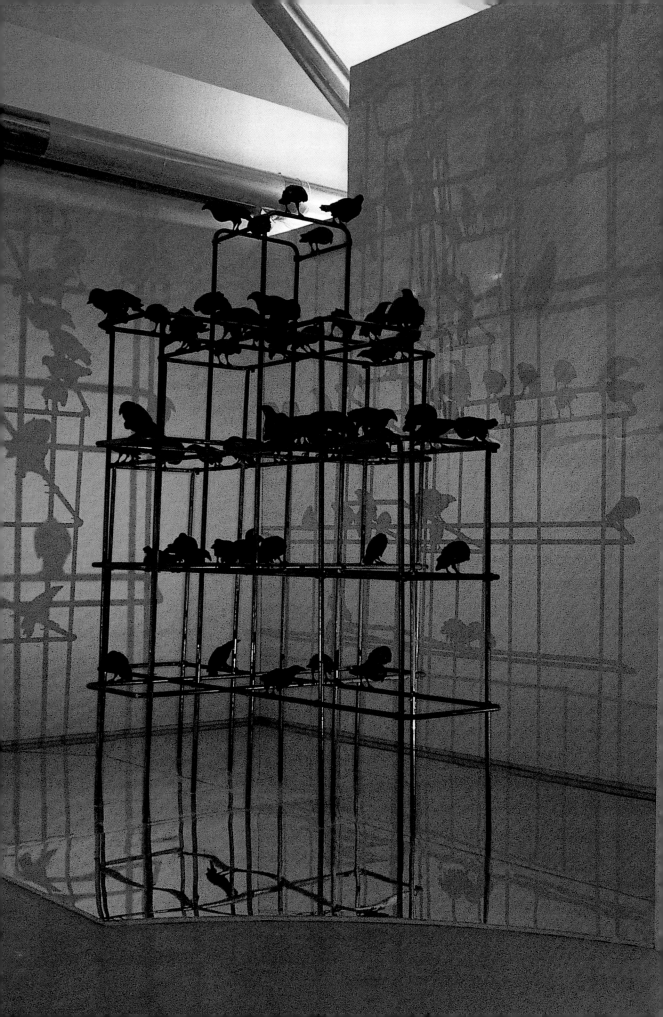

this concern to have "no holes and no blemishes," the place where the subject and/or his or her hopes die becomes all-important. The method chosen to do away with them is equally important. In fact, the place where a murder is committed—for murders are definitely perpetrated in a Hitchcock film (with the notable exception of *The Trouble with Harry*, where the alleged murder is nothing more than a welcome heart attack that frees Shirley MacLaine from her cumbersome, if absent, husband Harry) —is always dependent on the setting. "If I'd made a film in Switzerland, I'd have drowned the victim in a vat of chocolate," Hitch announced with greedy satisfaction. He takes us into a chocolate factory—Swiss, it just so happens—in *Secret Agent*. Which explains the windmills and the sea of umbrellas hiding a murderer in Holland (*Foreign Correspondent*), the Thames in London (*Frenzy*), the Statue of Liberty (*Saboteur*) and the UN building (*North by Northwest*) in New York, a Siberian gas cooker (*Torn Curtain*) in Russia (still called the U.S.S.R.), a private mansion in a smart Parisian neighborhood, and a jail in Cuba (*Topaz*).

There were times when he had more brazen ideas: the parted thighs of the delicious, very young, and very blonde Joan Barry in *Rich and Strange*. A film about a couple on holiday who are tempted by adultery. The movie ends—Catholic morals *oblige*—with the shipwreck of the steamer where they were having fun, and the sampling of a cat, skinned and cooked Chinese-style, on the raft. Joan Barry asked Henry Kendall to swim between her thighs when they were cavorting in the swimming pool, and then she squeezed her legs together when his neck passed through them. Hitch the daydreamer had imagined this scene off-script, but dropped it because he was afraid of what the censors might do. The scene would only have shown a gentle and face-tious strangling, but who knows what might happen during some simple horseplay between a blonde's thighs? The game is important in that other game of roulette called "dead or alive."

A man is shot because he is acting on a stage. In *The 39 Steps*, Mister Memory knows every-thing and says everything on the music-hall stage where he is performing. Robert Donat asks him what the mysterious thirty-nine steps are, and he starts to answer: "A criminal organization which…" Then bang! The man with the universal memory collapses in front of his audience, taking his conscientiousness to the brink of death. This murder reflects the spirit of its time: the music-hall vogue of the 1930s. Hitchcock is the universal recorder with one (camera) shot.

There is murder, and then there is murder. Shooting with a rifle or pistol is an impersonal act because of the distance between hunter and prey. And therefore it rarely works in a Hitchcock film. There is a sorry assassination attempt in both versions of *The Man Who Knew Too Much*, and in *North by Northwest*, Eva Marie Saint unloads her automatic in the direction of Cary Grant, who falls to the ground, but it is all a charade: the gun is loaded with blanks. An eldery scholar may or may not be shot with a pistol in *Foreign Correspondent*, but the gun in question is

hidden by a camera (a symbolic stand-in for the filmmaker's eye) and the episode serves to stir up the plot, which was getting a bit stale (mostly because the hero, played by Joel McCrea, is a bit of a bore). Anyway, it's only a pseudo-scholar who is killed.

Hitchcock's preference is for murders commited face-to-face, facilitated only by a shoelace, belt, silk scarf, or other similar accessory. Murder is a man's sport. Women, for their part, cut their victims to bits with scissors and knives. Instruments used by seamstresses, cooks, and good housewives. Women kill above all to get revenge.

His first female killer, music-hall star Anny Ondra in *Blackmail*, uses a bread knife to off the man who raped her, and Grace Kelly in *Dial M for Murder* uses a pair of scissors to stab the killer (Anthony Dawson) her husband hired. In this sequence Hitchcock clearly shows his perfectionism. He enjoyed the scene and, because the film was in 3-D, he asked for additional takes, saying: "There are not enough reflections on the scissors, and a murder with scissors that don't dazzle is like asparagus without Hollandaise sauce: tasteless!"

In *Sabotage*, Sylvia Sidney gores her husband (Oscar Homolka) with a carving knife—intended for a leg of lamb—because he has caused the death of her kid brother. Homolka had given her brother a package containing a bomb that the young boy accidentally sets off by playing with it. And although Anthony Perkins, in *Psycho*, wields a two-foot-long knife outside the world's most famous shower curtain, and then again on a landing seen from above, this is because, he believes he is his mother at that particular moment.

In this last example, it is worth noting that it is not Perkins who plays his mother in those particular close-ups. For the shower scene Margo Epper was actually filmed, and in the murder of the detective on the landing a circus dwarf, Mizi, was used. Real women.

Let us linger for a minute on what is undoubtedly the most famous murder in all film history. Although a minute is probably too long, since the murder of Janet Leigh in the shower lasts just forty-five seconds, it is made up of seventy separate shots and it took seven days to shoot. According to Herman Scholm, the production supervisor, quoted by Patrick Brion (in *Hitchcock*), "Hitch wanted the camera to be the audience all the time, for him to see as if he were the audience's very own eyes." So added to the voyeurism—Janet Leigh naked, bit by bit—was the spectator's share and the director's share: sadism. Seeing such beauty destroyed and killed. But the beauty was guilty, for Marion (Janet) had stolen $40,000 from her employer. Sin laid bare, taking an almost consecrated shower.

"The shower was a baptism," Janet Leigh explained to Stephen Rebello for his *The Making of Psycho*, "the chance for Marion to get rid of the thing that was torturing her. In the shower, Marion becomes a virgin all over again. Hitchcock wanted the audience first and foremost to feel

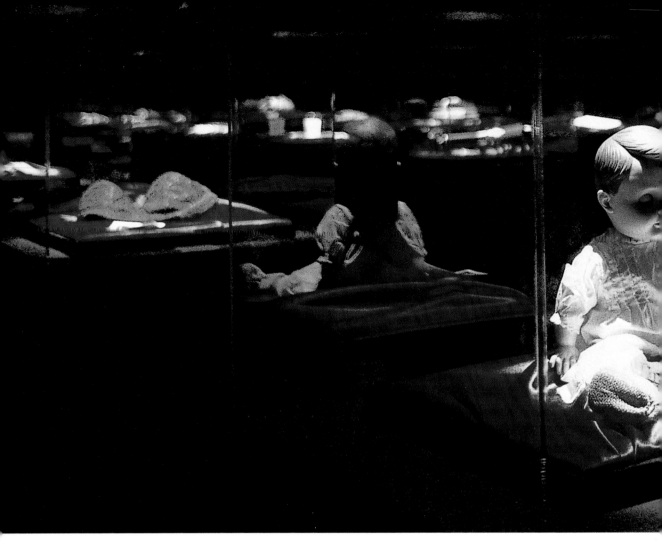

Above: Exhibits: The bloody doll from *Stage Fright*.
'Hitchcock and Art: Fatal Coincidences', Paris, Centre Georges Pompidou, 2001.

that peace, that redemption, that kind of resurrection, in such a way that the intrusion of Norman's mother is even more frightening and tragic." Mission accomplished. Seventy shots in just forty-five seconds, plus the insistent, staggeringly strident music of Bernard Herrmann's twelve violins, and, since 1960, no woman has ever looked innocently at a shower curtain.

Whether the murder is sophisticated or not, for Hitchcock, the craftsman, nothing beats manual work. A pretty neck, big paw-like hands, and go for it, boy! Ah, how good it seems to strangle your fellow man, and above all your fellow woman! Almost as sweet as a kiss, with the grimacing face of the strangled woman expressing a distorted ecstasy, with a dash of horrified surprise. The scene is running the risk of being unbearable, so maestro Hitchcock adds a gag to it. As in *Strangers on a Train*, when after Robert Walker starts to strangle the (loathsome) Laura Elliot, then the camera films the scene distorted by its reflection in the victim's glasses. It is worth noting that while at a party, after the murder, Walker is eager to demonstrate at a subsequent party the proper strangulation technique (strangulation having come up over the course

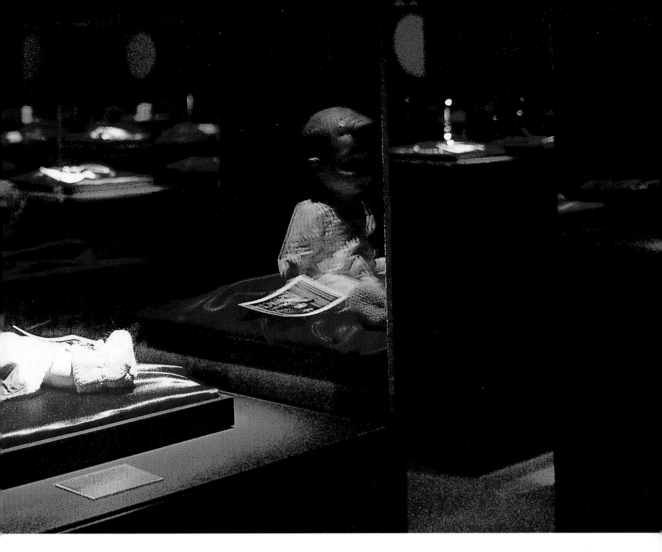

Following pages: Exhibits: The glass of milk in *Suspicion*.
'Hitchcock and Art: Fatal Coincidences', Paris, Centre Georges Pompidou, 2001.

of an overly sophisticated, and overly jaded conversation). Bothered by the glasses worn by the female guest (played by Hitchcock's own daughter Patricia) he is using as his model, his anxiety almost causes him to actually strangle her. It is also worth noticing that in *Lifeboat* everybody has a hand in the pie, all the survivors—men and women alike—when it comes to getting rid of the German naval officer in command of the submarine that has sunk their boat and who, furthermore, is the only person capable of steering their lifeboat. A triumph of the alliance of divided democracies, shot like a pack of dogs going for the kill (the film is from 1943).

The gallery of stranglers is famous and notorious: Joseph Cotten *(Shadow of a Doubt)*; Robert Walker, above-mentioned, in *Strangers on a Train*; the two rotten bastards in *Rope* (John Dall and Farley Granger) who strangle a friend, who is male, not female (they are gay); the killer in *Frenzy* who uses a club tie that comes from the club of the honorable politician seen campaigning on the banks of the Thames, which is where the corpse is found floating in the opening of the film! But this is not a complete list.

SPICION

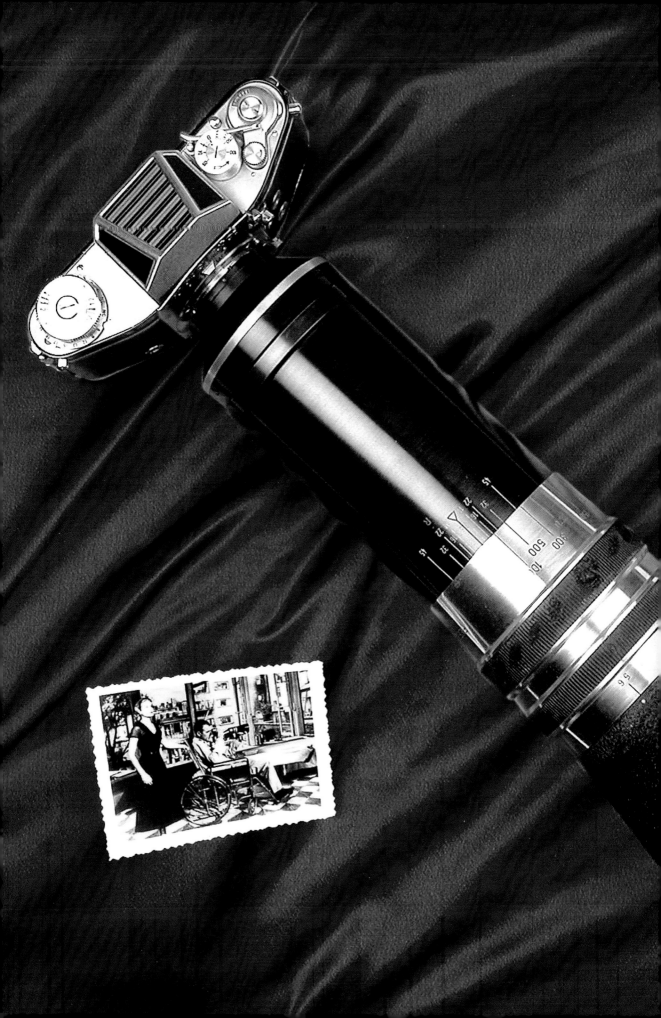

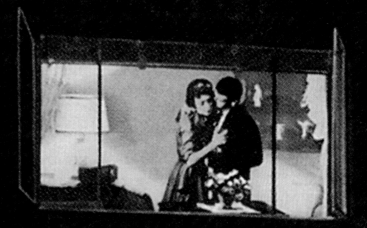

JAMES STEWART
in
ALFRED HITCHCOCK'S
REAR WINDOW
Color by
TECHNICOLOR

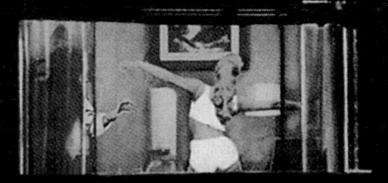

co-starring
GRACE WENDELL THELMA
KELLY · COREY · RITTER
with RAYMOND BURR · DIRECTED BY ALFRED HITCHCOCK · SCREENPLAY BY JOHN MICHAEL HAYES
BASED ON THE SHORT STORY BY CORNELL WOOLRICH · A PARAMOUNT PICTURE

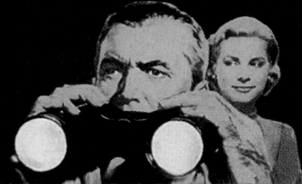

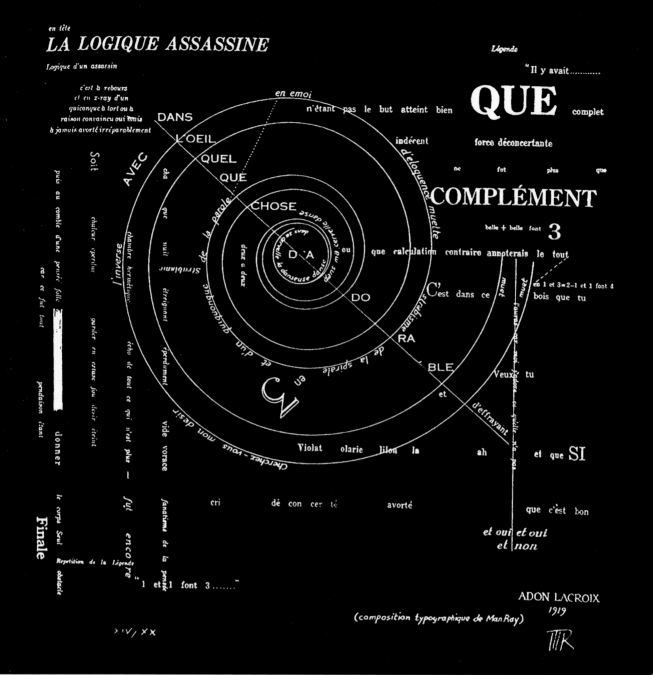

Opposite page: The poisoned cup from *Notorious*, 1946.
Above: All of Hitchcock? Man Ray, *La Logique assassine*, 1919.

Killing is not play, it is one hell of a job. Hitch dissects it for us in *Torn Curtain*. "I wanted to show how what a difficult, arduous, and lengthy business it is to kill a man […] the murder must be carried out with the means at hand. We are on a farm and it is a farmer's wife (Carolyn Conwell) who helps Professor Armstrong (Paul Newman) kill Gromek (Wolfgang Kieling). So we use household instruments: a pot full of soup, a carving knife, a shovel and last of all the gas stove." And note this appealing detail: the blade of the kitchen knife snaps in Gromek's neck. This criticism of junky Soviet-made products is a subtle joke playing off regional details.

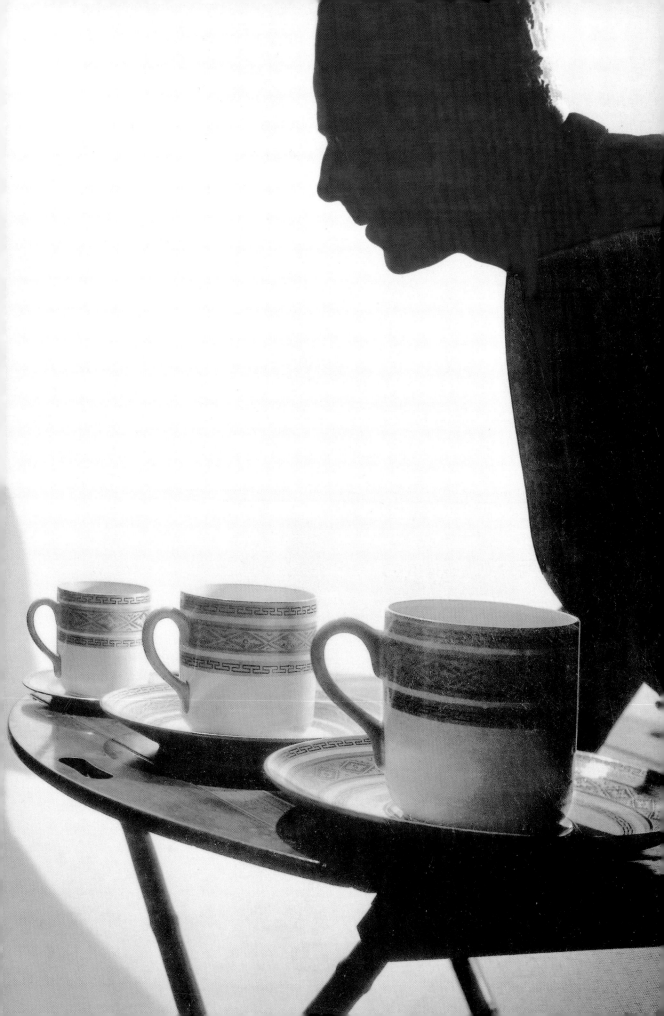

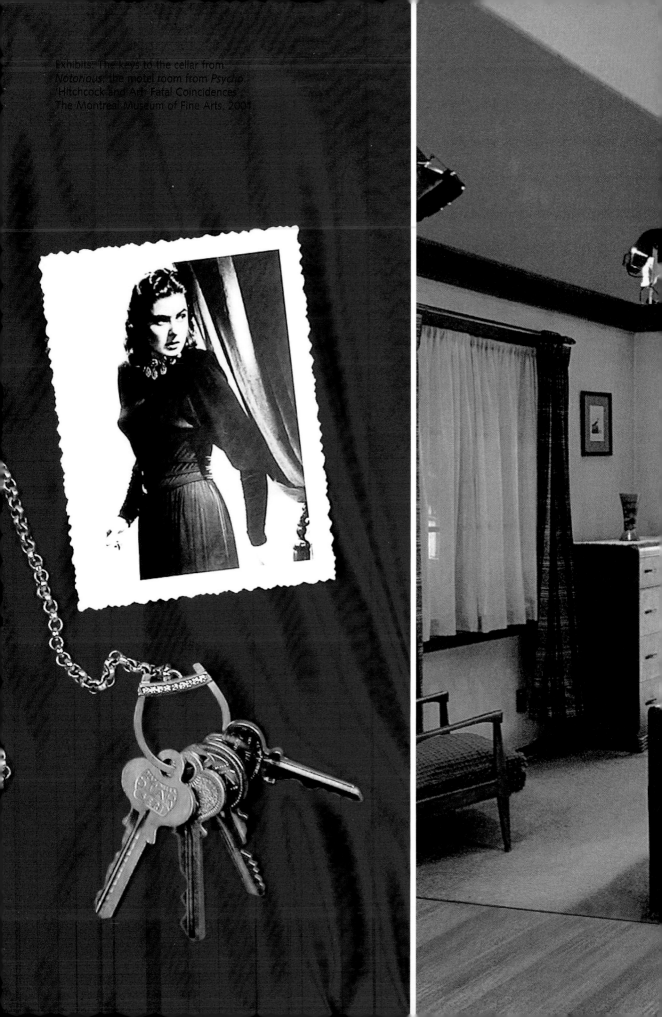

Exhibits: The keys to the cellar from
Notorious, the motel room from *Psycho*.
'Hitchcock and Art: Fatal Coincidences'.
The Montreal Museum of Fine Arts, 2001.

But sometimes killing is indeed child's play. Before being portrayed by the grown-up Tippi (Hedren) as a frigid kleptomaniac, the young Marnie has, at the age of five, used a poker (once more the use of a common-or-garden utensil within reach) to smash the skull of a drunken sailor roughing up her mother, a prostitute in Baltimore. Should we see only a coincidence in the fact that this city is also the city of Edgar Allan Poe? Is it by chance that Tippi Hedren, the master filmmaker's hopeless last mad passion (as we shall see later on), who plays the frigid kleptomaniac whose husband (Sean Connery) almost rapes her on a boat on their wedding night?

Because of its dizzying beauty, falling from a great height, whether provoked or self-inflicted, also obtains Hitch's vote in the register of violent deaths. A sleeve that comes unstitched, slowly, ever so slowly, and the spy is hurled from the top of the Statue of Liberty (*Sabotage*) as a victory sign for pure-of-heart America. Leonard (Martin Landau), James Mason's number one gun in *North by Northwest*, topples off the top of the effigy of Abraham Lincoln at Mount Rushmore, and it is patriotism that wins over treason. As for Kim Novak—who plays an actress hired to impersonate a woman already dead and thereby trick James Stewart (a private eye who suffers from vertigo)—she falls from the bell tower of a Spanish mission on the outskirts of San Francisco in *Vertigo*. A little comment signed by Hitch: "I needed a church with a pretty bell tower, so an elegant old church. Well, in California, old churches are Spanish Catholic missions. You can't imagine someone throwing himself off the top of a modern protestant church." Enough said.

And then one day, tired of the criminal human being lacking in imagination and in sufficient perfectionism to avoid being caught, Hitch instead chose *The Birds* (the year was 1962, and he had been filming murders and misdeeds for 38 years). Crows—those traditional winged vehicles of evil, even for Walt Disney, dark phantasms of our accursed thoughts ever since those esoteric thinkers of ancient Greece—along with legions of passerines and little sparrows enchanting our childhoods, as well as seagulls, like white brush-strokes in the painted skies of seascapes by novice water-colorists. And just one glimpse of blood: a drop on a woman's glove. Melanie Daniels (Tippi Hedren) is an American lady. *The Birds* is a film about beauty and fragility getting their revenge against human stupidity: Rod Taylor, Tippi's suitor, undoubtedly comes across as a handsome guy, but he is above all a great nincompoop—in a surprising metaphor.

Hitch liked to surprise but not trick. For many years he reproached himself for the misleading flashback that opens *Stage Fright*. This is why the spectator is always informed, before the film is even half-way through, about who did it. And how. The place, the moment, the weapon, and the possibility—nothing is kept from us. The motive, for its part, doesn't matter much. "Personally I don't give a damn. The mysterious motive is a fake mystery, without purpose, an absurdity, a MacGuffin!" MacGuffin? Who is he? An old major in the Indian Army? "Rudyard

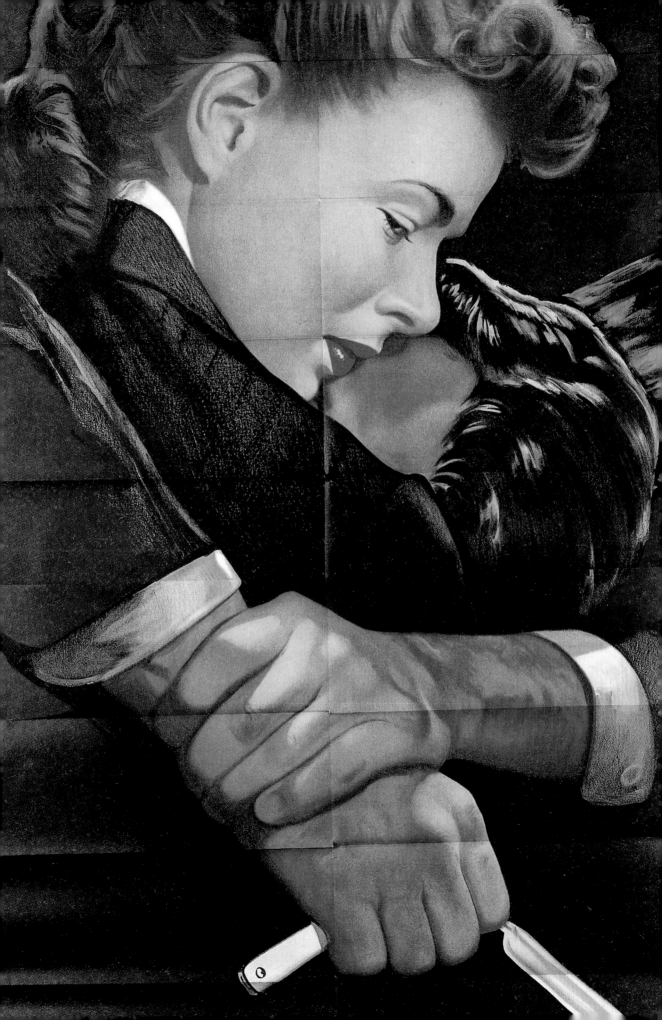

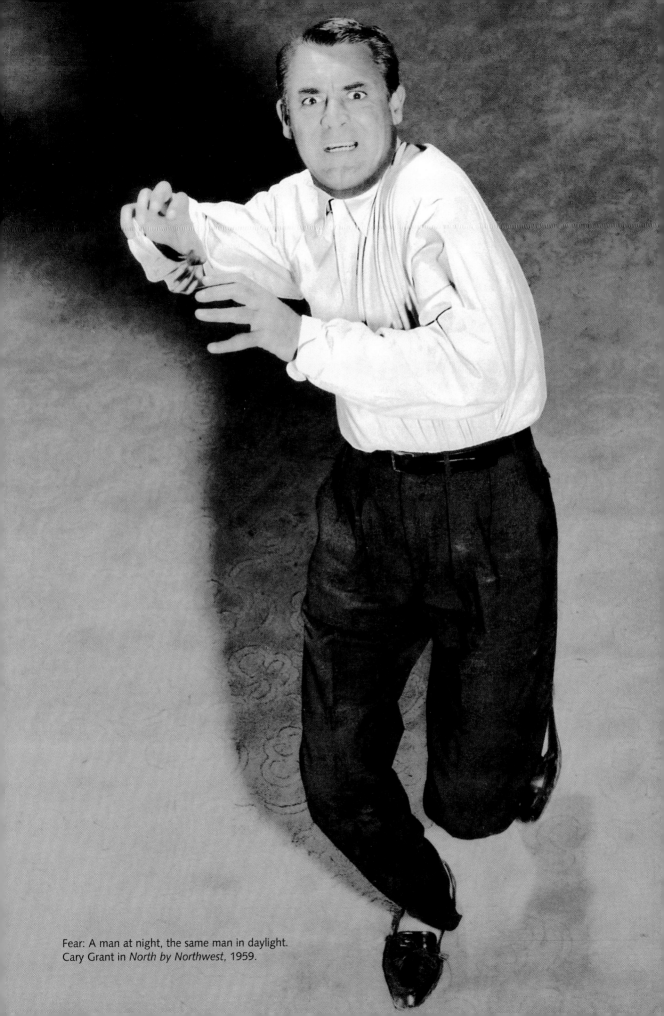

Fear: A man at night, the same man in daylight.
Cary Grant in *North by Northwest*, 1959.

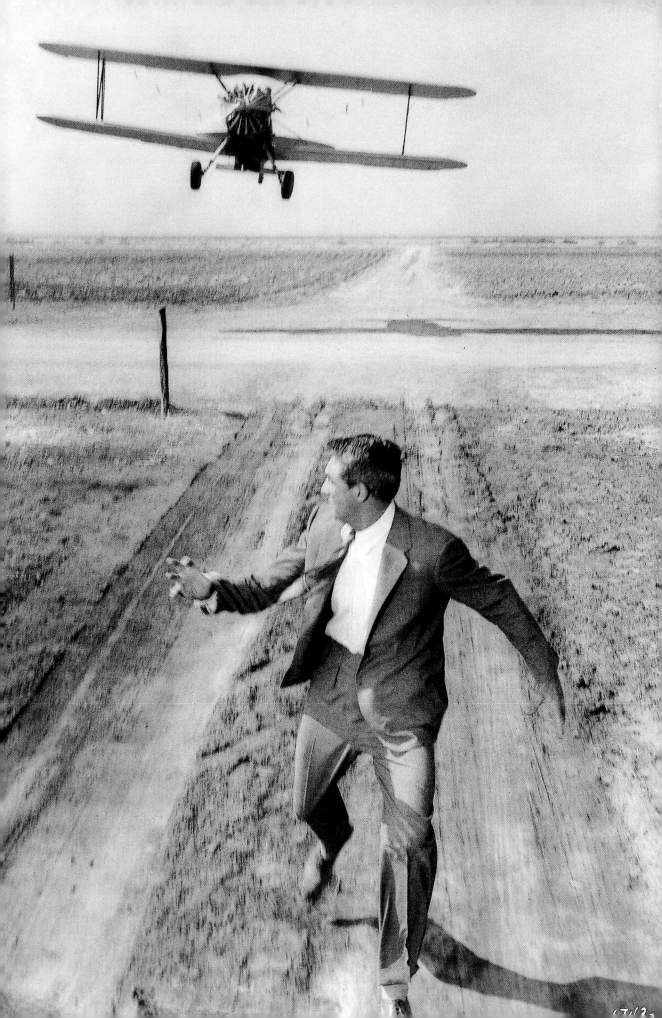

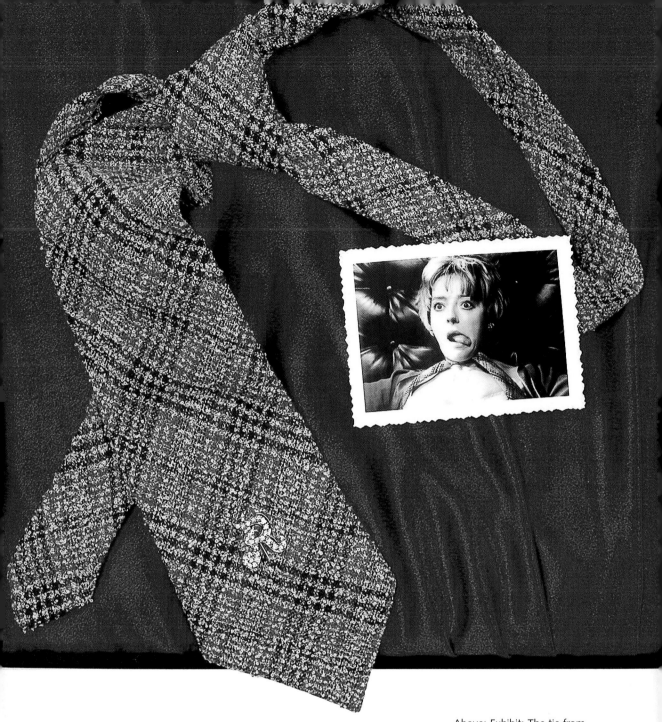

Above: Exhibit: The tie from
Frenzy (1972), 'Hitchcock and Art: Fatal Coincidences', The Montreal Museum of Fine Arts, 2001.
Opposite page: A murder attempt: Tippi Hedren facing *The Birds* (1963).

Kipling often wrote stories about the British endlessly fighting Indian rebels on the Afghan bor-
der. They always involved dark imbroglios of espionage, and things invariably lead to the map of
a fortress. That's what the MacGuffin is." A plot device that though seemingly important serves
only to set the plot in motion. The essence lies elsewhere, with the characters. If the character is
in danger, the audience's interest is guaranteed. In Hitchcock's world, everyone—murderers
included—has the right to life, a real life, and the right to preserve it and, above all, wreck it.

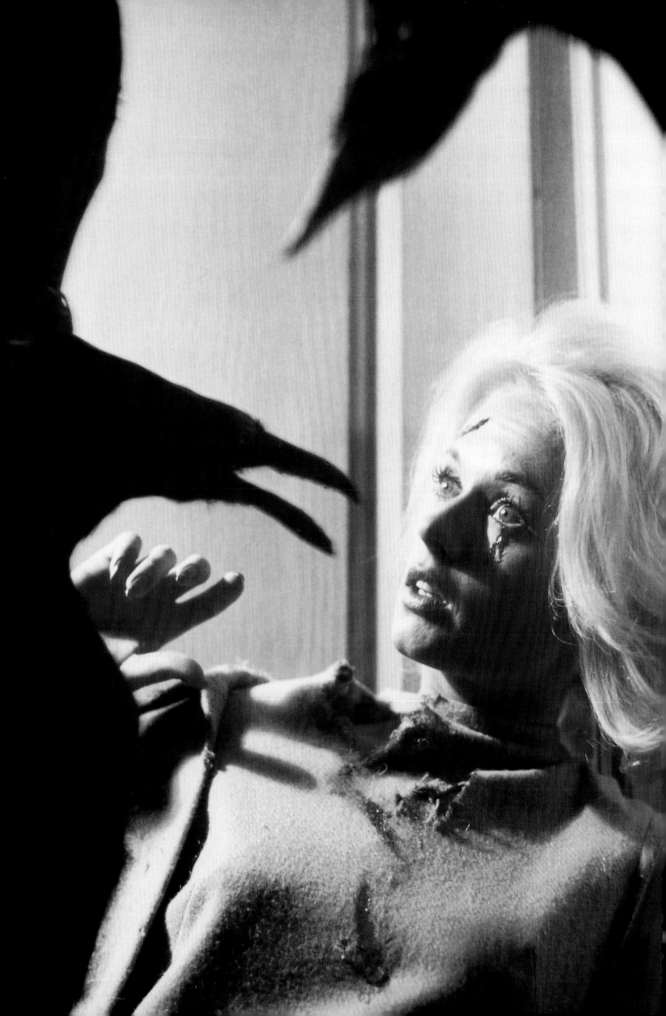

This was how Hitchcock, the pudgy midget, saw male humankind: the opposite of himself, physically, and completely like him ethically. Hitchcock was an artist.

Morality: his bad guy is up to his dirty tricks, all smiles, and announces them in honeyed tones. A caress turns into cruelty: James Mason lays a hand on Eva Marie Saint's shoulder, and we shudder. What exactly is a murder in Alfred's realm? We have seen what it is. A flirtatious affair that has gone wrong. A kiss that is too insistent becomes a twisted desire to strangle. Hitch invented two principles: filming crimes like lovers' embraces, and kisses like attempted murders. And he imposed this dogma: "The better the bad guy, the better the film." His films are excellent.

He made it a point of honor to choose his bad guys from the gallery of Hollywood gentlemen: Claude Rains (*Notorious*), James Mason *(North by Northwest)*, George Sanders

The beauty of the evil one: Anthony Perkins in *Psycho*, 1960.

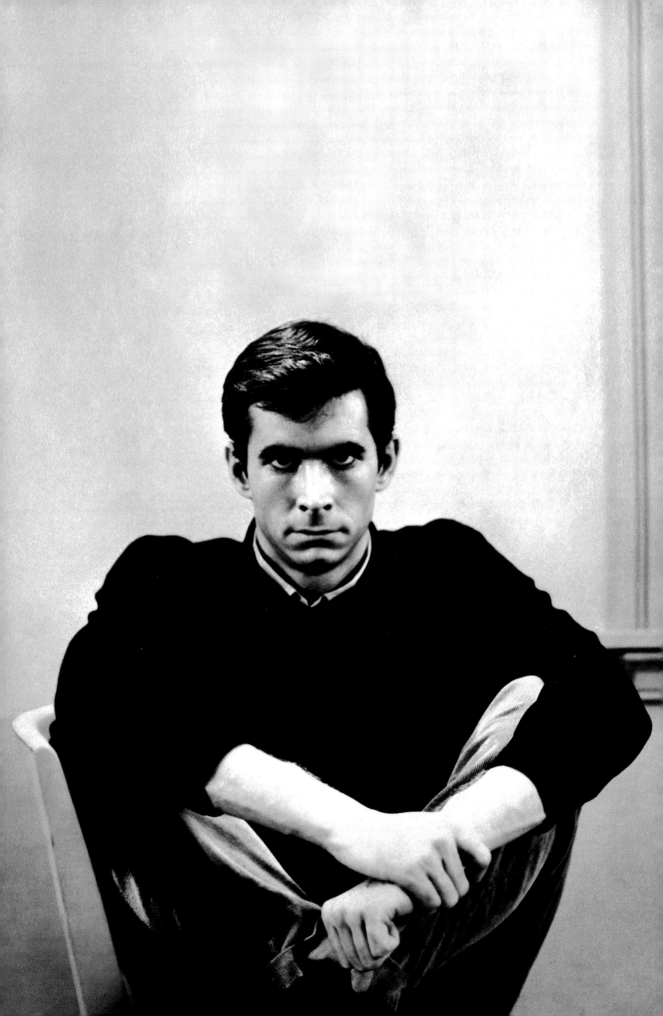

(*Rebecca*), Ray Milland (*Dial M for Murder*), Joseph Cotten (*Shadow of a Doubt, Under Capricorn*), Anthony Perkins (*Psycho*). Like his creator, the bad guy is often a British immigrant.

Claude Rains was born in London; James Mason was born in Yorkshire, and went to Cambridge; George Sanders hailed from an English family from St. Petersburg; Ray Milland came from Wales and, as his real double-barrelled name — Reginald Truscott-Jones — preordained, he was first of all a royal guard at Buckingham Palace.

Only Joseph Cotten and Anthony Perkins were authentic, but chic, Americans. Cotten came from Virginia, founding State of the United States, and Perkins was a product through-and-through of New York—intellectual, snobbish, and arrogant.

To these well-born gents Hitch handed well-made women: Ingrid Bergman, Eva Marie Saint, Joan Fontaine, Grace Kelly, Teresa Wright, and Janet Leigh.

He got his bad guys to don the (made-to-measure) clothes of a Nazi, a spy, a blackmailer, a greedy husband, a widow-killer, and a schizophrenic.

There is a curious resemblance between two Hitchcockian heroes, one good, one bad, one an adult, one a near child or at least an adolescent gone to seed. Two heroes, two actors, who contrary to Grant, Stewart, Cotten, played only once under Hitch's direction: Henry Fonda and Anthony Perkins.

One is the *The Wrong Man*, the other is the killer in *Psycho*. They are emaciated, dressed modestly, but it is their thinness that gives the clothes a certain class: whether it is Fonda's dull suit, or Perkins' velvet jacket, turtle neck sweater, and shirt with rolled up sleeves. Physically elegant, thanks to their own morphology, they are coat hangers on which to drape banality with grace. Apparent banality. Given that no criminal resembles a real criminal— that is how we can recognize them, would say Chesterton—from this stems the ease with which the misdeeds are committed. Ballestero-Fonda is normal but passes for a guilty man in a plausible way. And it will be necessary at the end, for the face of the real culprit (and is it really him since he is being recognized by the same witnesses that had previously inculpated Fonda?) to be superimposed over his own so that his innocence may surface. Norman Bates-Perkins has a purebred kind of face, but also a very young one full of the awkwardness of a retarded adolescent. An adolescent who could vaguely, but understandably, be perturbed by Janet Leigh's beauty. If the place itself is worrisome, he himself isn't, or at least he's not supposed to be. And his voyeurism, when Marion Crane-Janet Leigh undresses is… normal, in his case—sexual curiosity being common in adolescents. In a way, he does not kill, since it is his mother who brandishes the enormous knife in the shower and later

Opposite page: The most elegant one: Joseph Cotten in *Shadow of a Doubt*, 1943.
Following pages: Good or bad? Gregory Peck, Cary Grant, Sean Connery.

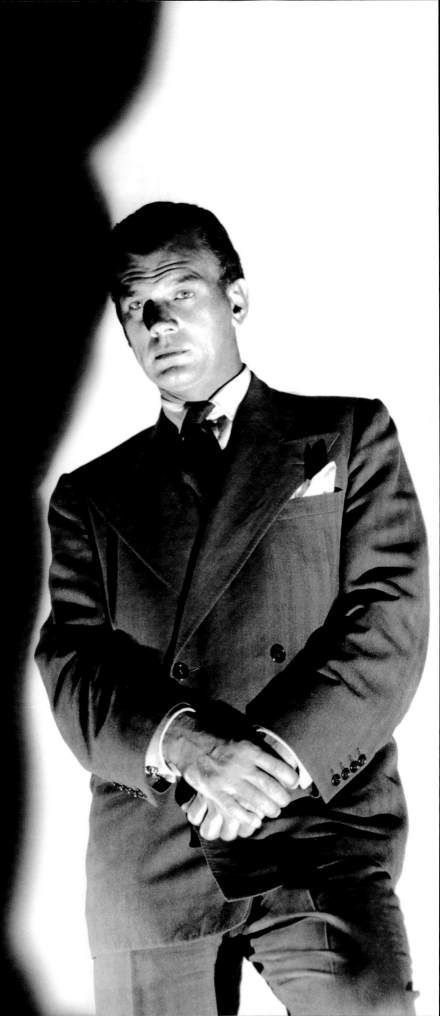

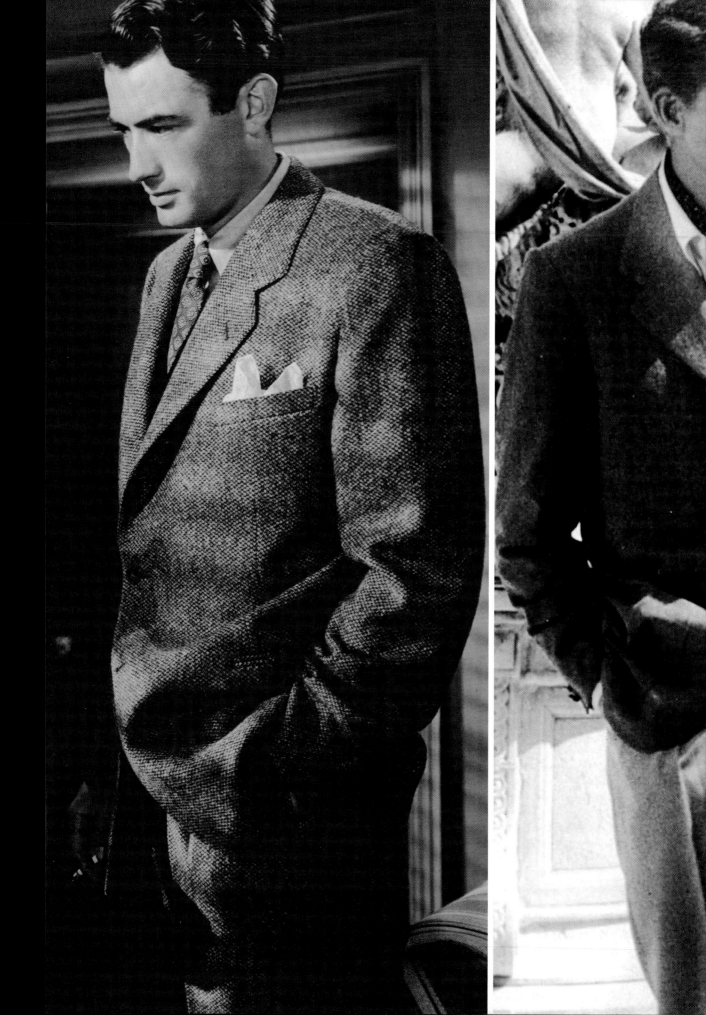

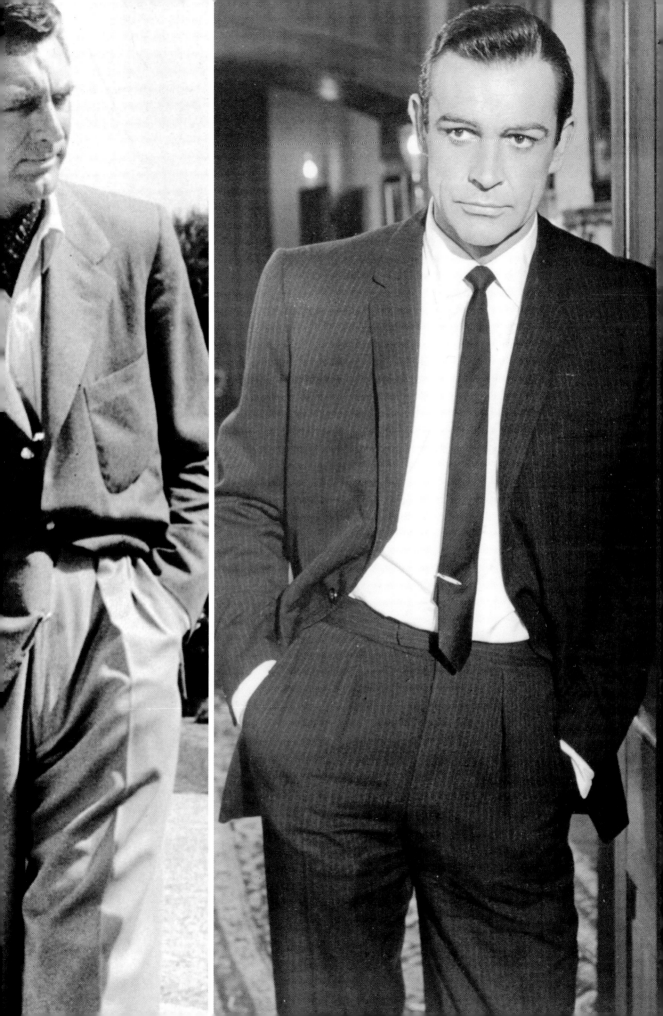

disfigures the detective. It is therefore necessary, here as well, to have the face of the Mother—stuffed like the birds that grace the walls of the motel—to be superimposed over Perkins' for the murderer to be recognized as such, while the voice of Mother says, "he wouldn't harm a fly." Guilty but sick, consequently legally innocent. Impossible to judge. Fonda plays in a realistic manner. Perkins in a nervous way, seemingly uncontrolled, in fact "fantastic". With the same outcome: another appearance of truth, the unveiling of one being's hidden face.

Perkins would never get over the role of Norman Bates, which clung to him forever after. He even had to put those clothes back on for *Psycho II, III*, and *IV*, but without Hitchcock, so therefore without any soul.

The fact is that bad guys do have a soul: if they did not, where would the delight and thrill of their bad behavior live? Hitch was a Catholic. It is worth repeating this, and he himself repeated it often. His sense of sin was even more acute than his gourmet's excesses and his lustful thoughts, which he tried to look as if he was fighting against. Hence his fondness for transforming women: he let loose a flock of sparrows on Tippi Hedren, so as to turn a top model into a scarecrow *(The Birds)*; Stewart re-created Madeleine Elster from Judy Barton in *Vertigo*, and, in a more vicious way, Cary Grant turned a boozy orphan, Ingrid Bergman, into a secret service time-bomb in *Notorious*. The ambition behind all this was noble enough: the struggl against Nazism and its South American bastions (the film was conceived in 1944). The means were so cruel that Hitch would never match it again.

In *Notorious*, he creates a double-barrelled nastiness: Claude Rains and Leopoldine Konstantin. The Sebastian son and his mother. Love in vain and hatred in action.

Claude Rains plays Sir Alfred's most head-over-heels-in-love bastard ever (he is a Nazi). But alongside him, in the same film, Cary Grant—who "infiltrates" Ingrid Bergman into that dark den in the Rio sun—achieves the highest peaks of perversity.

Rains does truly love Bergman (daughter of a dignitary in the despised regime), whereas Grant literally makes a whore of her. By using blackmail.

We know that Rains was not a tall man. For the shoot, they had to use a sloping set so that he would not seem too dwarf-like beside Ingrid the Viking. He was about Hitchcock's height, and born in London, like the director. For this particular role, oddly enough, Alfred wanted an actor who was overly elegant and openly homosexual, Clifton Webb (the sophisticated murderer in Preminger's *Laura*), but it was with Claude Rains, his slim double, that the alchemy worked. The scariest sentence in the whole film is when Bergman confesses to Grant that "He asked me to marry him." Its counterpart is when Rains tells his fearsome

The innocent: Henry Fonda (Italian poster for *The Wrong Man*, 1957).

N.Y.C. POLICE
B 80 922
JANUARY 15, 1953

HENRY FONDA · VERA MILES
IN UN FILM DI ALFRED HITCHCOCK
IL LADRO

CON ANTHONY QUAYLE · SCENEGGIATURA DI MAXWELL ANDERSON E ANGUS MacPHAIL

mother: "Mother, I've married a spy." The goal of all the manipulation was achieved, but tragedy reared its head in this cruel film that Hitch saw first and foremost as a great love film (complete with the longest kiss in the history of the cinema, as we shall see). The audience forgets that the transfixed little man is a Nazi. And that, as a suitor ridiculed by a lie of what would nowadays be called "national security," he readies himself to kill the object of his love, with a cup of tea. Remaining English. The real one hundred percent Nazi, the real "bad guy" is Mother, Mrs. Sebastian.

Alfred the meticulous had Mrs. Konstantin brought from Berlin. That great prewar actress had been part of Max Rheinhardt's Deutsches Theater. We must remember that Hitch was dispatched to Germany in the 1920's by the English studios, to check out the German filmmaking scene.

Mrs. Konstantin was unknown in America, so she earned a pauper's wages, and made just one film in Hollywood, but she will always be unforgettable at the top of a stairway, framed in a doorway, in a sugary manner wielding her tyranny over her distraught son. Or else with her face bent like a bird of prey over Ingrid knocked out by the doctored tea, her face squeezed between two braids of hair knotted on her head Prussian-style, as she doubles the dose of arsenic in the Earl Grey.

Is she human or is she a ghost, a modern-day offspring of the noble Borgia family, a credit to pharmacology. She wears the uniform (strict dress, discreet cameo, hair parted down the middle and braided) of Mrs. Danvers, that other menacing apparition who haunts a manor house in *Rebecca*.

Hitchcock divided this famous Mrs. Danvers (Judith Anderson) into a male being and a female being, as she terrified Joan Fontaine, damned Laurence Olivier, and set fire to Manderley, out of fidelity to the deceased invisible mistress of the house. So she is only a bad guy out of a depraved sense of loyalty.

Re-working this character in *Notorious*, Alfred H. chemically dissociates the active principles: exacerbated sentimentality finds its way into the masculine little body, effective evil-mindedness assumes the elegant silhouette of a tall, mature, hard-faced woman.

Hitch suffered from problems of height and repressed misogyny. But as a maniacal aesthete he tailored the roles of those two actresses (little known shooting stars), and Leopoldine Konstantin, like Judith Anderson, still haunts our nightmares, fifty years on.

It is worth noting that neither Mrs. Sebastian nor Mrs. Danvers have their first names included in the credits—as if no Church had agreed to baptize them and give them "Christian" names. Hitch, as a former pupil of the Jesuits, pushes this curse a step or two

Types of British bad guy: James Mason in *North by Northwest* (1959)...

further: by marrying Laurence Olivier, Joan Fontaine becomes Mrs. de Winter, period. What was her previous name? No first name, either. This delicious innocent young thing exists solely to depict a fragile blonde (taken up again in *Suspicion*, where she believes she has married a murderer, Cary Grant, again, and would readily let herself be killed), who shifts from the servile position of lady companion working for a wealthy American widow—who is vulgar (and fat)—to that of a British lady of the manor. A neat and simple form Hitchcockian geometry, and, for Mrs. Danvers, a usurper.

In this Manderley, a fairytale manor built in the middle of some wooded nowhere (which only exists as a model), Joan Fontaine behaves like some pauper astray among the rich: she hides the kick-knacks that she clumsily breaks, even though she is henceforth joint owner of all she surveys.

The fact is that in the moral world of the master, no victim can ever plead perfect innocence. Only the bad guy is bold. It must be said that, in film as in lawn bowling: doublets, duets, duos, twosomes, and doubles all work well. As a keen reader of *The Strange Case of Dr. Jekyll and Mr. Hyde* in his youth, Hitch would split his characters, white side, black side, enriched with every conceivable shade of gray.

The famous metaphor of *Strangers on a Train* with the parallel rails in the opening shot, followed by the two pairs of feet walking along and finally colliding beneath a table in the restaurant car to end up with a discussion about exchanging murders: I'll kill your wife who is bleeding you dry and stopping you from marrying the woman you love, and you, you'll kill my father so that I can inherit his money.

Who is the bad guy, Robert Walker making the proposition (and scrupulously fulfilling his half of the bargain) or Farley Granger, tennis champion, who is tempted but hesitant and, in the end, more chicken than honest?

In *Dial M for Murder*, Ray Milland (another tennis champion—tennis, according to Hitch, being a sport for potential criminals because it is a sport for good-looking guys?) commissions the murder of his wife (Grace Kelly), by way of blackmailing a rogue down on his luck, played by Anthony Dawson. It is Mrs. Milland who kills the killer. She will be roundly punished, because all that she is left with is her insipid nincompoop of a lover, Robert Cummings: the pity of inaccessible women!

Another perfect twosome, better even than Mrs. and Master Sebastian, is the Charlie duo in *Shadow of a Doubt*. Charlie, the man, is a strangler of widows dripping with pearls. Charlie, the woman, is a girl who is still a virgin, bored and dreaming her days away in a small provincial town. Charlie (Joseph Cotten) is the uncle of Charlie (Teresa Wright).

… and George Sanders in *Rebecca* (1940).

Their relations are those of false twins who do not openly dare to embark on an incestuous love relationship.

Shadow of a Doubt is a family saga, more perverse and brilliant than the last film made by Hitchcock—*Shadow of a Doubt* is the real *Family Plot* (1976).

All families are refuges and prisons where people lie in order to avoid killing each other. Daddy, mommy, children (irksome and deserving of many a nasty punishment), the grown-up daughter (Teresa Wright, bright-eyed sketch of the young American woman of the 1940s) and mother's brother turning up unexpectedly, and walking with a limp, emerging at the railway station from a cloud of black smoke, like a handsome devil (lame in accordance with the vision given by theology). They will all improvise the ballet of lies and murders in the too quiet town of Santa Rosa. Mouth-watering. And above all true.

Hitchcock, who poked fun at the "pawns" of film criticism, whom he called "our friends the plausible," worked on the details as never before. The house in which the film was shot was a real house belonging in real life to a father with the same income as the father described in the story. Joseph Cotten's clothes came from Joseph Cotten's personal wardrobe, and not from the prop shop. They are nothing if not elegant—the elegance of discretion.

And this time—and this time alone—the leading character is a criminal. A strangler, strangulation being, as we have observed, Sir Alfred's favorite method of murder.

The director and the audience identify (without remorse) with a murderer. Hitchcock signs his own identification: a note discovered at a later date shows that, in the screenplay, he dictated that his hero was "terribly maniacal and meticulous." A self-portrait.

He endows him with bits and pieces from his own childhood. His mother (played by Patricia Collinge) is called Emma, just like Hitchcock's mum, and, like Hitchcock's mum, she screams into telephones, in the belief that, in so doing, she will shorten the distances.

In the year the film was shot, 1942, Emma Hitchcock was very ill. Hitch was forty-three, felt he was already an orphan, and was nostalgic for life "before." Like Cotten, a killer out of nostalgia for bygone times, which he described as those times of a "good, kind world. A wonderful world, in which being young was quite something." That lost world has to be survived. And survived well. On Charlie's bedside table is a bundle of dollars extorted from a deceased victim. Uncle Charlie stretches out on his bed and then imagines a parade of old maids flying past, waltzing to the strains of *The Merry Widow* (a tune whistled many a time by various members of the family). A tune that is also whistled by Charlie II, the niece who is so close to him, and who signs her own death warrant by confiding in her

overly beloved uncle: "There's something in you that nobody knows about, a wonderful secret. I'll find it, I will."

Uncle Charlie then attempts to kill Charlie, his precocious niece, twice, but it is in fact Uncle Charlie who dies, falling out of the train that he had intended to push her from. Then a moving funeral for the (almost) unknown murderer, whose great qualities are listed by the priest. "Only we know the truth," whispers Charlie II in the ear of the detective who is in the throes of becoming her charm-free fiancé (played by MacDonald Carey, a dull actor). The punishment for pretty women is to marry unattractive nincompoops.

"He found the world awful," adds Teresa Wright-Charlie in the midst of her funeral address at the church door. One suspects that her world is about to turn sinister. Just like Hitchcock's: his mother is dying, his mother country is at war, and he cannot cross the Atlantic for her funeral; and the vastness of his unexpressed desires forms an ocean of guilt.

This is why, when looking at *Shadow of a Doubt*, every member of the audience clings closely to the strangler, a fact that owes a great deal to Joseph Cotten's charm, and everything to the dramas that beset the life of a plump little man who did not like himself very much.

Alfred Hitchcock began making films in 1925, and he waited until 1960 before he showed his first brassiere on screen. It was on the ravishing bust of Janet Leigh. Twenty minutes later she would die in the shower at the Bates Motel.

The breasts that can be seen beneath the knife blows (none of which actually touches the body) belonged not to Janet, but to stand-in Marli Renfro.

Exposing Janet Leigh's real breasts—decreed to be "legendary" in Hollywood, the euphemism used by anyone who had seen them in comedies like *Two Tickets to Broadway* and *My Sister Eileen*, in those full-breasted dresses of *Scaramouche* and under the skin-tight pullovers and white bustier of Orson Welles's *Touch of Evil*—in the nude would have affected the suspense and the disembodied, abstract violence of *Psycho*.

The male members of the audience would have shed their fear in favor of aesthetic contemplation; and the female members in favor of jealousy. Sir Alfred knew as much. What is more, Janet Leigh was a prude.

Oddly enough, as if to mark that fact that this was a significant date in his corpus of work, Hitchcock wrote on the screen the day, time, and place of this event: "Friday, December 11, at 2:43 p.m., Phoenix, Arizona," while the camera swoops down from the sky like a bird, hell-bent for a window with the blinds drawn, enters the bedroom and flushes out Marion Crane with her lover Sam Loomis (played by John Gavin). So Marion makes love in the afternoon, or when she takes her lunch break. She wears white lingerie. After the theft and before the murder, she would wear black undies, under the interested gaze of Norman Bates (Anthony Perkins) surrounded by stuffed birds. A phoenix, a "crane", birds belonging to a Peeping-Tom taxidermist. We shift from white to black. Is there any more perfect way to tell us a drama in black and white, which Hitch wanted to regard as a "macabre comedy"?

In his mind, undoubtedly this is what it was.

The first completely naked blonde to appear in a Hitchcock movie would not arrive until 1972: a corpse dragged out of the Thames at the beginning of *Frenzy*. Not completely

Test for blondness and style: Grace Kelly during the filming of *Dial M for Murder*, 195

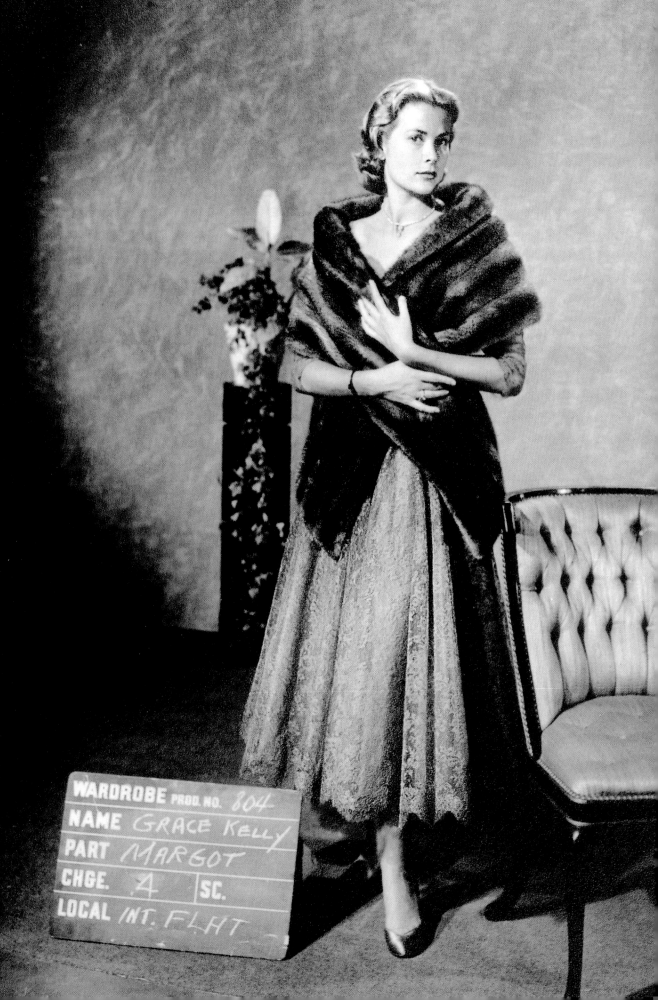

naked, though, because this lady is wearing a tie, the tie she had been strangled with. So it might be possible not to suspect Hitchcock of voyeurism, exhibitionism, sadism, and all the other nice expressions for the libidos of ugly fat people. Yes!

His air of not touching or showing anything is even worse. With the nape of a neck and a chignon, a pearl gray suit, a low-cut back, he assails our libidos.

Hitch and his audience are never as well portrayed as voyeurs as in the scene when Norman Bates, glued to his secret peep-hole, spies on Janet Leigh (might we admit to a weakness?), who on the other side of the wall, is undressing to take a shower at the motel.

From the start he admits to this voyeurism. In order to better "ogle" Janet, he moves the reproduction of a painting, *Suzanne and the Elders*, which depicts a scene of biblical voyeurism, reproduced and therefore is diverted from its religious function for an extremely profane pleasure. The defilement of the female star who is about to leave us in the first third of the film! Another transgression.

But let us take a closer look at the defilement of a superb woman's body. We will not actually see anything, except, shot by shot, a shoulder, a hand, ankles leading to calves, bare feet, an arm, a body in pieces—but you can imagine everything. Eroticism in smithereens—like a landmine.

So he was ugly, fat, and bald, and he suffered from all three (in 1945 he went on a crash diet and lost 110 pounds), but, as with Marion in *Psycho*, he knew how to choose his make-believe women, his film loves, his favorite fantasies. Even though the woman in the thriller or film of pure terror is the more or less consenting victim fated to utter friendly howls and charming squeals, Hitch frees her.

If he threatens her, it is to make her more dangerous. She spies, lies, steals (ah! Tippi Hedren with her slim gazelle-like legs emptying Sean Connery's safe in *Marnie*), scolds men, and now and then kills them. With the help of a pair of scissors (*Dial M for Murder*) or a bread or carving knife (in *Blackmail*, 1929, and *Sabotage*, 1936), or a poker (young Marnie), which are all utensils befitting a good housewife. A good housewife, the Hitchcockian blonde? A character that she would have trouble feigning.

Rather than house-proud housewives, he preferred his women to be altogether unforgettable and irresistible. For "Mr. Hitchcock," as Truffaut used to say, overlooked no detail.

Because he could not undress them, he arranged their hair and decked them out splendidly, in other words, with discreet elegance. He flushed out partners who were every bit a match for them, and handed them over to charming bad guys. He imagined himself

as Scottie (James Stewart) re-creating Julie (Kim Novak) as the supposedly dead Madeleine in *Vertigo*. The fantasy went a long way. This was how he "had" them. An enviable hunting schedule.

Hitch would be over a hundred years old today. His century was the age of Nazis, murders, mistakes, torture, "rum business" and dictatorships. The age of film and psychoanalysis as well, those machines for exploring fear, every manner of fear. That fear he teaches us only blondes know how to vanquish.

A guided tour of the museum of icy blondes, unapproachable princesses (or, before too long, a real princess, as seen in the example below) who push you on to the sofa as soon as the bedroom door has been closed (Grace Kelly with Cary Grant in *To Catch a Thief*) or threaten to marry you when your leg is too broken to allow you to escape (Grace Kelly opposite James Stewart in *Rear Window*).

Is it this brazen look that we find so seductive? Or something else that is more permanent? Yes. The Hitchcoquettes despise us: they turn their backs on us, like the loveliest women in Watteau's most beautiful paintings.

Disdain fully intended by a man who preferred to take them by surprise since he could not have them. Disdain which sets the teeth on edge and is felt to be a "follow me young man" by any male complying with the norm, and, by ladies, as a lesson in deportment, the better to hook that silly twit of a fish.

The view from behind reveals the nape of the neck, and the above-mentioned "follow-me-young-man" look, created by the fashion designers of those respectable years (when a woman never appeared without hat and gloves—the Hitchcock ladies all wear gloves when they sally forth into the world), designated twin strands of hair clinging to the neck.

The nape of the neck was the only piece of skin lined by the kind of hairiness that it was permissible to show. Hitchcock had to do without everything else, but he wasn't going to do without this.

Short hair, bare necks and shoulders—very important, the bare shoulders, to highlight the fragility of the neck—and, above all, chignons. When we peruse Sir Alfred's fifty-three movies, we understand the importance of seeing the names of these ladies' hairdressers included in the credits.

Short hair for the redheaded (the one exception) Shirley MacLaine (*The Trouble with Harry*), for Julie Andrews (*Torn Curtain*), Eva Marie Saint (*North by Northwest)*, and Janet Leigh (*Psycho*), and the nape of the neck was then emphasized by boat necks and sharp triangles cut low down the back.

Following pages: From 'Hitchcock and Art: Fatal Coincidences', Paris, Centre Georges Pompidou, 2001, Tippi, Kim, Grace and Man Ray's *Venus*, Sadean metaphor.

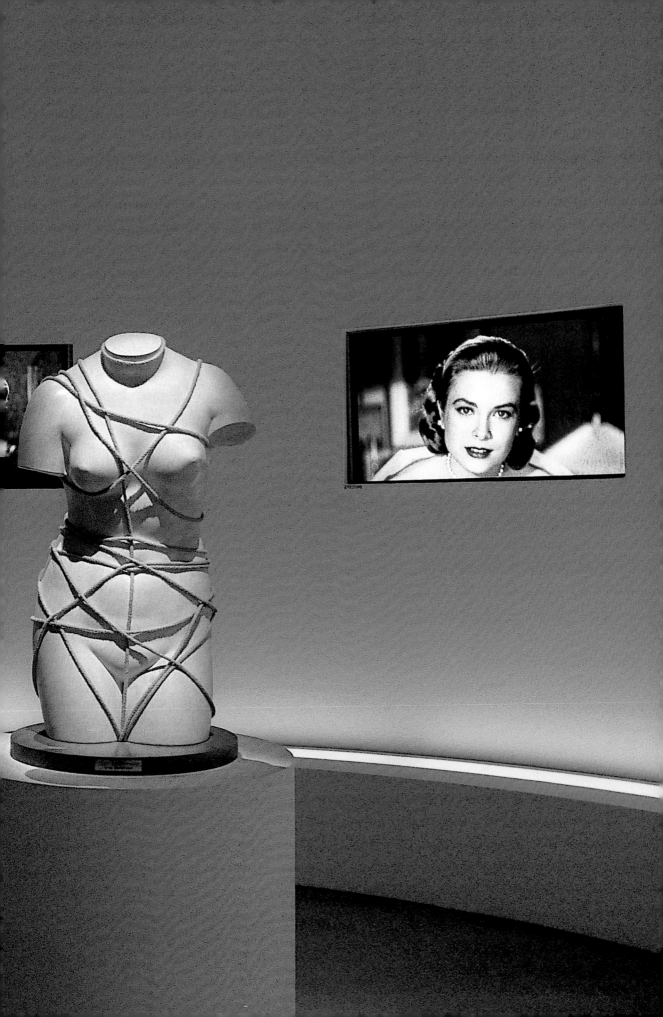

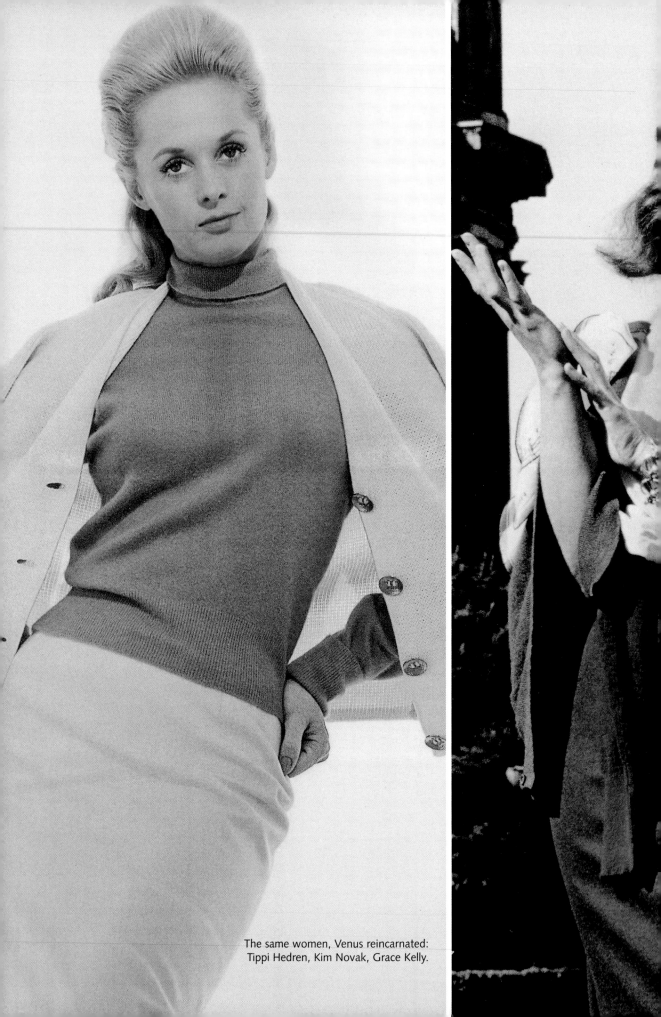

The same women, Venus reincarnated:
Tippi Hedren, Kim Novak, Grace Kelly.

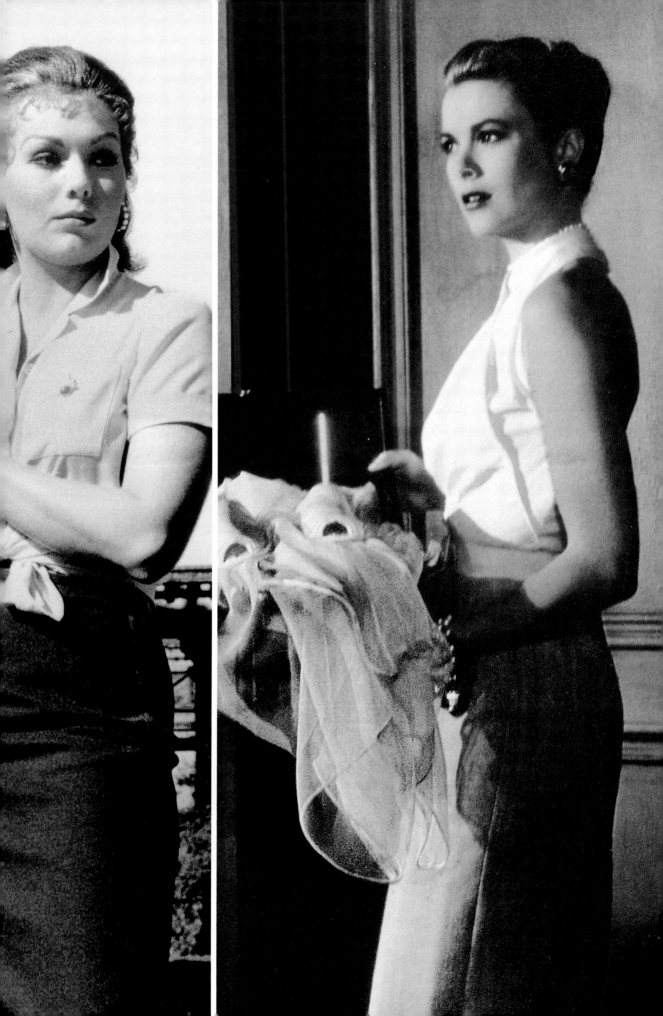

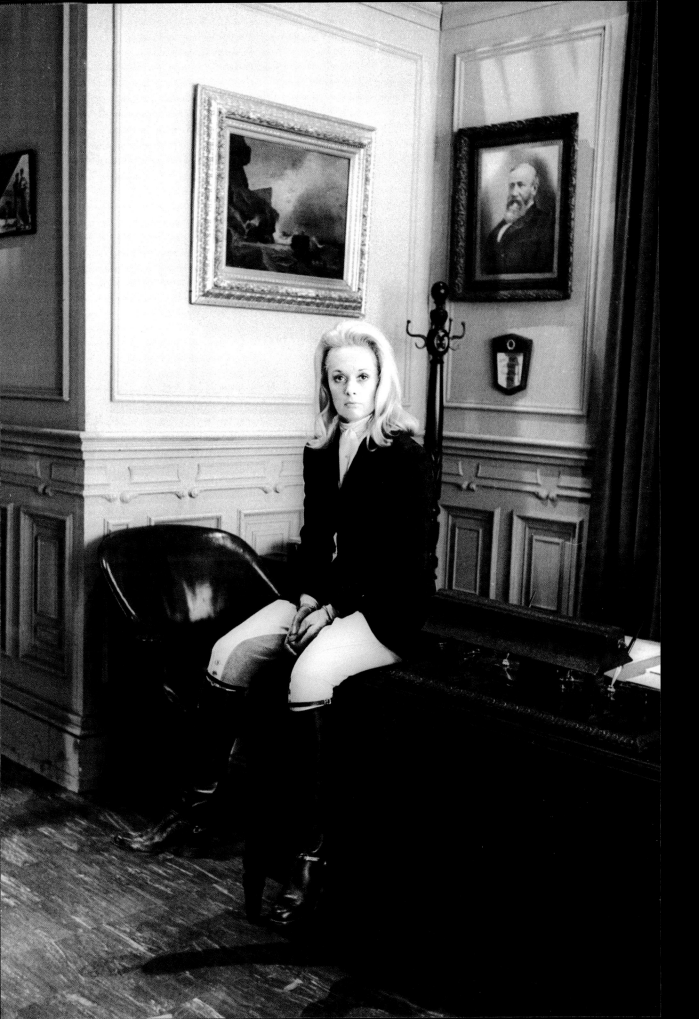

The list of spiral chignons or French twists includes Grace Kelly (she would lend her name to this hairstyle as she would to a Hermès handbag), Kim Novak (*Vertigo*), Tippi Hedren (*The Birds, Marnie*), Ingrid Bergman *(Under Capricorn, Spellbound, Notorious*), and Ann Todd (*The Paradine Case*). In this supporting role that might have been forgettable, the architectural chignon was combined with a white dress with a hell of a bare shoulder, so as to send Charles Laughton, an overly uncompromising judge because he's a feigned puritan, into a right Hitchcockian state.

The first "chignon'd" lady was Tallulah Bankhead in *Lifeboat*. Playing a snobbish and sarcastic journalist lost in the middle of the deep blue sea in a lifeboat with sailors, surviving passengers, and the German captain of the submarine that has just sunk them, she gradually abandons her jewels (the hook of her 24-carat bracelet comes in handy for catching fish) and lets her hair down as she becomes human, which is to say easy-going (the love of a "leftwing" sailor).

A little tidbit, for the record. On the shoot, the grips would throw dice for the lowly job of holding the ladder in order for Miss Bankhead to climb safely to the level of the huge tank of the Atlantic re-created in the studio. Because the beautiful Tallulah, a thoroughbred southern aristocrat, an immensely wealthy heiress of vast estates in Alabama, star of many a Broadway stage, leading an unpredictable and extravagant life, had total disregard for wearing

Preceding pages: All the *Marnies* in the world:
Hitch's monomania times ten.
Left: Nape of the neck and hair: Eva Marie Saint,
Shirley MacLaine, Grace Kelly.
Right: Grace Kelly during the shooting of
To Catch a Thief, 1955.

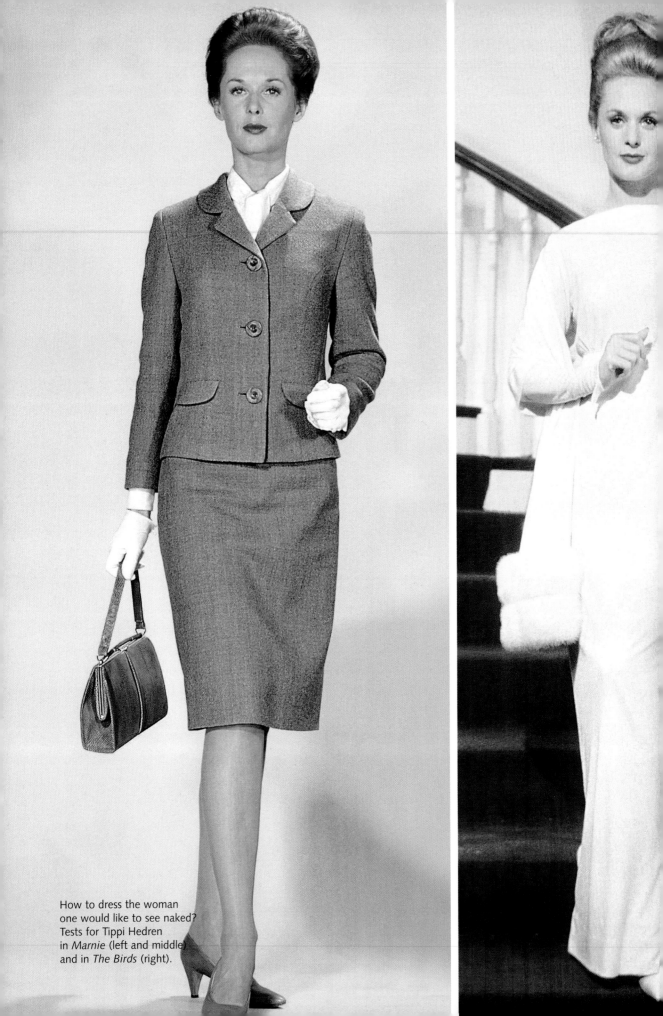

How to dress the woman
one would like to see naked?
Tests for Tippi Hedren
in *Marnie* (left and middle)
and in *The Birds* (right).

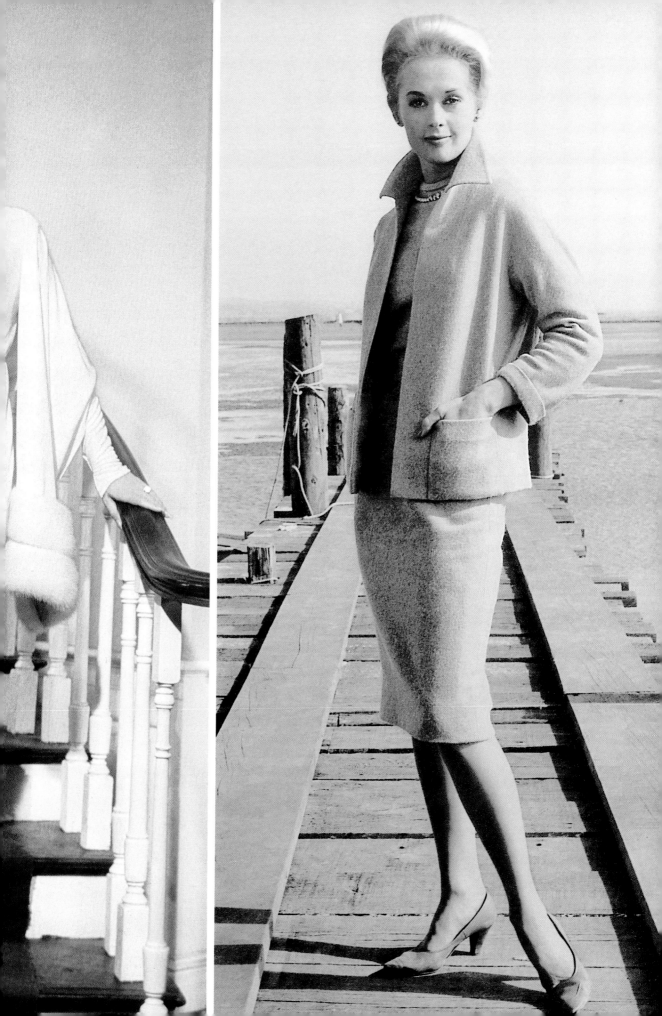

under-garments. This is in no way hearsay, but a precise detail that Alfred Hitchcock himself insisted on contributing to the history of his filmmaking.

The fact that his actresses wore nothing beneath their gowns tailored by Edith Head and other great Hollywood costume makers was, for Hitchcock, a feverish preoccupation, since, in his book of interviews with Truffaut, the famous *Hitchcock*, he leapt at the chance to point out that Kim Novak (whom he thought vulgar) boasted that she never wore a bra. Which prompted Jean-Luc Godard, summing up *Vertigo*, to come up with the following description of the film: "It's a braless blonde tailed by a detective who's afraid of the void." There are other quips, all very intelligent, but this one is the best.

The most beautiful chignon is indisputably in *Vertigo*: the dizzy spirals, generated by the close-up of James Stewart's iris, as he is hanging in mid-air, culminate at the end of their tortuous journey in the platinum blondeness of Kim Novak's chignon filmed from behind—the way it should be. "His dream," writes Michel Grisolia, "was that they should all come from Stockholm, London, Berlin, or, on a pinch, from Philadelphia, but never from Madrid, Paris, or Rome; he never managed to translate the woman on the screen into a Latin version. Even if they had been born in Tokyo, like Joan Fontaine, née De Beauvoir De Havilland, in Cincinnati like Doris Day, in Fort Wayne (Indiana) like Carole Lombard, or Chicago, like Kim Novak, he always more readily imagined that they were Scandinavian, distinguished, subtle, and as lacking in earthiness as they could possibly be, often old-fashioned, with pearls and black velvet, or looking like school-marms. Vacant, lost, and remote, their eyes suggested a state wavering between menace and nightmare. With Hitchcock's heroines, it is never very far from the Van Cleef salons to the mental asylum."

It is in a psychiatric clinic, in Dr. Edwards' home in *Spellbound*, that an elderly shrink, the only wise man in that mad house (doctors and patients alike, a killer, an obsessive woman-chaser, a frigid woman) that Dr. Brulow (played by Michael Chekhov) utters this sentence: "Women make the best psychoanalysts until they fall in love. Then they make the best patients." Bergman, the frigid, thwarted shrink, could not help but blush.

For beneath their bleached-blond, pallid, and ash-blond, crowns, these young ladies are frigid and/or teases, alcoholic, depraved, kleptomaniac, and forever surprising in both their decisions and their behavior.

Furthermore, let us note that the French title of *The Lodger*, to which we often refer, was *Cheveux d'or* (Golden Hair). The invisible murderer, "The Avenger," in fact, only strangles blondes. And only on Tuesday nights. "The Avenger" is an odd nickname for a murderer. Especially as the film never says what it is that he is avenging. The fact of not being a blonde?

As for the others, the redheads, the brunettes, the women with auburn and chestnut hair, either they would fail to inspire him, or would proceed, without further ado, to the dye, a word that, for so many of them, spelled die.

He even filmed that moment that was always magical for him. In order for Judy the red-head (Kim Novak) to re-become Madeleine, the (false and real) dead woman, Stewart takes her to a hair salon to have her hair bleached and make her a blonde once more. The woman agrees, like a victim, and like a woman condemned to death also. For she knows that the conspiracy is known. Hitchcock (and the Stewart character) gets around and beyond this guilt: "I was very fascinated," Hitch confessed to Truffaut, "by the *key scene* [emphasis added] of *Vertigo* where the color of the woman's hair is changed; it had so much in common with a sex scene". Stewart's gaze, as it follows with interest the shampoo operation, offers no disclaimer.

The man who knew too much, facing them, or rather behind their backs, never knows enough, and is always learning, for he wants to know more. To this end he gets away with disfiguring them, cutting their throats, terrifying them, sometimes with their consent. Such is the lot of these noble and discreetly sentimental creatures, doomed to the dual kiss of love and death on their blonde hair. From *The 39 Steps* to *Shadow of a Doubt*, and from *Foreign Correspondent* to *Stage Fright*, we have lost count of the lengthy shots of the hair, or the back of a woman's head.

Daydreams. Fantasies that could be made use of—to the utmost—by a fearful and all-powerful creator who was frustrated, perverted, and sadistic; at once a Victorian Pygmalion, in the straitjacket of his boyish fears and his upbringing, and a paunchy, scatological and pitiless Marquis de Sade, who slept little, and dreamt a lot.

Despite its title, which nevertheless sums the whole thing up, he would never have filmed (Frank Tashlin's) *The Girl Can't Help It* with Jayne Mansfield in the lead part— bust: 42 inches; IQ: 149. The precise symbol of everything Hitchcock loathed seeing on his film.

"The conventional big-breasted blonde holds no mystery. I don't like those actresses, Brigitte Bardot, Marilyn Monroe, and Sophia Loren, who constantly have their sex on display, if I may so put it, on their faces," he declared during the filming of *Vertigo*.

Misogyny? "Ten shots of *Marnie* and the objection fades," wrote Michel Grisolia. That "great sick film," as it was called by the author of *The 400 Blows*, well aware of the portrait of a woman whose childhood had been devoid of warmth, "that red melodrama is a hymn to love and to the resistance and courage of women."

Lots of apparent reserve, lots of temperament in private: according to Hitchcock this is the standard female type. Ice cold tea, piping hot sex.

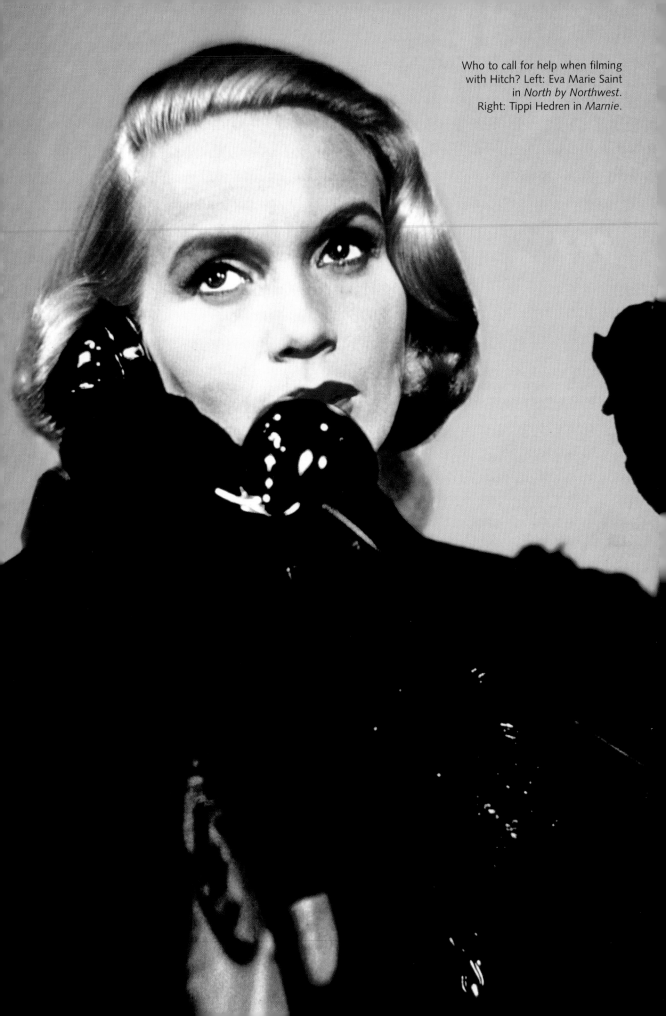

Who to call for help when filming
with Hitch? Left: Eva Marie Saint
in *North by Northwest*.
Right: Tippi Hedren in *Marnie*.

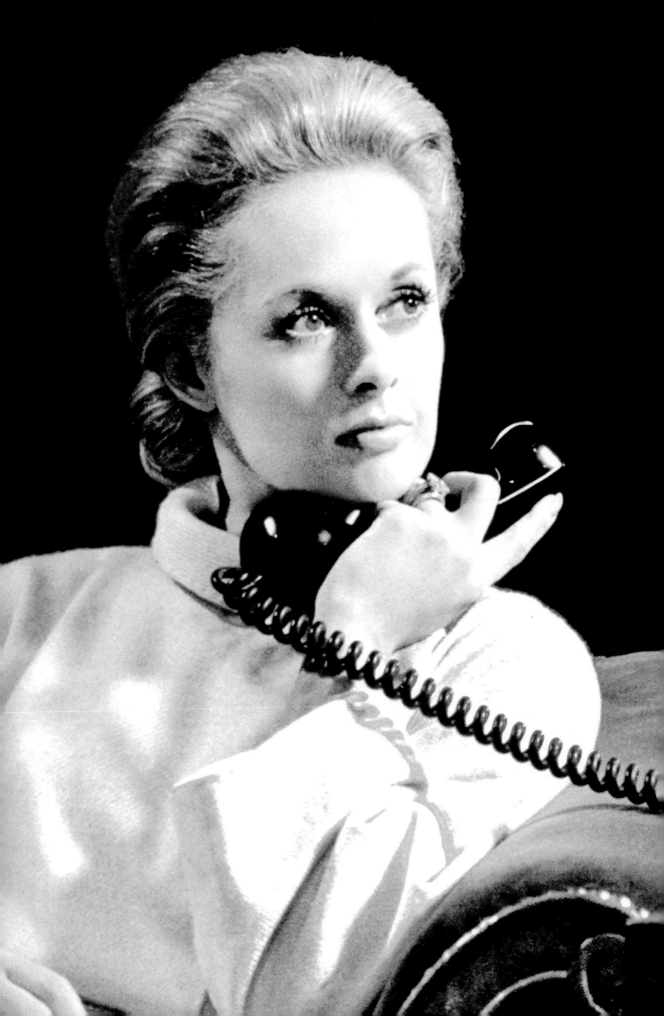

The first woman to pay for the mixture was called Madeleine Carroll—abbreviated from her real name Marie-Madeleine. She was ideal for becoming the master of suspense's first sinner. In *The 39 Steps*, a film of love, espionage, and fantasy, this very British, erstwhile French teacher had what it takes: presence and excellent diction.

Hitch would film Carroll the way Sternberg idealized Marlene. But without the delicate handling. "It was the first day of filming, at nine in the morning," recounts Grisolia. "Hitchcock introduced Carroll to her partner, the illustrious Robert Donat. He immediately put a pair of handcuffs on them, vital for the scene, then, offering the pretext of some technical problem, he vanished until teatime, leaving them handcuffed to each other the entire day. When he returned, and despite the crew's indignation, Hitch released his two stars, and asked them just one question: 'How did you manage for all those hours when you had to answer the call of nature?' Carroll did not hold it against him and in *Secret Agent*, the second film they would make together, he took even more care when it came to styling her hair, framing her, and lighting her.

"Was he in love with her? Did he even desire all those blondes he idealized film after film? He kept himself in check, at least until *Marnie*, and was careful not to give away too much. And humor always came to his aid. When he arrived in the United States in 1939, he happily replied to those who were taken aback that he was offered the chance to make a *Titanic*: 'I've had plenty of experience with icebergs. Don't forget that I've directed Madeleine Carroll.'"

Other sublime icebergs would follow in front of his camera, all of them more or less docile and more or less melting. With rebels, however, he was unforgiving. Vera Miles would bear the brunt of this.

It was with her, and not Kim Novak, that Hitchcock wanted to make *Vertigo*. He had much enjoyed directing her in his previous film, *The Wrong Man*, where she played Henry Fonda's wife, and proclaimed loud and clear, for all to hear, that he would turn her into "the new Grace Kelly." The screen tests were made with her, Edith Head designed her costumes, and her face was photographed for days, soft and distinguished. Everything was primed. But Vera Miles was pregnant from her husband, Gordon Scott, the new Tarzan. Hitch wanted to put off the filming until after the baby's birth. Impossible.

He was full of loathing for her. Then he calmed down. He had found a way of getting his revenge—he would give her the supporting female role in *Psycho*. The part of Janet Leigh's sister. Why did he blow so hot and cold? Out of cruelty: Vera Miles had had her head shaven because she was starring in Martin Ritt's *Five Branded Women*, and Hitch decked her

out in a wig which destroyed her beauty. "What makes blondes cry?" goes the song. The man who declared: "When Paramount gave the part to Kim Novak, I lost all interest in the character, and for the film itself."

Which is not true, given the outcome.

But the monster added in an interview given to *The New York Times*: "If I'd used a really gifted actress who would have created two different types of woman, *Vertigo* wouldn't have been so effective."

A strange avowal. That Kim Novak, Columbia's star, took with a certain detachment. Much later on, in 1997, she declared to *Le Monde*:

"I think I disappointed Hitchcock. I didn't fit his image of the ideal blonde. In my opinion, he was well aware that he'd made a mistake in choosing me, and he decided to go along with that mistake. It's as if he had wanted to put himself in the skin of the James Stewart character, who discovers Judy when he's hoping to find Madeleine and doesn't… Hitchcock was hoping to find in me a Grace Kelly-like blonde, which wasn't the case, all along hoping he could change my nature. As a result there's this resistance on the screen."

And so much the better for the film, in which Hitch, wounded by Vera Miles abandonment, never gave any directions to Kim Novak. That lead to the even stronger enigmatic nature of this blonde with two faces.

Another blonde, another new "Grace Kelly"—the future princess had become a real friend—suffered when they made their films. A top model of sorts for dietetic beverage advertisements: Tippi Hedren, mother of a young five-year-old girl, Melanie (like her mother in the role of the heroine in *The Birds*), who would become the Melanie Griffith of *Working Girl*.

As Hitchcock grew older, he allowed himself to make advances at his film's star. She balked and complained. So he shot the scene where the birds attack her. And he replaced the planned mechanical birds (computer-generated images did not exist in 1963) with real birds, "forgetting" to warn Tippi. For a whole week she coped with the winged creatures they threw at her. She was wounded both physically and mentally, and had to have treatment.

"On the set," she declared in an interview given to *Ciné Revue*, "there was always a representative of the SPCA [Society for the Prevention of Cruelty to Animals]. But it was me who really needed protecting. I don't know how many times I was pecked, scratched, sometimes painfully, by panic-stricken birds. The people handling the gulls and crows wore gauntlets, but I was just there, the innocent target invented by Hitch."

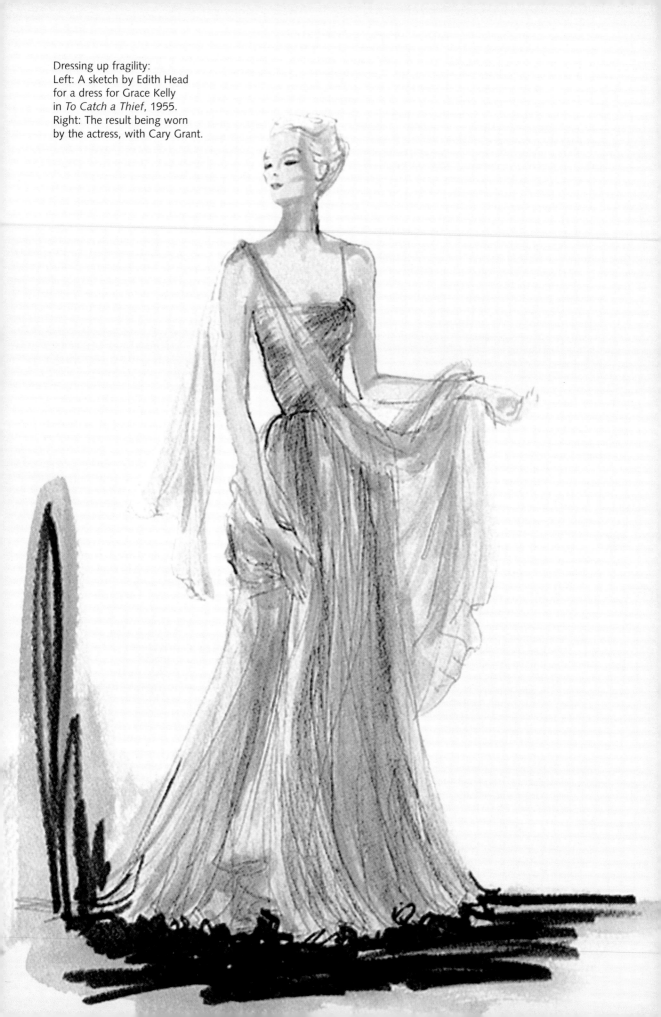

Dressing up fragility:
Left: A sketch by Edith Head
for a dress for Grace Kelly
in *To Catch a Thief*, 1955.
Right: The result being worn
by the actress, with Cary Grant.

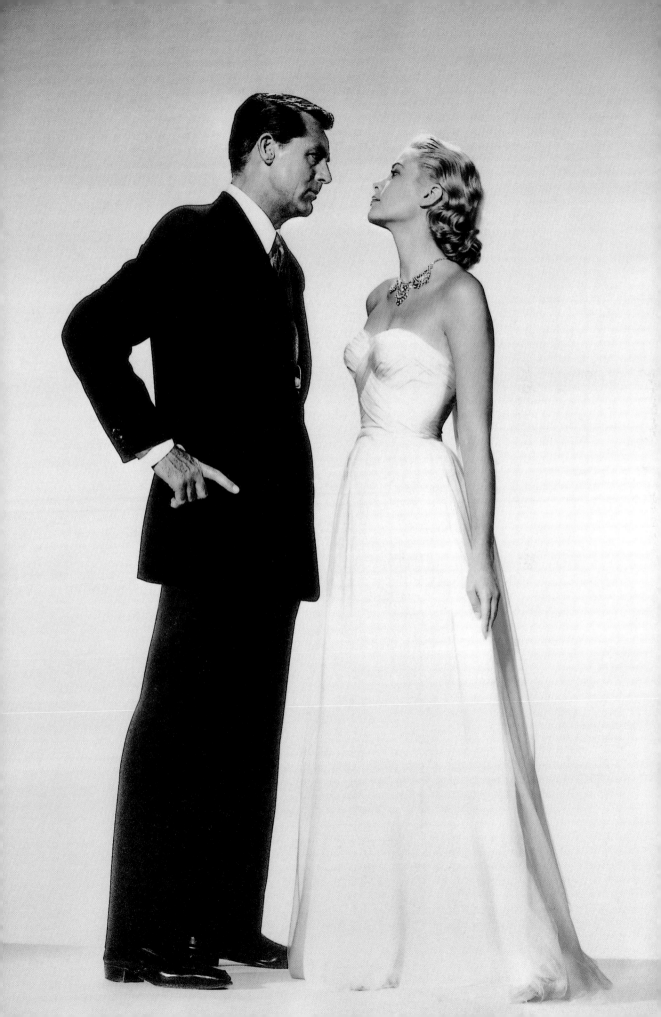

And Melanie Griffith, now grown up, would tell *Télérama* at a later date:

"I've always thought that Hitchcock stole my mother from me. She obsessed him and he shattered her career because she didn't want to let him have his way. For my sixth birthday he sent me a coffin-shaped box, with a little doll in it representing my mother the way she had been in *The Birds*. He was sick."

Even worse was to come in *Marnie*.

His heightened desire would develop even into a cinematographic rape. And Tippi Hedren would soon abandon films.

Sadly, too, Hitchcock's talent also started to wane. Producers who were appalled by the goings-on with Tippi made him use blondes of their choosing. Hitch the Catholic saw that we are always punished when we have sinned.

Transforming "vulgarity" into elegance: Kim Novak in *Vertigo*, 1958.

[LAST OF ALL, FILM DESIRE AT WORK...]

Notorious is a comedy of errors forever on the point of turning into tragedy. A tale of espionage, which is also the cruelest love story ever concocted by Hitchcock.

Ingrid Bergman, the daughter of a former Nazi dignitary, has sunk into alcoholism. Cary Grant is an FBI agent who has nothing but contempt for women who drink. He is eager to trap Claude Rains, head of an organization that has taken refuge in Brazil and nostalgic about Hitler. He will end up manipulating the tall German woman to get his hands on the key to a cellar that contains a dangerous secret: uranium for making a bomb, hidden in a 1934 bottle of Pommard (the dangers of being fond of the bottle). And a tribute to the good taste of maestro Hitch's own cellar, which was as famous among the Bel Air hills as his painting collection.

Alfred Hitchcock controls this ballet and the feelings it engenders: Rains really loves Bergman, who loves Grant, who will end up being in love with Bergman, but not before he has used her as a prostitute. And then there is the kiss. It starts on the balcony, works its way across the living room toward the bedroom, and stops at the front door. With a smile from Cary Grant, who makes good his getaway. This kiss lasts more than two and a half minutes—a tunnel, no less, in film terms. And an outlawed act to boot, for under the iron rod of the Hays Code governing cinematographic morals, a lovers' kiss must not last more than ten feet of film—in other words just three seconds. The kiss in *Notorious* is thus an uncensored embrace. And one of a rare elegance. Bergman and Grant go on and on pecking and nibbling at each other, with just an inch or so between their faces as they answer the phone, then start kissing all over again, spinning around on their own axis. And the whole thing in close-up. Their kiss seems endless and all of a piece, although there is no moment when their lips actually touch for more than two seconds. They grumbled about the ordeal of having to move about clinging to each other like that, but all Hitchcock said was: "I don't care whether you're comfortable or not; the only thing that interests me is the effect on the screen."

Nice guy Alfred. But then it wasn't him who was kissing Ingrid Bergman. To his equally erotically inclined colleague François Truffaut, he would further confide: "The scene was

Opposite page: The man between the dead woman and her living double: Kim Novak and James Stewart in *Vertigo*, 1958.

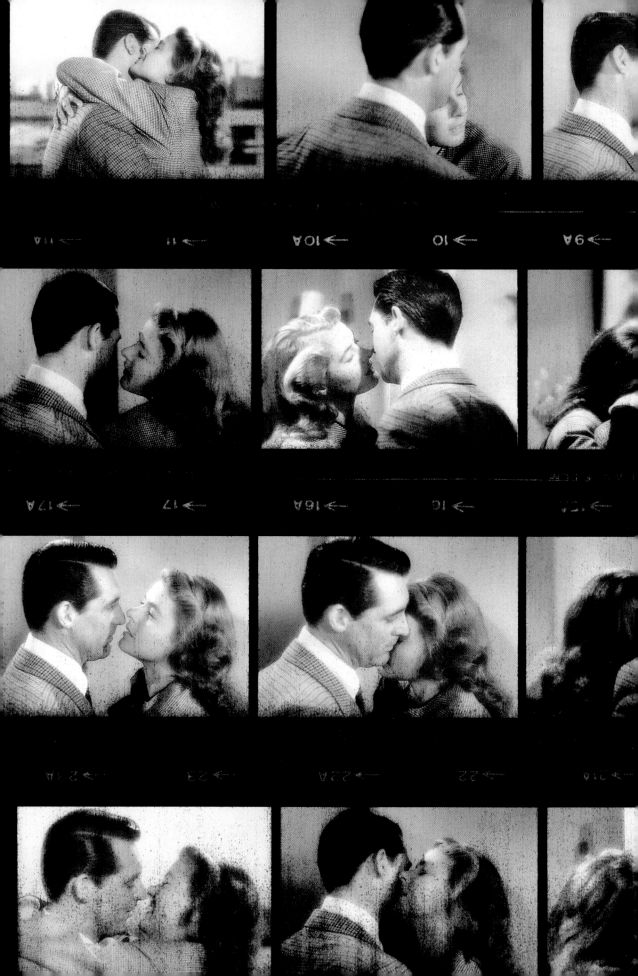

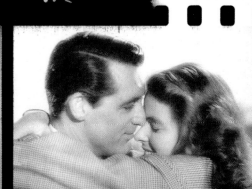
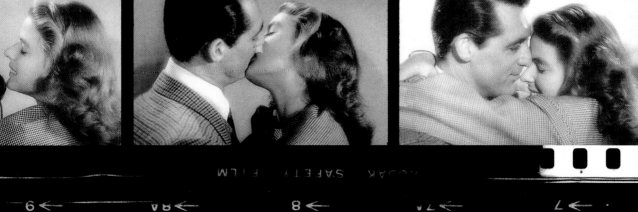
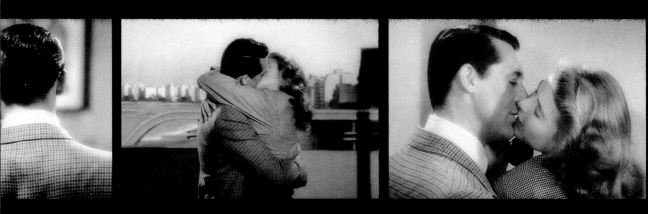
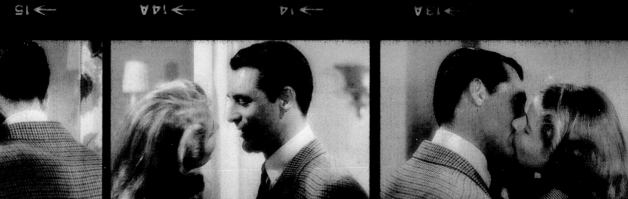
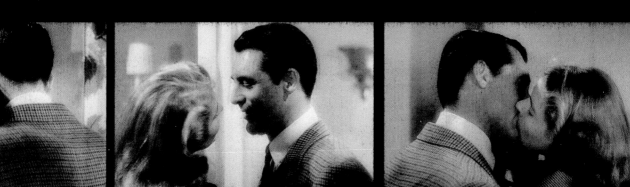
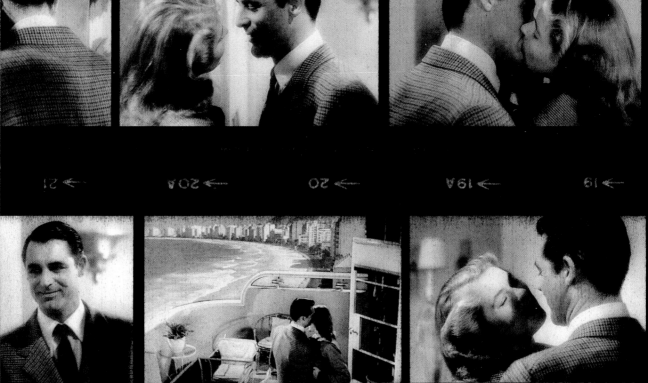

Preceding pages: The kiss in *Notorious*: The art of cheating censorship in 1946.
Cary Grant and Ingrid Bergman.

devised to show their desire. It was crucial not to interrupt that embrace. The camera represented the audience, which had to be allowed to join in that lengthy hugging and kissing. I offered the audience the great privilege of kissing Cary Grant and Ingrid Bergman at the same time. In a temporary menage à trois."

The words we've been waiting for are out—menage à trois. Such threesomes crop up in many of Hitchcock's films. Almost all of them, in fact. He added this splendid confession, to François Truffaut again:

"That feeling of love was inspired by a train journey. We had left Paris and were slowly traveling through Etaples. We were trundling along beside a red brick wall and there was a young couple leaning against that wall. The boy and girl were arm in arm and the boy was peeing against the wall; the girl never let go of his arm. She was looking at what he was doing, then she would look at the train going by, then back at the boy. I thought now there's true love at work." The glorious mystery of inspiration.

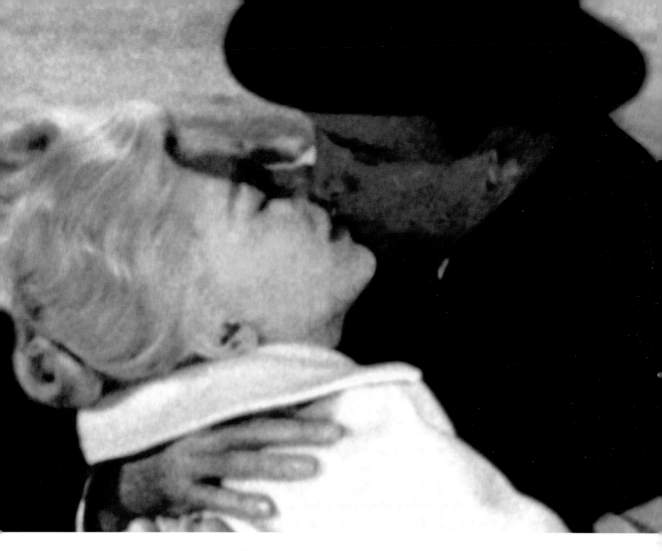

Mortal kisses: In *Blackmail* (1929, left), and just after the resurrection in *Vertigo* (1958, above).

"Love at work" has darker, not to say murkier, aspects as well. *Vertigo* is crystallized in the green light of a hotel sign—an aquarium light—that has nothing gratuitous about it since Scottie (James Stewart) has saved the woman he believes to be Madeleine (Kim Novak) from drowning under the Golden Gate Bridge in San Francisco. In this green light of a rather shabby hotel room where Judy (also Novak) is staying, Scottie will endeavor to turn her back again into Madeleine. We have already seen that he will do away with the redhead and restore her to her icy blonde-ness. Now he will dress her. In other words, undress her in reverse. Chic suits, light cashmere coats, and everything in gray, camel, and pastel, instead of her rather vulgar clinging sweater.

"These are last year's models," the saleswoman at the couturier he takes her to tells him. What could be better than clothes that are no longer in vogue for a dead woman who must be brought back to life? "It seemed to be the opposite of making her naked, but in reality it was the same thing," he said to Truffaut. "I made that film to achieve that subtle dream-like quality that occurs in human nature."

In the green of resurrection, Scottie will lead Judy-Madeleine to her death, after a last kiss (which is only the film's second kiss), and thus lose for a second time the woman he desired behind two images. After *Rear Window*, where he is immobilized by a leg in a cast, in *Vertigo* James Stewart suffers from vertigo—acrophobia. Two disorders. Two forms of loss of mobility and powerlessness, not to say impotence. Because in discovering Judy, and hoping to re-find Madeleine in her, he doesn't get anywhere. Death alone, and identical deaths—falling off the top of a church tower—reunites the two women in one and the same dead body. Scottie suffers as much from acrophobia as he does from advanced necrophilia. Is this his "subtle dream-like quality"?

Another undressing, another watery environment, another sartorial and physical transformation, driven by desire, but this time it is female desire: *Lifeboat*. In the lifeboat, which brings together representatives of the human race: a capitalist, a black radio operator from the sunken ship, a "communist" engineer, a sailor, a nurse (female), a young mother and her baby which she clutches tightly in her arms, and the arrogant and snobbish woman journalist played by Tallulah Bankhead, plus an officer from the submarine, which has also sunk.

Desire surges up in the middle of the deep blue sea, as does the hunger that threatens them all. Wide-ranging, lively—and funny—political discussions pit the leftwing engineer Kovak (played by John Hodiak) and the appallingly snobbish journalist in her mink coat (played by Tallulah), and in so doing draws them closer together, even as another drama burgeons, a drama of madness: we realize that the baby being clutched by Heather Angel to her bosom is dead; the mother, who has gone mad, casts herself into the sea. Eros and Thanatos, Love and Death, once more playing side by side.

There is a visible attraction between the mink (beneath the chignon) and the bare communist chest. The journalist, called Constance Porter, starts by throwing the fetish objects of her trade overboard: her camera, her typewriter. Last of all, she gets rid of her mink coat, then offers the assembled company, so to speak, her gold bracelet, the hook of whose clasp will act as a fishhook. Thus "freed" from her profession, which divides her socially from the man she is attracted to, she gives herself over totally to this desire by—undoing her chignon. Her wonderful tumbling curls—which are also a high society convention—cascade about her shoulders.

It is impossible to make love on this overcrowded lifeboat. But Hitchcock is on the lookout. A run in her stocking prompts Tallulah to take off them both. And the naked feet of the New York beauty and of the immigrant from the East touch, brush against each other, and caress one another in a close-up that is both indecent and disturbing. And by grabbing the last trinket she has from her earlier status, her tube of lipstick, she inscribes—nay, engraves!—her initials

on the naked torso of her lover, on her knees, almost flat on her stomach, as a sign of social—but also overtly sexual—submissiveness.

Is forcing open a safe a sex act in disguise? For Hitch, yes, when the film in question is *Marnie*. And it is not really in disguise. Marnie (Tippi Hedren) is a thief, Marnie is a flawless secretary, Marnie has long legs that are much noticed by her employers, and Marnie loots the coffers of her bosses who desire her. Then she flees. Like Marion (Janet Leigh) in *Psycho*. And after every theft, like Marion, she takes a shower.

She is hired by the handsome publisher Mark Rutland (Sean Connery). A friend of the last man she has just robbed, a man in whose house Mark had done much more than just notice her. On the eve of a weekend, she opens his safe. This is the crime he has been waiting to discover. He offers her a deal: either she agrees to marry him, or he will tell the police about her. "To put it crudely," said Hitchcock, "it would have been necessary to show Sean Connery surprising Tippi Hedren at the safe, and wanting to pounce on her and rape her on the spot."

Why does he want this woman? Because she is a thief, like Janet Leigh, and because she is frigid, like Bergman at the beginning of *Spellbound*. And he does in fact rape her. When they are married, he forces himself upon her. He is fascinated by the "abnormality" of his wife. Just as she is fascinated by the color red, storms, and safes.

But which desire is the murkier? The desire of the fictional character, or Hitchcock's desire? He would fire his scriptwriter, Evan Hunter, and replace him with a woman, because Hunter refused to write the rape scene between man and wife to Hitch's satisfaction. Hitchcock was unhappy with everything. He had dreamed of using Grace Kelly again, now Princess of Monaco, for the part of Marnie, and not Tippi Hedren. Grace had agreed. But she had to turn the part down. Here, Tippi Hedren's icy coldness helped the film—a coldness due not least to her memories of her misfortunes during the shooting of *The Birds*. She was very cool when confronted with the maestro's obsession with her, which had not changed. Nor had the costume designer, Edith Head, changed, who compounded the slimness of the iceberg and her distinctly uncarnal look of a chic, untouchable secretary, who, what's more, could not stand being touched. All Hitch could do was watch "his" healed Marnie finally and passionately kiss Sean Connery, the husband-cum-"rapist" who, by that rape (Hitchcock was getting his revenge for Tippi Hedren's repeated rejections of his advances), managed to free her from her youthful fantasies and from her childhood crime: she had killed a brutish lover of her mother, a prostitute, by hitting him with a poker.

And then we come back to the other great film of "impotent desires" *Rear Window*. Here, the desire at work is a piece of theatre, in a film setting. James Stewart, a photographer, has his

Harper's BAZ★AAR

August

COLLEGE FASHIO

25 fr in Paris · 50 cents · 2/6 in London

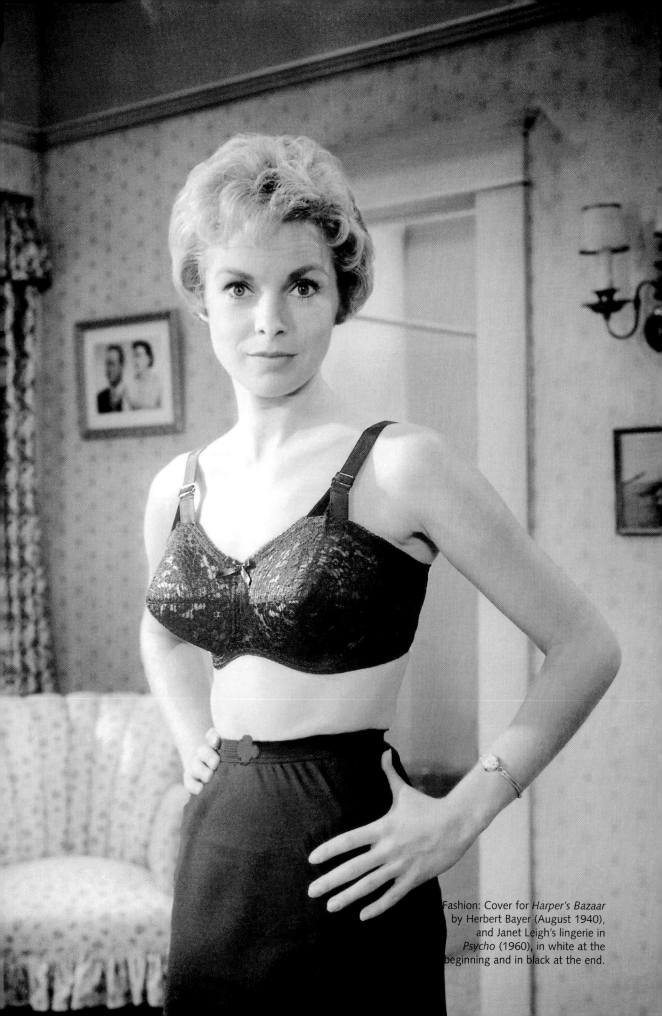

Fashion: Cover for *Harper's Bazaar* by Herbert Bayer (August 1940), and Janet Leigh's lingerie in *Psycho* (1960), in white at the beginning and in black at the end.

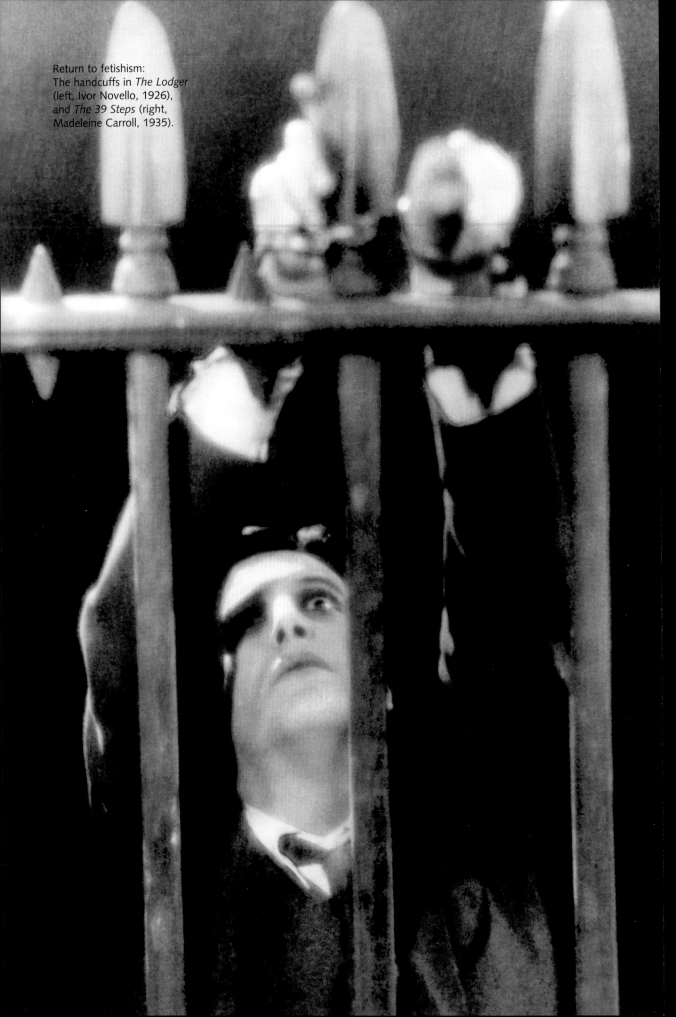

Return to fetishism:
The handcuffs in *The Lodger*
(left, Ivor Novello, 1926),
and *The 39 Steps* (right,
Madeleine Carroll, 1935).

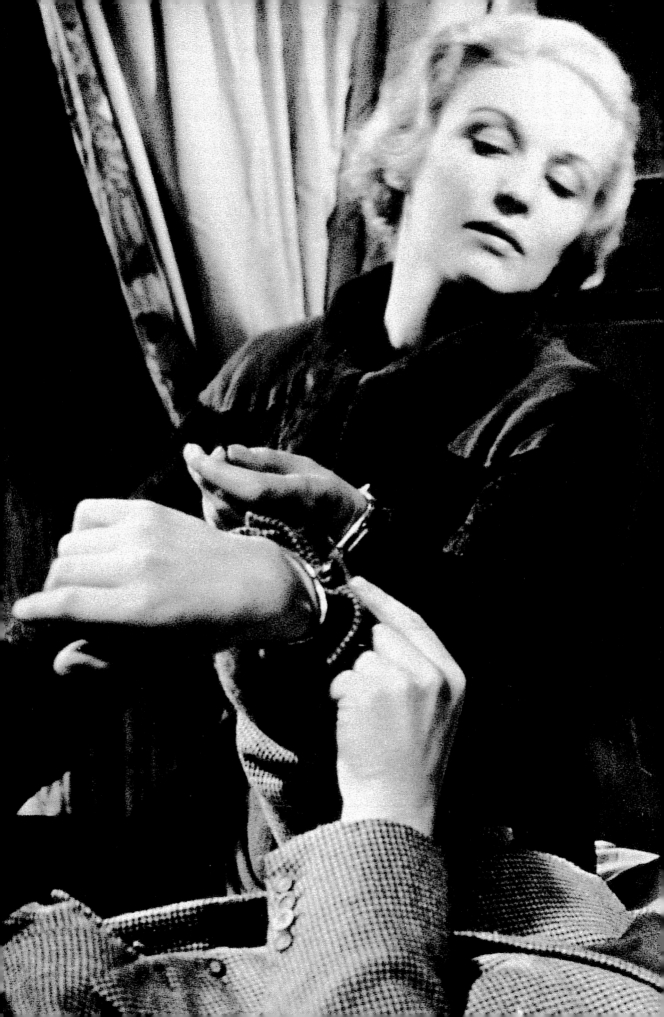

leg in a cast, and is under doctor's orders not to move (we can see the photo of a racing car during a race, possibly Indianapolis, and a broken camera, suggesting the accident). Like good children, we do not move from our movie seats, and keep our eyes on the screen. It is hot and sweat trickles over his drowsy but sickly face, like in a bad dream. And the credits scroll down while the blinds of picture window in the living room where Stewart is dozing rise like a stage curtain before act one. And we discover thirty-one apartments in the building opposite, seventy doors and windows, a narrow street leading to the main street where real life is. What do we see? A lone woman laying the table for two and eating on her own. Two top models, a dancer and her choreographer, an unsuccessful musician, a newlywed couple engaging in impressive sexual activities (but suggested solely by the raising and lowering of their blinds), a couple with a little dog, a man whose sick wife is in bed, reducing her husband to a state of domestic bondage: all leading unfulfilled lives.

Then Grace Kelly arrives for her daily visit to her out of commission, impotent lover who refuses to marry her (the exchanges between them are extremely subtle, and ferocious).

And then the bedridden woman disappears. Condemned to spying on all these sad lives, because of his immobilized state, Stewart imagines that the bedridden woman's husband has killed her and cut her into pieces; pieces he is depositing elsewhere, using a suitcase that he carries back and forth with him. Stewart fails to persuade anyone, but he upsets Grace Kelly. Because she is eager to marry Stewart, who balks, she becomes his legs, his eyes, and his actions. She does everything that he cannot do, and is nearly caught red-handed by the murderer in his apartment—for the husband has indeed killed his wife. Every day Grace Kelly appears wearing a different dress or suit, and a different hairstyle. She becomes more and more seductive as the crime mystery slowly turns out to be for real. The fact is that Stewart hopes so much that the crime has actually taken place, that his mind—the only free thing in him—ends up by almost hatching it. And his patient and sprightly mistress helps him prove it. The help she gives him in his criminal fantasy is a way of making "mental" love.

The excitement at being right can be read on the Peeping Tom's face, the way you might read sexual pleasure. When Kelly is in the dead woman's bedroom, in place of the assassined woman herself. With the reality of the crime proven, their love and their union will be cemented. Stewart ends up with both legs in casts, for the murderer had noticed that Stewart was watching him, and duly pushed him out of the window. Sitting beside her lover, Grace reads her favorite magazine, with an oh-so-faint smile playing on her face: the man resting at her side will be her husband. A husband hobbled and at her mercy. The result of "love at work" and a singular view of marriage.

Blondes undone: Preceding pages: Magritte (*Le Viol*, 1945),
Kim Novak's nape of the neck (flesh and hair) in *Vertigo*, 1958,
and opposite page: Tippi Hedren's discarded lingerie in *Marnie*, 1964.

[THE ACCOMPLICES]

Edith Head. Hollywood's greatest costume designer. The very symbol of film costumes. From Mae West's wasp-waisted suits with their amphora-shaped hips to Audrey Hepburn's black "cigarette" pants with ballet pumps in *Sabrina* (Billy Wilder, 1954), which every girl and young woman in the world wore in the 1950s and 1960s and after. It was with Hitchcock that Head's talent quite literally exploded. In Edith, Hitch found the perfect accomplice for dressing his slim blondes. There ensued a veritable fashion parade of mock-severe suits. In some cases they were doomed to be destroyed (the massacre of Tippi Hedren's suit in *The Birds*, for example). There were flowing dresses revealing with each and every move the dangerous elegance of Grace Kelly and Kim Novak. Dangerous for the person wearing them that is. As well as for the men eyeing them. Tambourine hats to further highlight the blondeness, the chignon, the apparent purity of the face, with omens of one or two dark things behind the façade.

Kim Novak would not be a plausible Madeleine, doomed to commit suicide and haunted by a death, without her coats, and her dresses, all exclusively white, gray, black, or beige. The neutral colors came from *The Living and the Dead*, the title of the source novel by Pierre Boileau and Thomas Narcejac that inspired Hitchcock to make *Vertigo*.

Tippi Hedren would not seem so "frigid" and so pathologically kleptomaniacal without that same elegance that makes her even slimmer and reminds us that this top model embarked upon a fatal adventure with Hitch. She is a female version of the gentleman thief, a lady who loots safes, and then escapes even more easily thanks to those clothes that are like so many passports for strangeness and invisibility after her crimes.

Finally, in *Rear Window*, Grace Kelly (we learn in the screenplay that she is a model) organizes a real fashion show of Head creations, appearing in each shot in a different costume, including a diaphanous and swirling cocktail dress that would arouse the half-dead and thus impotent James Stewart, who has a leg in a cast. So when she goes into the murderer's apartment in a very bright floral dress, James Stewart and the entire audience tremble because she is in mortal danger.

Opposite page: Edith Head at work.
Following pages: Drawings by Edith Head for *Topaz*, 1969.

The "Topaz" look

Tailleur in —
Topaz look

Edith Head

The "Topay" look —

White Satin
theatre Suit
Topay crepe
shirt & scarf —

GAllxfred —

Edith Head died in 1981 at the age of seventy-four. But her dresses still caused a stir in Carl Reiner's film montage, *Dead Men Don't Wear Plaid*, in 1982. A Hitchcockian title translated into pure cockney.

Bernard Herrmann. A graduate of the prestigious Julliard School of Music. For the radio he composed the disturbing score for Welles's *War of the Worlds* which so scared America. Then he moved to film, still with Orson Welles, with *Citizen Kane* and *The Magnificent Ambersons*.

With a calling card like that, he could not fail but seduce Hitchcock. This man knew how a tune could scare people. He worked on a first film, *The Trouble with Harry*, a real macabre comedy. He was there for *The Man Who Knew Too Much*, *The Wrong Man*, *Vertigo*, *North by Northwest*, *Psycho*, *The Birds*, and *Marnie*.

It was in *Psycho* that he pulled off his masterpiece. Totally spellbinding. Hitch himself confessed: "A third of the film's effectiveness comes from Bernard Herrmann's music." The theme of the Bates Motel would be borrowed by Scorsese for *Taxi Driver* (1976). Dissatisfied with the editing of the film, Hitchcock called on Herrmann: "Sort it out for me!" In just a week Herrmann composed the music for the murder. "The violins did it," he would say at a later date. "People laugh, incredulous, after trembling, when they learn that just twelve violins underscored the violence of the knife blows and every change of shot. That's what interested me. I gave them ice-water, and they asked me what brand of champagne it was!"

Saul Bass. The master of credits. An abstract style using straight lines, arising from a shocking image, or leading to that same shock or impact. Verticals and horizontals are transformed into the building where Cary Grant works in *North by Northwest*, and into window blinds behind which John Gavin and Janet Leigh make love, leaving on their faces stripes of light and shadow, like so many prison bars, in *Psycho*.

Stewart's terrified iris, as he hangs in mid-air after a chase with a criminal, who falls off a roof, gives rise to a litany of spinning spirals in *Vertigo*, and these effects crop up again at the end of the film in the stairway leading to the fatal church tower, by way of Kim Novak's blonde chignon. It was Bass as well who designed the storyboard for the murder in *Psycho*. His work was so precise and perfect that he dared to take credit for its direction for himself. He had also created the credits.

Preceding pages: Hitchcock and his servants: Left: With Alma Reville and their daughter Pat during the filming of *Psycho*, 1960; and right: with Bernard Herrmann. Opposite page: Drawings by Saul Bass for the credits for *Vertigo*, 1958.

[SETS DESIGNED FOR ANXIETY

There are plenty of dangerous places in Hitchcock's movies. Obliquely lit court-rooms, cinemas, manors, an ultra-modern villa—all are cradles of every manner of danger.

Rope takes place in a posh penthouse inhabited by well-to-do students. Cartoon-like, the clouds in the New York sky sail by, the daylight varying with the action, controlled by some 50 different lighting systems, and as night falls neon signs are turned on: 6,000 little lights, 200 miniature signs, 126,000 watts.

Everything that is seen through the picture window depicts a sweeping thirty-five-mile view of New York, surveyed by the soaring Empire State Building and the Chrysler Building.

Finally, one of the illuminated signs traced the famous silhouette of Hitchcock's profile, a design with which he often signed his personal letters.

Rear Window. The set of the "building opposite" the studio apartment where James Stewart is confined is a masterpiece, created by Sam Comer and Ray Moyer. It features, as we have seen, a scaled-down version of city life, along with the professions of the "middle class" that Hitch was so fond of.

That set took up the whole of Paramount Studios sound stage 18: 100 feet deep, 200 across, and 45 high. It represented a series of sections of buildings, 31 apartments in all, twelve of which were fully furnished, while the others contained one or two suggestive pieces of furniture. And it contained seventy doors and windows.

The size of this set forced Hitchcock to direct some actors by walkie-talkie and lapel microphones. The very narrow opening leading to the main street adds to the "closed door" feeling of the leading characters looking out on to that courtyard that becomes suffocating and disquieting as the murder fantasies assailing James Stewart take hold.

After the little dog is killed, at dusk, all the residents appear at their windows and on their balconies, except for the murderer, who stays seated in the dark—you only know he is

Opposite page: The art of making fashion. Hitch and a model by JeanLoup Sieff.
Following pages: The art of showing: New York seen from the bachelor's pad in *Rope*, 1948.

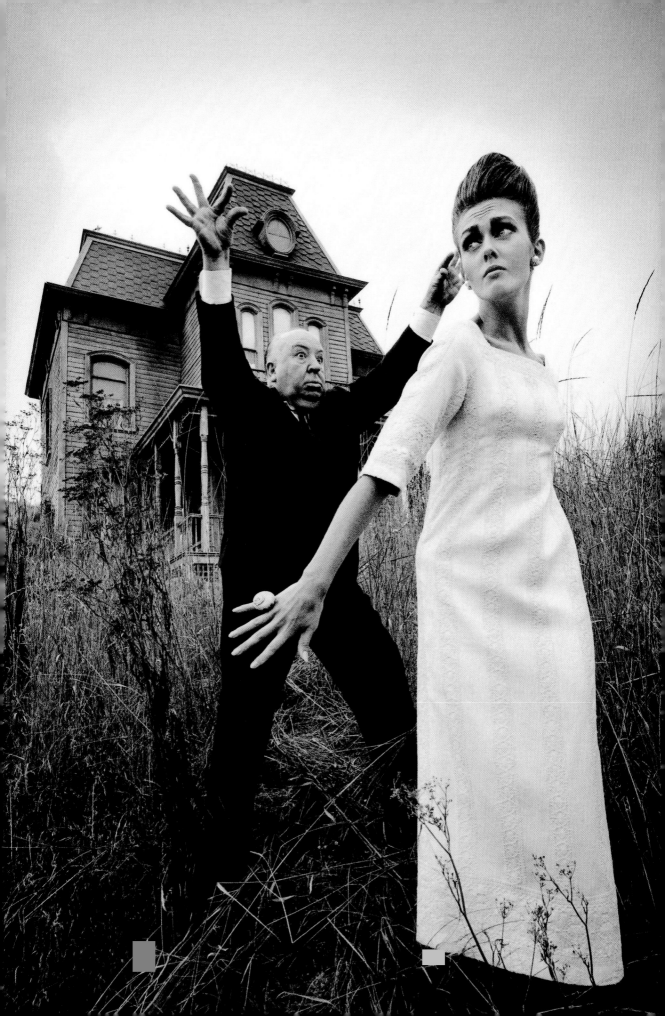

there by the glowing tip of his cigarette. Here again, the set is an important character in the drama, and the comedy.

Mama Bates's House. In *Psycho*, the lofty, yet heavy and menacing Victorian edifice, with its colonial style, is the most disconcerting factor that foreshadows the drama and that, once the murder has been committed, goes on unsettling actors and audience alike.

In the film's trailer, it was Hitchcock himself who organized a guided tour of this house (along with the fateful bathroom). Ever since, the Bates house has been part of the itinerary when people visit Universal Studios.

The House of Spies. In *North by Northwest*, not only was the house of the spy Vandamm (James Mason) reconstructed in the studio, but Mount Rushmore itself was also re-created.

Inspired by Frank Lloyd Wright to the interior decorators Henry Grace and Frank R. McKelvey, this villa with its perfect geometry becomes, despite its large windows, indoor staircases, and very simplicity, a labyrinth (the whole film is a labyrinth, actually) in which Grant struggles to find Eva Marie Saint. And it is his reflection on a television screen that gives away his presence.

The house is an accomplice of the spies Mason and his secretary, Martin Landau, whom Hitchcock wanted to make at once the male (homosexual) double of Eva Marie Saint with Mason, as well as Cary Grant's dark double. Incidentally, they wear suits signed by Quintino, Cary Grant's tailor.

The Room of Dramas and Confessions. It is easy to see why courtrooms and police stations are plentiful: *The Paradine Case*, *Rebecca*, *Vertigo*, *Young and Innocent*, *I Confess*, *The Wrong Man*, and so on. They are obligatory sets—and settings—for all police and detective plots, often put across in an expressionist way using the play of light and shadow—the light of truth (often falsehood, not far from judicial error), which is supposed to well up from the murky darkness of crime (at times alleged).

But in his *Hitchcock*, Jean Douchet pinpoints another place of revelations, *the kitchen*. As a place busily linked with food (Hitch was both a glutton and a gourmet), the kitchen is the room where material nourishment is prepared, as opposed to spiritual nourishment such as beauty, elegance, and purity. The kitchen is the secret den of the criminal, and the proof of his crime. Douchet's demonstration cum revelation is so obvious (though hidden from many audiences) that we shall mention examples without bothering to add any comments.

Opposite page: Perspective: The Golden Gate,
James Stewart and Kim Novak in *Vertigo*, 1958.

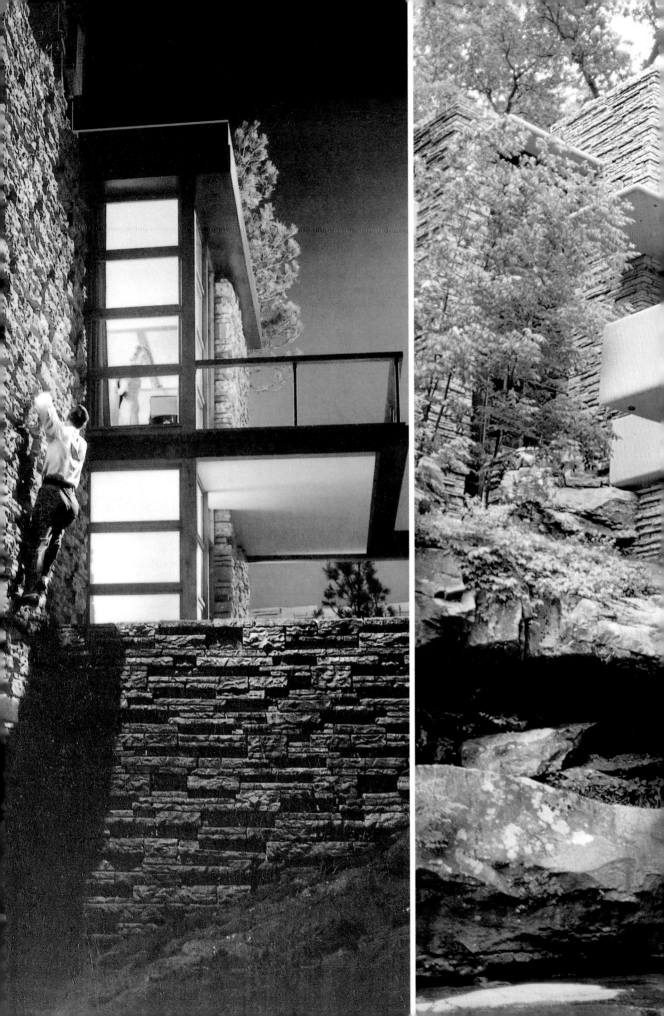

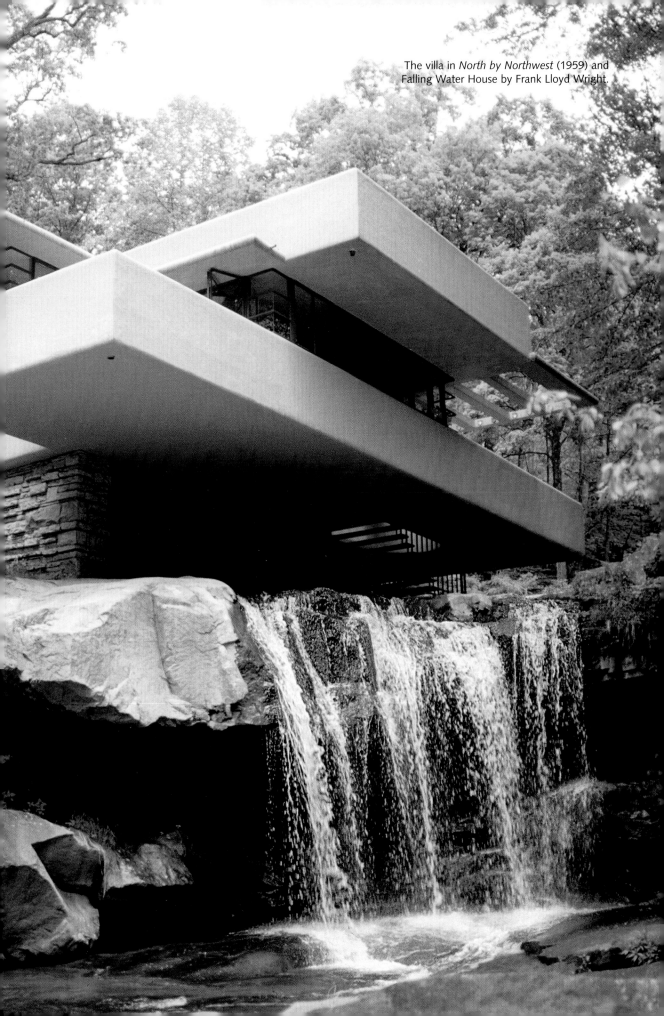

The villa in *North by Northwest* (1959) and Falling Water House by Frank Lloyd Wright.

"It is in the kitchen that Uncle Charlie gives the merry widow's ring to his niece Charlie (he has strangled the widow) in *Shadow of a Doubt*; it is in the pantry run by the housekeeper Milly that the demonic atmosphere of *Under Capricorn* reigns; it is in the kitchen that the murderous rope is stashed and sought (*Rope*); it is in the presbytery kitchen that Keller [the real murderer in *I Confess*] lives; it is in the kitchen of a big hotel that the chef's assistants are hit by bullets; it is in the kitchen that the murderer in *Rear Window* cuts his wife into pieces; it is in the kitchen of a restaurant that the real criminals work in *To Catch a Thief*."

We might simply add that, in *Torn Curtain*, it is in a Siberian kitchen that Paul Newman, helped by the farmer's wife, finally manages to kill Gromek, the Soviet agent, by shoving his head into the gas stove.

Where do we logically go after the kitchen? To eat, in the *dining room*. It is here, with light pouring through large windows, or streaming down from chandeliers, that revelation and doubt make their appearance in broad daylight, after the murky mysteries of the kitchen.

Here again let us quote Jean Douchet:

"It is at the table that Charlie (Teresa Wright) in *Shadow of a Doubt* starts to suspect Uncle Charlie of being a widow-killer; at the table that Ingrid Bergman (*Notorious*) guesses from the discomfort of one of her Nazi guests, the secret it is her mission to uncover; at the table that Michael Wilding in *Under Capricorn* becomes privy to the secret that is keeping his cousin, Ingrid Bergman, apart from her husband, Joseph Cotten; at the table that the psychoanalyst Ingrid Bergman in *Spellbound* starts to have doubts about the new director of the clinic, Gregory Peck; it is during a copious afternoon tea that professor James Stewart glimpses the truth (*Rope*); it is at the table in the restaurant car that Robert Walker suggests to Farley Granger that they swap crimes (*Strangers on a Train*) [...]; at the table that Cary Grant ushers the insurance agent (responsible for keeping an eye on the jewels) into his secret (*To Catch a Thief*); at the table, in *Rear Window*, that Grace Kelly and James Stewart, enjoying a cozy dinner together, with all the blinds down for once, are wrenched out of their intimacy by the neighbor's cries, their suspicions duly confirmed by the death of her little dog; at the table, laden with a wonderful Moroccan meal (*The Man Who Knew Too Much*), that Doris Day and James Stewart reveal the secret that links them to the French spy (Daniel Gelin), to the couple who will before long kidnap their son."

It is also at the table that Sylvia Sydney, in *Sabotage*, discovers that her husband, Oscar Homolka, is a spy who is responsible for the death of her young brother in an explosion, and is fascinated by the dazzle of the knife with which she stabs him. It is at the breakfast table in *Dial M for Murder* that Grace Kelly reads the transatlantic passenger arrivals in *The Times*,

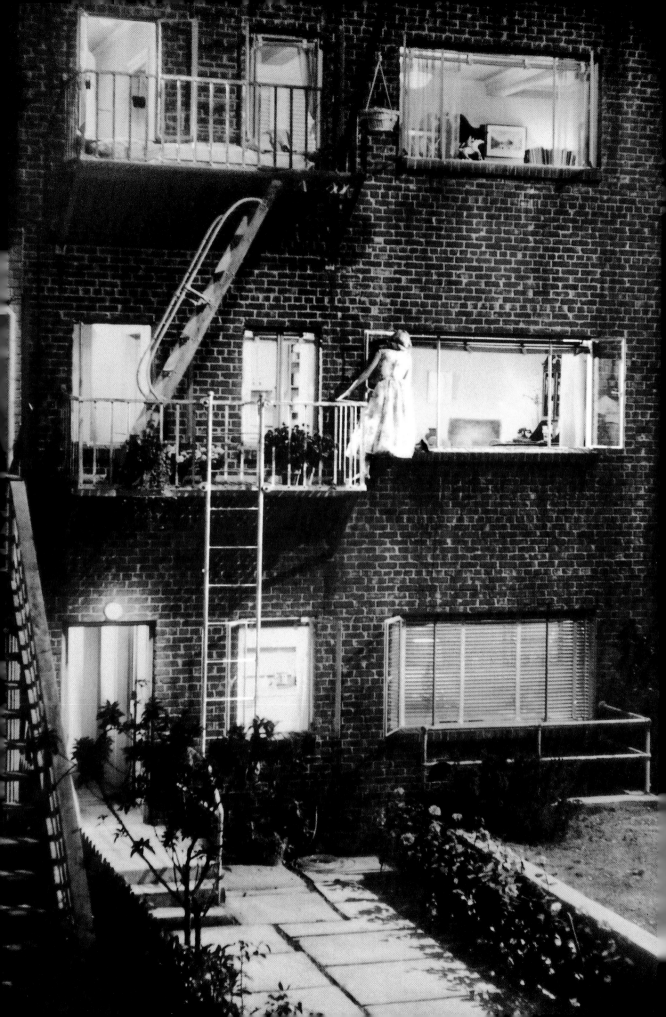

and glances over the paper at her husband, Ray Milland, because she has seen that her lover's ship will be docking that very day, something that her husband already knows.

The table is the real "courtroom" where innocence and guilt rear their heads. Bedrooms are less present, not to say often completely absent, in Hitch's films. Or else it's the place where Marnie is raped by her husband, Sean Connery. We can clearly see the direction of Alfred's favorite pastime in his hit parade of pleasures: the table rather than the bed.

Preceding pages: Architecture and voyeurism:
The building in *Rear Window*, 1954.
Opposite page: In the kingdom of the dead:
The ruins of Manderley (model for *Rebecca*, 1940).
Following pages: The garden of delights:
The good ones dine with the bad ones (Doris Day,
James Stewart, Bernard Miles, Brenda de Benzie
in *The Man Who Knew Too Much*, 1956).

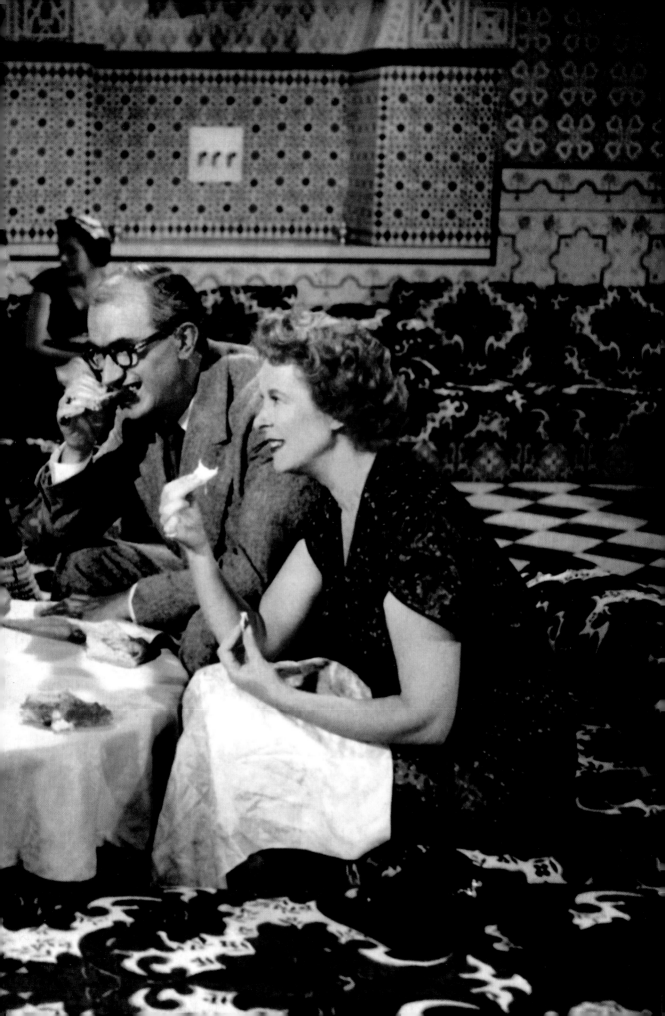

[SPECIAL EFFECTS,
PERVERSE EFFECTS...]

We have seen what a voyeur Hitchcock was. And we remember the praise of objects made by Godard in his *Histoire(s) du Cinéma*, which serves as the epigraph for this book: "We remember a handbag, a key in the palm of a hand,...," and so on. So a fetishism peculiar to Hitchcock does exist. And what are the main accessories to a Peeping Tom's crime?

Glasses. Their erotic power is duly conjured up in psychoanalytical treatises. Heroes do not wear glasses (except for the sunglasses Cary Grant uses to disguise himself in *North by Northwest*), but what about the others, all those extras, thieves, criminals, seductresses, and frightening supporting roles?

On the beach of the Carlton in Cannes, Grace Kelly wears dark glasses when Cary Grant emerges from the sea exhausted by a motorboat race (*To Catch a Thief*). Those dark glasses form a mirror through which we can see, reflected, Farley Granger's wife (who is thoroughly loathsome and greedy for money) being murdered by Robert Walker in *Strangers on a Train*. And it is on seeing Patricia Hitchcock's glasses at a high society party that the same murderer almost strangles a (female) guest.

Marion (Janet Leigh) making her getaway after stealing $40,000 deposited by her boss's client, is stopped by a highway cop, who leans through the door of the car, his eyes hidden by dark glasses. Fake suspense of *Psycho*: the cop is not interested in arresting her, but, intrigued by her nervousness, is basically coming to ask her if "everything's okay?" His appearance merely heightens Janet Leigh's uneasiness—and fear.

In *Ciné-Revue*, Hitchcock explained what he had in mind with this brief but very alarming sequence, which announces that Marion is headed for worse trouble yet:

"American cops are scary. The first time you hear the sirens which mean you've got to slow down, it has a strange effect on you! Los Angeles is riddled with cars and freeways. The cop approaches, asks to see your driver's license, and asks if the car is yours. He invariably wears big, dark glasses, which give him a sinister look. A monster with a dangling billy and

The false menace: The policeman's glasses in *Psycho*, 1960.

a gun in his belt." And what about when the glasses are taken off? When Ingrid Bergman takes hers off—and they are particular to her profession of psychiatrist (*Spellbound*), and thus hints to a line of work, just like the policeman's—her eyes appear naked. Her face becomes more alive, more giving. This happens when Gregory Peck, the fake shrink, real patient, enters her office. And it is right then that she instantly falls in love. Her frigidity topples with the cold lenses, as soon as the man who will, for her, symbolize desire—and problems—makes his appearance.

Anxiety, fear, and that sacrosanct suspense do not come without gags in Hitchcock's movies. And all the gags are without the spice of cruelty. So in the macabre *Vertigo*, a film about obsessions, the woman, Midge (played by Barbara Bel Geddes), who is hopelessly in love with Scottie, wears glasses. She is a fashion illustrator, mainly drawing brassieres (one of which, she says, is particularly aerodynamic, and was "made by an engineer working for Boeing"). Midge herself is obsessed by Scottie's obsession with Madeleine (Kim Novak), and through that obsession she becomes obsessed by the portrait of Carlotta Valdes in the museum—believing herself to be Valdes's reincarnation, she redraws her, replacing Carlotta's face with her own. Wearing glasses. And with this prop, the picture becomes ridiculous, which can be read all over Stewart's face when she shows it to him, amused by her own joke. She knows at that moment that she has just lost him forever.

Lastly, there are those special glasses, which magnify things and verge on the monstrous: Stewart's telephoto lens in *Rear Window*. A Cyclopean spyglass—no less!—enabling the photographer to examine thoroughly, through his open window, everything that happens through the seventy windows of the building across the way. The presumed killer as much as the dancer who receives many male visitors, the sinister intimacy of Mrs. Lonelyheart, the indefatigable young newlyweds, etc. In the lens of this Cyclopean eye, the audience even sees the reflection of a scene, the spectator thus seeing the interesting object to be "spied on" by the voyeur as well as the face of this same voyeur, with his perverse, satisfied smile. Great art.

Jewels. Among the finery sported by his blondes, Hitchcock never overlooked jewels. Objects embellishing their beauty, as well as objects of fetishism revealing their personalities. With their evil influences, jewels are the props of fantasy literature. Hitchcock was very keen on jewelry. And he played with it. The liberating jewel (relieving people of their hunger, and their good manners) is the bracelet that Tallulah Bankhead gives up in *Lifeboat* to be used as a fish hook, as well as to put her on a social level with the "communist" to whom she is attracted. A vehicle of complicity when Uncle Charlie offers his niece Charlie a

Opposite page: The revealing detail: The nun's high heels in *The Lady Vanishes*, 1938.

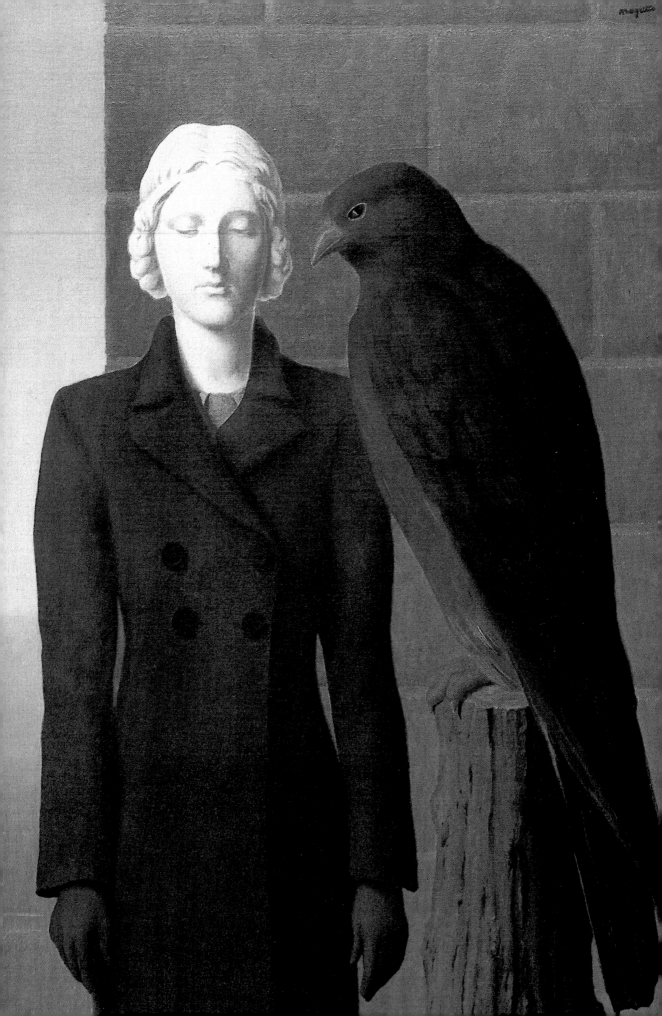

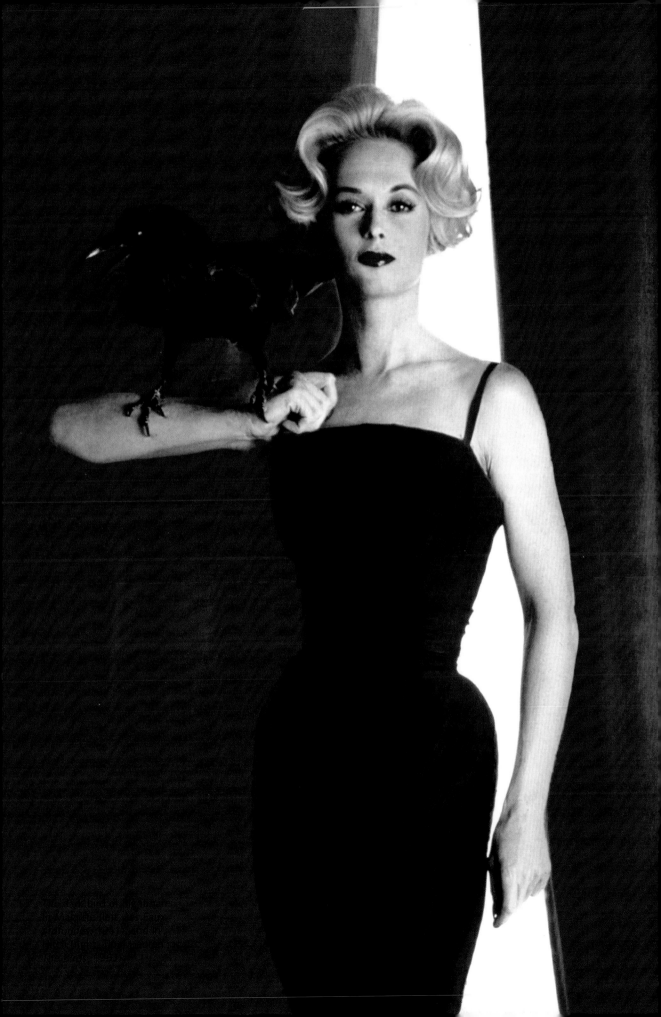

ring stolen from a corpse in *Shadow of a Doubt*; by accepting it, Charlie thus becomes his accomplice. Robbie the Cat (Cary Grant) is a jewel thief in *To Catch a Thief* and someone steals Grace Kelly's mother's jewels (the same actress who plays Cary Grant's mother in *North by Northwest*), which leads to Grant being wrongly accused of the crime. It is the wedding ring of the woman who has vanished, which is discovered by Grace Kelly in the murderer's apartment, risking her life in so doing, that persuades her that James Stewart's suspicions are right in *Rear Window:* the husband he suspects of murder did indeed kill and cut up his bedridden wife. And in *Vertigo*, the ruby necklace round Carlotta Valdes's neck in the picture crops up again on Kim Novak's neck. *Between the Dead* is the litereal translation of the title of the Boileau and Narcejac novel, which was adapted for the movie.

And then there is another piece of jewelry—another sort of bracelet, in police jargon.

Handcuffs. They are used to manacle Henry Fonda in *The Wrong Man*. Ivor Novello, *The Lodger*, is attached to a gate with them, while the infuriated mob wants to lynch him. But the real Hitchcockian and fiercely mischievous use of handcuffs occurs in *The 39 Steps*. Madeleine Carroll and Robert Donat spend a good third of the film handcuffed to one another. They are both picked up by policemen who are hunting them down as the result of a false accusation, while the real culprits, who are spies, are also trying to track them down. Hitchcock forbade the two actors (both major stars of the day) to meet each other before filming began. And the first sequences filmed with the two of them face to face were the scenes where they are attached to one another by handcuffs. Hitchcock turned them into a veritable stylistic exercise of sensuality and fetishism. Madeleine Carroll's stockings are wet. In order to take them off, she undoes her suspenders, with her handcuffed hand pulling Robert Donat's with it, brushing against the actress's legs, first sheathed in silk, then naked. To say that Hitchcock uses close-ups throughout this scene would be a euphemism, not to say understatement—he abuses them!

Exhibits. The list of objects used by Hitchcock would be an extremely long one. But certain objects take on a symbolic dimension, which sheds light on the film. We have mentioned the cellar key in the palm of Ingrid Bergman's hand in *Notorious*, which the camera discovers as it plunges from the ceiling, crossing the entire and immense reception room (of the Nazis) to end up at the beautiful Ingrid's back, and her clenched hand, which opens to reveal the key. But in *Under Capricorn*, the key ring is the key to the power being squabbled over by Lady Henrietta (Ingrid Bergman again), mistress of the house, and her housekeeper

Milly (Margareth Leighton). Keys are used to store things and protect them, to re-establish order, in a way, to this divided couple (Bergman-Cotten); for Milly, on the other hand, who never closes a drawer or door, and intentionally leaves the drinks cupboard open so that her mistress will sink even further into her alcoholism, the key ring that she wears on her belt is the symbol of her power over a wished-for greater disorder—she wants to take her mistress's place, both in the house she runs and in her master's bed.

A cigarette lighter can be a piece of jewelry too. Farley Granger's is a present from his fiancée, made of precious metal, in *Strangers on a Train*. Robert Walker gets hold of it, keen to present it as an exhibit, in order to obtain a verdict against the man who has failed to keep his part of the deal. It is when he tries to place it at the scene of the crime in the fairground (after having lost it in a sewer, but a lighter produces a flame, and thus creates light!) that Walker comes to an untimely end on a merry-go-round. As for the handbags that Marnie carries, they contain her thief's disguises—wigs, different clothes, as well as stolen bundles of money.

Cameras. The camera is another supremely useful and versatile Peeping Tom's tool. In one of his earliest ritual film appearances, Hitch carries one, it looks tiny on his impressive belly (*Young and Innocent*, 1937). Stewart is a photojournalist in *Rear Window*; in *Foreign Correspondent* a murder is committed with a pistol concealed by a camera; Cary Grant is photographed holding the knife that has just been used to stab the ambassador to the United Nations in the back (*North by Northwest*), and the snapshot shows him in the process of stabbing him, when it is precisely the opposite that is happening. Lastly, Uncle Charlie (*Shadow of a Doubt*) always refuses to be in family photos, for fear of being recognized. And Ray Milland chooses the man whom he will get to murder his wife in *Dial M for Murder* from an old college photo. The photograph is a fixed reflection of the real character, inanimate, and thus soulless. A deceptive appearance.

Disguises. A nun wears high heels (*The Lady Vanishes*) because she is a spy. A Protestant church is used as a spies' refuge (*The Man Who Knew Too Much*), while the Catholic priest in *I Confess*, Montgomery Clift, comes close to saintliness, condemned by the secrecy of the confessional, which forbids him to give away the real murderer, the caretaker of his church. *The Wrong Man* resembles the real man and their faces are superimposed beneath the same hat. Truth bursts forth in *To Catch a Thief* in a masked ball scene where the presumed thief (Cary Grant) wears the same disguise as the insurance detective. Not to forget the murderous Norman Bates, who wears the clothes of his deceased mother in *Psycho*.

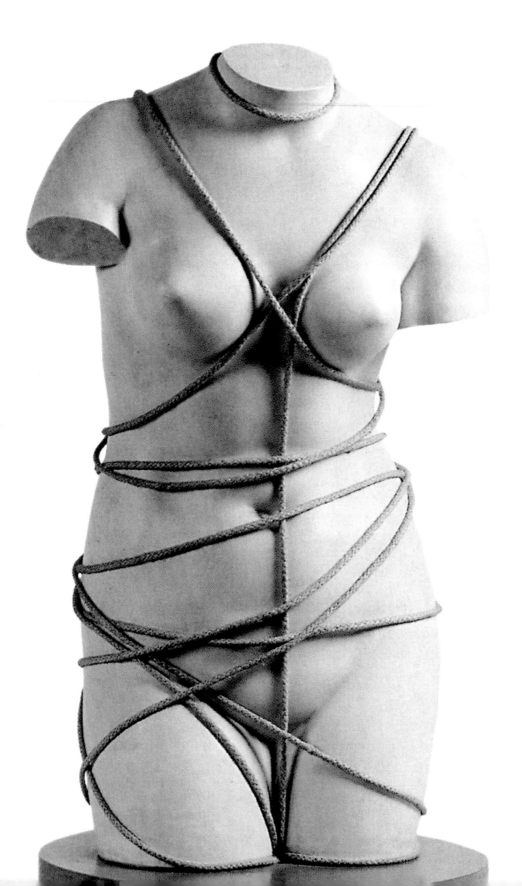

The dream woman according to
Hitch: Left: The *Vénus restaurée*
by Man Ray (1936), and right:
Ingrid Bergman in the dream
in *Spellbound*, 1945.

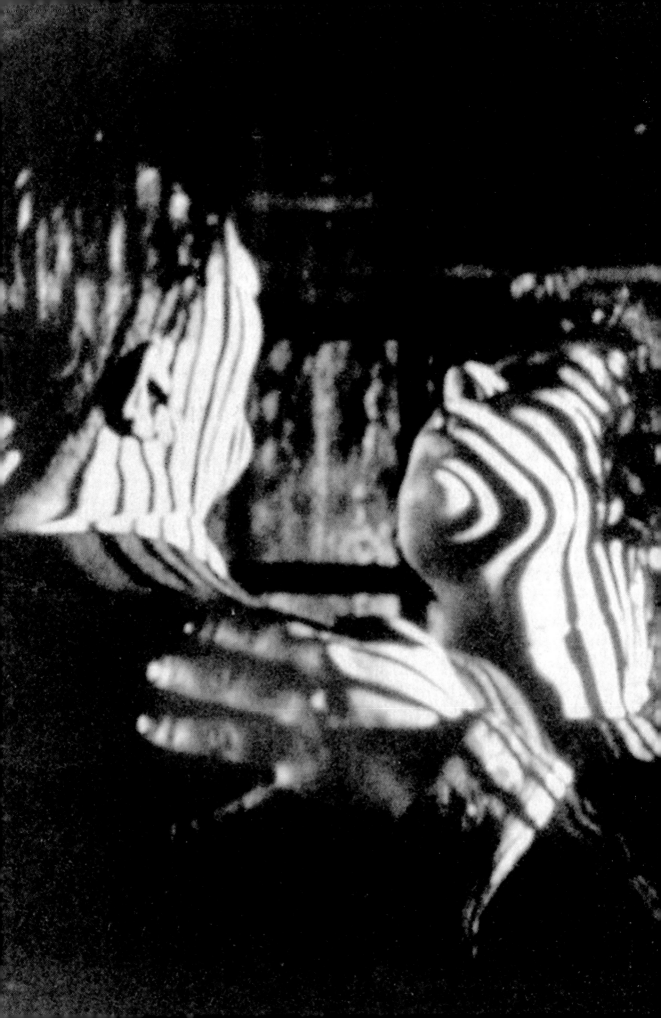

Water also disguises itself. Death comes from its limpidity. The passengers in *Lifeboat* have escaped a watery death by drowning, and the young mother throws herself into the ocean so that she will not outlive her baby. In *Vertigo*, Madeleine jumps into the sea from the Golden Gate Bridge, under the watchful eye of James Stewart, who is spying on her. Janet Leigh's car is driven into a swamp by Anthony Perkins, after the murder in the shower. A corpse floats in the Thames in the opening scene of *Frenzy*.

An impressive technique involving the counterpoint of the purest of symbols. The young married couple (tempted by adultery in *Rich and Strange)* ends up on a raft!

Threesomes and partner-swapping. Marriage and love are not actually exempt from sailing in troubled waters. In the early *Downhill* (1927), there is a lovers' toing and froing between Ivor Novello, Robin Irvine, and Annette Benson. Cary Grant pushes Ingrid Bergman into Claude Rains's arms (*Notorious*); and it is the American government that pushes Eva Marie Saint into James Mason's in *North by Northwest* so that she will hound and betray Cary Grant, before pretending to kill him when they are already in love. It is worth noting that in this film, Mason's private secretary, Martin Landau, is "in love" with his boss. Hitch had clearly specified in the script that this character ought to be quite "feminine." *Rebecca* is a menage à trois between Laurence Olivier, Joan Fontaine and—a ghost. The murdering lover (Louis Jourdan) and the lawyer (Gregory Peck) are both much smitten by the accused (Alida Valli) in *The Paradine Case*. Lady Henrietta (Ingrid Bergman) is shared between her husband, Joseph Cotten, and her cousin, Michael Wilding, in *Under Capricorn*.

Hitchcock made up for being "hitched" to his lifelong wife, Alma Reville, when he (cinematographically) directed the most beautiful blondes in the world. They were often chosen by Alma herself, from the very first one, Madeleine Carroll, the famously obliging iceberg. Another triangle.

Pages 146-147: The man's nightmare: James Stewart dreams of falling in *Vertigo*, 1958. The nightmare was designed by John Ferren, a painter who was a friend of Hitchcock. Preceding pages: On the good use of chaos: Left: *The Scream* by Edward Munch (1893), one of Hitch's favorite paintings, and right: Ivor Novello and Manette Benson in *Downhill*, 1926. Opposite page: Alfred Hitchcock's signature (*I confess*, 1953).

[FILMOGRAPHY]

THE BRITISH PERIOD

1925

The Pleasure Garden
Screenplay: Eliot Stannard, based on the novel by Oliver Sandys. Produced by: Michael Balcon, Erich Pommer. Assistant director: Alma Reville. With Virginia Valli, Carmelita Geraghty, Miles Mander, John Stuart, Nita Naldi, Georg H. Schnell, Karl Falkenberg, Ferdinand Martini, Florence Helminger.
Filmed in Munich at the Emelka studios. Alma Reville was assistant director. Michael Balcon was the man who sent Hitch to "study" German expressionism. The great producer of German expressionist films was Erich Pommer. Pommer produced Robert Wiene's *The Cabinet of Dr. Caligari*, F.W. Murnau's *The Last Laugh*, and *Tartuffe*, Fritz Lang's *The Three Lights*, *Dr. Mabuse*, *Metropolis* and *Die Nibelungen*; Pommer then produced Carl Dreyer, and it was he as well who discovered Marlene Dietrich and hired Josef von Sternberg for *The Blue Angel*.

1926

The Mountain Eagle
Screenplay: Eliot Stannard. Produced by: Michael Balcon. Assistant director: Alma Reville. With Bernhard Goetzke, Nita Naldi, Malcolm Keen, John F. Hamilton.
Filmed once again in Munich. No copy of this film exists, just photographs. Bernhard Goetzke played Death in Fritz Lang's *The Three Lights*. It was on December 2 of that year, 1926, that Hitchcock married Alma Reville at the Brompton Oratory, a stone's throw from London's Victoria & Albert Museum. They honeymooned in St. Moritz, which Hitch would keep in mind for the first version of *The Man Who Knew Too Much*.

The Lodger
Screenplay: Eliot Stannard and Alfred Hitchcock, based on the novel by Marie Belloc Lowndes. Produced by: Michael Balcon. Assistant director: Alma Reville. With Ivor Novello, Arthur Chesney, Marie Ault, Malcolm Keen, Helena Pick.
This was the first film Hitchcock shot in the Islington studios in London. First appearance by Hitchcock in the newspaper offices and among the lynch mob. When it came out, the film was acknowledged as a masterpiece. Michael Balcon suggested several changes, which Hitchcock agreed to—like getting rid of most of the insert title "cards." Keep in mind that in Berlin, he had attended the filming of Murnau's *The Last Laugh*, the only silent feature film without any title cards. Hitch welcomed the advice and observations of his producers, but didn't submit to them. This was so with Michael Balcon and later with David O. Selznik, for *Rebecca*.

1927

The Ring
Screenplay: Alfred Hitchcock, Eliot Stannard, adapted from a story by Alfred Hitchcock. Produced by: John Maxwell. Continuity: Alma Reville. With Carl Brisson, Lillian Hall-Davies, Ian Hunter, Forrester Harvey, Harry Terry.
Hitch took over the reins of power: he co-wrote the screenplay after coming up with the original idea, and got his wife Alma to be in charge of continuity; the "continuity person" is a script girl with the occasional responsibility of art director. He left Michael Balcon for British International Pictures. Once again, the scene of the action was a show venue: a traveling circus. For the fight, the rounds were ushered in with drum rolls and a knocked-out boxer was revived in the 13th round with champagne, a double British tradition of the "noble art."

Easy Virtue

Screenplay: Eliot Stannard, Ivor Montagu, based on the play by Noel Coward.
Produced by: Michael Balcon, C. M. Woolf.
With Isabel Jeans, Robin Irvine, Franklin Dyall, Eric Bramsby Williams, Ian Hunter.

Well before *Strangers on a Train* and *Dial M for Murder*, a tennis court assumes a tragic importance, and leads to a scandal. And as in those other two films, the marriage was a mistake, and a dangerous one at that. (Hitch had been married for a year, and Alma was pregnant). Noel Coward, author of the original play, was the most fashionable playwright of the day. Hitch inovates and magnifies certain objects, as he would subsequently do with the hand holding the pistol in *Spellbound*; here, he had a gigantic monocle made (the judge wore a monocle) to create an overall effect in the courtroom scenes.

Downhill

Screenplay: Eliot Stannard, based on the play by Ivor Novello and Constance Collier.
Produced by: Michael Balcon, C. M. Woolf.
With Ivor Novello, Robin Irvine, Isabel Jeans, Ian Hunter, Norman McKinnel, Annette Benson, Sybil Rhoda.

The first Hitchcockian *menage à trois*, and the first "wrong man." And once again, Ivor Novello, writer of librettos and screenplays for musical comedies, and D. W. Griffith's actor in *The White Rose* (1923). His character appeared in Robert Altman's *Gosford Park* (2001). Hitchcock had a salary of £13,000 a year, a considerable sum of money for both the time and the profession.

1928

The Farmer's Wife

Screenplay: Alfred Hitchcock and Eliot Stannard, based on a play by Eden Philpots. Produced by: John Maxwell.
With Jameson Thomas, Lillian Hall-Davies, Gordon Harker, Maud Gill, Louie Pounds, Olga Slade, Antonia Brough, Ruth Maitland.

A widower wants to get married again. Caricature is fierce and misogyny triumphant. The success of this film enabled Hitch to buy a detached house near Guildford, south of London, for £2,500. Hitchcock's family was expanding: his daughter Patricia Alma was born on July 7.

Champagne

Screenplay: Eliot Stannard and Alfred Hitchcock, based on a novel by Hall Caine.
Produced by: John Maxwell.
With Betty Balfour, Jean Bradin, Theo von Alten, Gordon Harker, Marcel Vibert, Clifford Heatherley.

A fallen young woman, and possibly the very first "Hitchcockette," Betty Balfour—spontaneous, very modern, and the kind of girl Fitzgerald would have called a flapper—is wrongly ruined, wrongly fallen, with a disconcerting private eye keeping an eye on her. She is a cigarette vendor in an auditorium. There is a boat whose pitching makes everyone sick, except the drunk employee who is the only person who manages to walk straight. Hitch continued to fine-tune his style and his "trademark": wit amidst danger.

1929

Blackmail

Screenplay: Alfred Hitchcock and Benn W. Levy, based on a play by Charles Bennett.
Produced by: John Maxwell.
With Anny Ondra, John Longden, Sara Allgood, Charles Paton, Cyril Ritchard.
With an appearance by Alfred Hitchcock as a passenger on the underground, terrified by a small boy.

Anny Ondra's blondeness is magnified. She kills a painter who attempts to rape her after having gotten her to pose in a dancer's tutu. The show business costume leads to drama!
The script plays on the concealment of evidence, a glove the murderess has forgotten, by a detective who is in love with her. The blackmailer is killed, plunging through a glass roof at the British Museum. Filmed without sound, *Blackmail* was turned into a talking picture. Hitchcock had planned on this

switch and had prepared dialogue. The first sound you hear in the film is the noise of broken glass, a sound that will recur at the end of the film when the blackmailer falls through the glass roof. The first spoken words only come when the film has been rolling for eight minutes. There are often long silent passages with Hitch, who favored images over words.

The Manxman
Screenplay: Eliot Stannard, based on a novel by Hall Caine. Produced by: John Maxwell.
With Carl Brisson, Malcolm Keen, Anny Ondra, Randle Ayrton, Clare Greet.
A true melodrama. A new threesome: two men and a woman. Who is betraying whom? And above all who is passing judgment on whom? One of the men becomes a judge responsible for sentencing or acquitting the woman he has shared and loved, while betraying a promise. This is the first appearance by Anny Ondra, Hitch's first stylish blonde, who goes on to kill her rapist in subsequent film. This new love triangle is defined at the outset by an object seen in close-up: a giant wheel with three spokes. It is also Hitch's final silent film.

1930

Murder!
Screenplay: Alma Reville, adapted by Alfred Hitchcock and Walter Mycroft, from a novel by Clemence Dane and Helen Simpson. Produced by: John Maxwell.
With Herbert Marshall, Norah Baring, Phyllis Konstam, Edward Chapman, Miles Mander. With the re-appearance of Alfred Hitchcock, who is seen walking down the street with a woman.
Alma has risen a notch further in the credits, to scriptwriter. Murder in the theater world. The actress who is found next to her rival's corpse is charged with murder, but a member of the jury thinks she is innocent. She is sentenced to death. How is she to be saved? Hitch uses the play-within-a-play device

(borrowed from *Hamlet*) to unmask the real murderer: a transvestite trapeze artist (and a homosexual, in the French version he becomes "mixed race", a dash of racism replaces the homophobia!). Hitchcock would film a German version with German actors, under the title *Mary, Sir John Graft Ein!*

Juno and the Paycock
Screenplay: Alfred Hitchcock and Alma Reville, based on Sean O'Casey's hit play. Producer: John Maxwell.
With Sara Allgood, Edward Chapman, John Laurie, Marie O'Neill, Sidney Morgan.
Alma Reville has been promoted, to co-scriptwriter. *Juno* was part of the "collateral damage" of the shift to talking pictures, as the film industry adapted successful plays left and right. Films were becoming "wordy," audiences adored them and this film was a success.

Elstree Calling
A traditional big studio musical film, after the arrival of talking pictures, where everyone sings and dances, directed by Adrian Brunel. Hitch concerned himself only with the sketches linking the musical numbers, which, at the birth of talking pictures, showed that—like the Hollywood studios—Elstree Studios was suitable for the shift to sound and quite capable of making talking pictures. Some of the songs were written by Ivor Novello, who acted in *The Lodger* and *Downhill*.

1931

The Skin Game
Screenplay: Alfred Hitchcock and Alma Reville, based on a play by John Galsworthy. Produced by: John Maxwell.
With Edmund Gwenn, Jill Esmond, John Longden, C.V. France, Helen Haye, Dora Gregory, Phyllis Konstam.
A case of blackmail, a struggle between an aristocrat and an upstart, a suicide by drowning, and an auction. Hitchcock continues to establish his world. And now that Hitch is better and better off,

he embarks on a world tour, with his family, just like the couple in *Rich and Strange*, which he would go on to film once he was back in London.

1932

Rich and Strange
Screenplay: Alma Reville and Val Valentine, adapted by Alfred Hitchcock from a novel by Dale Collins. Produced by: John Maxwell. With Henry Kendall, Joan Barry, Betty Amann, Percy Marmont, Elsie Randolph.
A couple has a tiff over a plateful of kidneys, and is then offered an unexpected cruise by an eccentric old uncle. Once on board the cruise ship, there is romantic intrigue between the wife and the captain, and the husband and a princess. However, the princess is a bogus one. The ship travels from the Mediterranean to the East China Sea: a cruise that Hitchcock must have daydreamed about as a boy when he read about sailing, and one that he had fun (fun for us too) turning into a test of conjugal love to the point of shipwreck—and another quarrel around a kidney pie. It is amusing to note that this tale of the couple flirting "elsewhere" was fine-tuned in a collaborative way by Alfred and Alma. It has been observed, and rightly, that the plot of this adventure comedy plying the world's seas bears a resemblance, albeit in a comic version, to the one set in the streets of Manhattan by Stanley Kubrick in his last movie, *Eyes Wide Shut*, which was freely adapted from a short story by Arthur Schnitzler.

Number Seventeen
Screenplay: Alfred Hitchcock, Alma Reville, and Rodney Ackland, from a play by J. Jefferson Farjeon. Produced by: John Maxwell.
With Leon M. Lion, Anne Grey, John Stuart.
Deceptive appearances again: an empty house, a light that should not be on, a death, a tramp. And the abandoned house fills with people with nothing to do there. A priceless necklace has vanished. A bus chases a train (model).

The cop marries the heroine. The necklace is used as a wedding gift. A true detective comedy.

1934

Waltzes from Vienna
Screenplay: Alma Reville and Guy Bolton. Produced by: Tom Arnold (Gaumont British).
With Jessie Matthews, Edmund Gwenn, Esmond Knight, Fay Compton.
A cream puff with Johann Strauss Sr. and Jr., a countess, and the birth of the famous *Blue Danube* music (imagined while looking at a bakery making sweet pastries). Already that sacrosanct local color! But Hitch would never be at ease with period films.

The Man Who Knew Too Much
Screenplay: A. R. Rawlinson, Edwin Greenwood, Charles Bennett, and D. B. Wyndham-Lewis. Produced by: Michael Balcon and Ivor Montagu (Gaumont British).
With Leslie Banks, Edna Best, Nova Pilbeam, Peter Lorre, Pierre Fresnay.
A star-studded cast; with the French star Pierre Fresnay; Peter Lorre, fresh from playing the child-murderer in Lang's *M*; and Leslie Banks, who played Count Zaroff in the famous *Hunts* (here playing a respectable family man!). It all starts on the pure white snows of St. Moritz, where Hitch was fond of going every year with his family, and ends one night in London with a church harmonium drowning out the noises of a fight. The remake with James Stewart and Doris Day will be even better!

1935

The 39 Steps
Screenplay: Charles Bennett. Continuity: Alma Reville. Adapted from the novel by John Buchan. Produced by: Michael Balcon and Ivor Montagu.
With Robert Donat, Madeleine Carroll, Lucie Mannheim, Godfrey Tearle, Peggy Ashcroft, John Laurie, Helen Haye, and

Alfred Hitchcock passing on the street.
A woman with a knife in her back near a man returning home from a music hall performance where shots have been fired. A map of Scotland, a pair of handcuffs, a hand with the little finger missing, a blonde—Hitch's first star, Madeleine Carroll. A wrong man hunted by police and spies. An international male star, Robert Donat. Mr. Memory, guardian of the formula for a new aircraft engine. Hitch made this comment on Alma Reville's work: "She didn't do anything!" A joke? On the other hand, Hitch offered his old "director" a chance to work with him— this was Graham Cutts, for whom Hitch had worked as assistant in his early days with Lasky, but who had sunk into alcoholism: bitter and sweet.

1936

Secret Agent
Screenplay: Charles Bennett, Alfred Hitchcock, and Ivor Montagu, based on the novel by W. Somerset Maugham and the play by Campell Dixon. Continuity: Alma Reville. Produced by: Michael Balcon and Ivor Montagu.
With Madeleine Carroll, John Gielgud, Peter Lorre, Robert Young, Lilli Palmer, Michael Redgrave.
Based on a play, which was in turn adapted from short stories (Somerset Maugham). The hero is Mr. Ashenden, a secret agent, the film borrows the title of a Conrad novel, which will become *Sabotage* when Hitch adapts it for his next film. This change explains the frequent confusion between these two films. An empty coffin at a burial, and, here again, a pretend couple who are real spies, a real Mexican killer (Peter Lorre, incredibly haggard and greasy), a train clattering toward Constantinople, a derailment. The hero is an unwitting one, through whom Hitch demonstrates how ordinary people may be gripped by courage. And one feels the pleasure he had in directing Madeleine Carroll again. Reappearing as well his grim vision of the world of espionage: no heroes and not a whole lot of morality.

Sabotage
Screenplay: Charles Bennett, Alma Reville, based on the novel by Joseph Conrad.
Produced by: Michael Balcon, Ivor Montagu.
With Sylvia Sidney, Oscar Homolka, Desmond Tester, John Loder, Joyce Barbour and Alfred Hitchcock, near the Le Bijou cinema, site of the "revelation."
The film caused a scandal because in it a child was allowed to be killed by a booby-trapped parcel containing a bomb. What is interesting, however, is the fact that Sylvia Sidney discovers that her husband is the murderer of her young brother while going to the cinema to see Walt Disney's cartoon *Who Killed Cock Robin?* What is more, the bomb-maker is a bird catcher who hides his diabolical contraptions in the depths of his bird cages; and the policeman passes himself off as a vegetable vendor, just like Hitch's father.

1937

Young and Innocent
Screenplay: Charles Bennett, Edwin Greenwood, Anthony Armstrong, and Alma Reville, based on the novel by Josephine Trey. Continuity: Alma Reville. Produced by: Edward Black.
With Nova Pilbeam, Derrick De Marney, Percy Marmont, Edward Rigby, Mary Clare, Basil Radford, John Longden, and Alfred Hitchcock as a press photographer.
A chase combining wit and suspense. A murderer whose face is distorted by a nervous tic, a raincoat belt, a wrong man, glasses stolen from a lawyer to create a disguise for an incognito escape, a model of a small town, mischievous children at a kids' party which "imprisons" our heroes, and a dazzling tracking shot in a grand hotel, right to the made-up face of the murderer—a drummer—who is caught because of his revealing tic. This overhead tracking shot was a harbinger of the one in *Notorious*. Great art, preceding the first masterpiece.

1938

The Lady Vanishes

Screenplay: Sidney Gilliat and Frank Launder, and for the final scenes Alfred Hitchcock, from the novel by Ethel Lina White. Continuity: Alma Reville. Produced by: Edward Black (Gainsborough).
With Margaret Lockwood, Michael Redgrave, Paul Lukas, Dame May Whitty, Cecil Parker, Linden Travers, Naunton Wayne, Basil Radford, Catherine Lacey, and Alfred Hitchcock waiting at Victoria Station.

A brilliant espionage comedy for which Hitchcock won his first award: the New York Film Critic Circle Award for Best Director. What do we remember from it? Miss Froy who writes her name on the steamed-up window of the restaurant car, and then vanishes—both the lady and her name disappear. A nun in high heels that give away the fact she is a spy, but refuses to let some of her British compatriots be killed. A pretend doctor and his pretend wife, and two cricket-loving gentlemen who think of nothing other than the test match at Manchester. And a melody played on a mandolin that conceals a state secret. It should be pointed out that the two cricket-lovers, Caldicott and Charters (Naunton Wayne and Basil Radford), would crop up again in two films and on the radio for a series of BBC programs. We are in 1938, Nazism is gaining and expanding over the continent, and the film denounces the neutralism that the cricket lovers refer on "pacifism" before they themselves opening fire during the attack on the train. Ordinary people can become combattants!Especially if they are English. History would soon back up this vision during the London Blitz.

1939

Jamaica Inn

Screenplay: Sidney Gilliat, Joan Harrison, and J. B. Priestly, from the novel by Daphne Du Maurier. Continuity: Alma Reville. Produced by: Erich Pommer and Charles Laughton for Mayflower Pictures.
With Charles Laughton, Maureen O'Hara, Robert Newton, Emlyn Williams, Leslie Banks, Horace Hodges, Wylie Watson.

Daphne Du Maurier's story of ship wrecked people was rewritten more than once before filming started, because of censorship rules: the wreckers' leader could not be a priest so Charles Laughton made him a "sir". The actor-producer turned out to be very dictatorial during the shooting. And Hitch gradually lost more and more interest in this second period film a genre with which he would never feel at ease until *Under Capricorn*. Yet he was happy to be working again with Erich Pommer, the great German producer who had moved to Great Britain. Finally, a new star appeared in the credits: Maureen O'Hara, in her second movie. And of course Wylie Watson, who was the unforgettable Mr. Memory in *The 39 Steps*.

THE AMERICAN PERIOD

1940

Rebecca

Screenplay: Robert E. Sherwood, Joan Harrison, Philip MacDonald, Alma Reville, Alfred Hitchcock, and Michael Hogan, from the novel by Daphne Du Maurier. Produced by: David O. Selznik. With Laurence Olivier, Joan Fontaine, George Sanders, Judith Anderson, Nigel Bruce, Leo G. Carroll, and Alfred Hitchcock waiting by a telephone box for George Sanders to finish his conversation.

Hitchcock's first international masterpiece, marking his sensational entry into the Hollywood scene: *Rebecca* received 11 Oscar nominations and walked away with the Oscars for Best Picture and Cinematography. Hitchcock, the Briton, a little disoriented, chose an English novel by Daphne Du Maurier and managed to put Great Britain's most famous actor in the leading role: Laurence Olivier. So he felt "at home." David O. Selznick, a producer who was ubiquitous rather than dictatorial, was also distracted by the colossal and adventurous shooting of *Gone With The Wind*. While following the (shrewd) instructions of his producer, Hitch also managed to make a thoroughly personal film: the start is a sunny, lively sentimental comedy, but what follows is an extremely disconcerting and troubling English "Gothic" tale. The interior scenes in Manderley manor already foreshadow Hitch's entire artistic style: with its gloomy atmosphere and endless staircases, the building seems to be a living being, personified by Mrs. Danvers—clad in black—who always suddenly appears without noise, like some human emanation of the manor house. The idea for the final fire that engulfs the manor came to him, by his own admission, from the fire of the Burgundians's castle in Fritz Lang's *Die Nibelungen*, which he had seen in Berlin during his work there in 1925.

Foreign Correspondent

Screenplay: Charles Bennett and Joan Harrison. Cinematography: Rudolph Mate. Visual effets supervision: William Cameron Menzies. Produced by: Walter Wanger. With Joel McCrea, Laraine Day, Herbert Marshall, George Sanders, Robert Benchley, and Alfred Hitchcock, who appears reading a newspaper which talks about the threat of war in Europe.

Shooting started on March 18, 1940. Great Britain had been officially at war with Germany for 8 months. The film was completed on June 5, but on July 5, Hitch added the final sequence, Joel McCrea's radio appeal to America, "the last light of freedom," at a time when his own country was all on its own in the war against the Nazis after the armistice signed by France. So the subject is a serious, solemn one, although the way it is handled is—by all appearances—light. One recalls is a sea of umbrellas, a windmill with its sails turning the wrong way, a pistol hidden in a camera, the leader of a pacifist organization who is actually the head of the killers, an airplane plunging into the ocean, a hotel bedroom invaded like the Marx Brothers' steamer cabin in *A Night at the Opera*. The film got three Oscar nominations, but walked away with none. Noteworthy in the credits is the name of Rudolph Mate, Carl Dreyer's favorite cameraman, and William Cameron Menzies, the B-movie director, who would later direct the dream sequence in *Spellbound* for Hitchcock.

1941

Mr. and Mrs. Smith

Screenplay: Norman Krasna. Produced by: Harry E. Edington (RKO). With Carole Lombard, Robert Montgomery, Gene Raymond, Jack Carson, Philip Merivale, Lucile Watson.

The Hitchcocks had become friends with their landlady at No. 609 St. Cloud Road, in Bel Air—Carole Lombard. The actress asked Alfred to direct her in a movie. He agreed. "The script had

been written by someone other than me, but as my job was to direct movies, I went on to the set and shouted: 'Action' and 'Cut'." Which is tantamount to admitting that his involvement in this film was a very minor one. In a somewhat anachronistic way, this marital comedy, about a couple who realize after three years of wedlock that they are not legally married, has a whiff of the comedies made much later by Woody Allen. What's more, we can see an excerpt from *Mr. and Mrs. Smith* in the Manhattan bard's *Crimes and Misdemeanors*. Carole Lombard and Robert Montgomery are both excellent and elegant, and there are tasty misunderstandings. But Hitch is no Woody! Legend has it that Carole Lombard asked Hitch if she might be permitted to direct him in his traditional cameo appearance—a passer-by in the street in front of the building where the character played by Carole lives. For the only time in his life, therefore, he was an extra actor for another "director"— and a woman, to boot.

Suspicion
Screenplay: Samson Raphaelson and Joan Harrison, based on the novel by Francis Iles. Produced by: Harry E. Eddington (RKO).
With Cary Grant, Joan Fontaine, Sir Cedric Hardwicke, Nigel Bruce, Dame May Whitty, Isabel Jeans, Leo G. Carroll, and Alfred Hitchcock passing by in the street.
Hitch inherited an old RKO project. But he also inherited the male star of the moment, Cary Grant. He meets again with Joan Fontaine, from *Rebecca*, as well as Dame May Whitty, the delicious Miss Froy in *The Lady Vanishes*, and Leo G. Carroll, in an amiable supporting role, who will appear again as head of the secret service in *North by Northwest*, and as a murderous psychiatrist in *Spellbound*. It was impossible to turn Cary Grant into a murderer, which was the plot of the novel. And even if Hitchcock was independent-minded, with a style very much his own, he nevertheless respected certain Hollywood rules.

He had thought up three endings. Then an almost psychoanalytical explanation presented itself (already!): Joan Fontaine's fear that her husband is trying to murder her is the sheer fantasy of a woman treated as an outcast by her family (she marries him in secret), a woman who is virtually frigid, as dfemonstrated by her inelegant bourgeois clothes with their prim tall collars, which she is wearing when they first meet on the train. And Hitchcock's genius bursts forth in the way he makes Cary Grant as unsettling as he is seductive, with the audience now seeing him through Joan Fontaine's eyes, quite ready to let herself be killed out of love, but "freed" by this marriage. This suspense reaches its peak with the glass of milk that her husband takes up to her, and that Hitchcock makes even brighter by lighting it, from within, with a light bulb. For the first time—the second and last would be with *Stage Fright*—he did not hesitate to "trick" the audience by letting Joan Fontaine picture the murder of their friend Beaky by Cary Grant, a murder that was never actually committed. But since the audience sees the husband, a gambler, something of a swindler, and a spendthrift, through her eyes: is it a "lie" or the exciting fantasy of a young woman finally having access to free sexuality in wedlock?

1942

Saboteur
Screenplay: Peter Viertel, Joan Harrison, and Dorothy Parker, based on an Alfred Hitchcock story. Produced by: Frank Lloyd and Jack K. Skirball for Universal.
With Priscilla Lane, Robert Cummings, Otto Kruger, Alan Baxter, Clem Bevans, Norman Lloyd, Alma Kruger, Jeanette and Lynn Roher (the Siamese twins), Walter Miller and Marty Curtis (the dwarfs), and Alfred Hitchcock as a deaf mute.
A rare screenplay not adapted from a fictional work but coming from an idea concocted by Hitch himself. In fact, when filming started, America had not

yet entered the war (it would not enter until December 1941, after Pearl Harbor). And Hitch was already warning the United States of the dangers threatening it within its own borders, by way of saboteurs. It could not remain deaf to the appeal from the free world, which was now reduced solely to Hitch's native Great Britain; in his traditional cameo appearance, what's more, he plays a deaf mute. It is worth noticing that this marked Hitch's entry to Universal Studios, famed for their fantasy films. Furthermore, the sequence where Robert Cummings, the wrong man—another one—goes to the house of a blind man who welcomes him warmly and in complete confidence, refers directly to the monster sequence in the home of the blind violinist in *The Bride of Frankenstein* (1935). It is in this film that the finale unfolds at the top of the Statue of Liberty, with the real culprit toppling off while the wrong man tries to save him. In New York harbor we also see the wreck of the *Normandie*, while the spy smiles, as if he himself had sabotaged and sunk it.

1943

Shadow of a Doubt

Screenplay: Thornton Wilder, Sally Benson, and Alma Reville, based on a story by Gordon McDonnell. Music: Dimitri Tiomkin and Charles Previn. Produced by: Jack H. Skirball for Universal.
With Joseph Cotten, Teresa Wright, MacDonald Carey, Patricia Collinge, Henry Travers, Hume Cronyn, and Alfred Hitchcock playing bridge in the train holding all thirteen spades.

A triumph of realism: the city of Santa Rosa is unmistakably the city of Santa Rosa, in northern California, the family home is the home of a family with the same standard of living as that of the characters, and Joseph Cotten wears his own clothes. It is a fantasy vision of the "widows" who fritter away the fortunes that the men had spent their lives working for, silly women "drinking money, eating money, losing money at cards, stinking of money, proud of their jewels and nothing else." This is uncle Charlie, the killer's monolog. Hitch had this to say: "He doesn't have any feelings of guilt; for him, doing away with widows is a contribution to civilization." It is worth noting in the credits the name of the screenwriter, Thornton Wilder, author of the hit play *Our Town*, about the life of a small American town, that, six decades later, would provide Lars von Trier with the inspiration for his *Dogville*, with a tremendous blonde actress whom Hitch would have much enjoyed directing, Nicole Kidman. The mother's first name is Emma, like Hitchcock's own mother, who would die in England while her son was shooting the film in California.

1944

Lifeboat

Screenplay: Jo Swerling, plus Alma Reville, and Ben Hecht for the dialog, based on a story by John Steinbeck. Produced by: Kenneth MacGowan for Darryl F. Zanuck. With Tallulah Bankhead, William Bendix, Walter Slezak, Mary Anderson, John Hodiak, Henry Hull, Heather Angel, Hume Cronyn, Canada Lee, William Jetter, Jr., and Alfred Hitchcock in a newspaper ad.

An ocean created in the studio with back projection. Each actor and actress had eight identical costumes so that they could always act "dry." The film was shot like filmed theatre, in the order of the sequences, unity of place, a lifeboat, and the various incidents and accidents, people falling into the sea, mistakes with lines, meaning that nothing changes from one take to the next. Because of the discomfort of the situation, there was a great deal of tension on the set. Tallulah Bankhead regularly hurled insults at Walter Slezak, calling him a "filthy Nazi!". The metaphor of the biblical flood is ubiquitous throughout the film, which is nevertheless supposed to be an anti-Nazi propaganda film. But in this

scaling-down of humankind, represented by this group of survivors, we find two couples forming, on account of the catastrophe: under the protective tarpaulin, trying to hide from prying eyes, Mary Anderson and Hume Cronyn, and, in broad daylight and in an arrogant way, the snobbish New Yorker Tallulah Bankhead and the "communist" engineer John Hodiak. But they will all play a hand in the death of the captain of the German U-boat. All save one, the black man, Canada Lee, who merely quotes the Bible all the while.

Bon Voyage
Screenplay: J.O.C. Orton and Angus MacPhail.
With John Blythe and the Moliere Players.
Aventure Malgache
With the Moliere Players.
Two films produced by Phoenix Films for the Ministry of Information.
Two short propaganda films (twenty-six and thirty-one minutes respectively) about the French Resistance and the Free French forces. A new crossing of appearances. Actors play real life heroes, as well as alleged traitors who are also sometimes heroes, while the alleged heroes are traitors! This complexity introduces a doubt into the minds of the audience. And the sought-after effect is far from convincing.

1945

Spellbound
Screenplay: Ben Hecht and Angus MacPhail, based on the novel by Francis Beeding. Psychiatric consultant: May E. Romm. Dream sequence conceived by Salvador Dalí, directed by William Cameron Menzies. Produced by: David O. Selznik. With Ingrid Bergman, Gregory Peck, Rhonda Fleming, John Emery, Leo G. Carroll, Michael Chekhov, Steven Geray, Norman Lloyd, and Alfred Hitchcock getting off an elevator.
With six Oscar nominations, the film walked away with just one award, for Best Music (Miklós Rózsa). There was a

fashion, at the time, for psychoanalytical films (Freud had been dead for five years), and the producer David O. Selznik himself had been through analysis (as had the scriptwriter Ben Hecht) with the film's consultant, Dr. May Romm. But what Hitch was really interested in was Ingrid Bergman, whom he was filming for the very first time, and sumptuously, too. At last a truly Scandinavian "iceberg." There was also a vogue for Dalí, who had taken refuge in the United Sates because of the war in Europe. And Selznik relied more than a little on that illustrious name in the credits to pull in audiences. Two geniuses of self-promotion (Hitch and Dalí) in the same casting was the stuff of dreams. Dalí was hired for the sum of $4,000 to devise, design, and paint Gregory Peck's dream sequence, which Bergman wants to interpret to prove the innocence of the amnesiac patient who thinks he is Dr. Edwards, and who is suspected of being the doctor's murderer. He offered one of his paintings to Selznik and another to Hitch, and it was from that time on that Hitchcock started to collect paintings. His initial preference was for Klee and Soutine.

1946

Notorious
Screenplay: Ben Hecht (plus Hitchcock and David O. Selznick), based on the short story by John Tainter Foote. Costumes: Edith Head. Produced by: Alfred Hitchcock for RKO.
With Cary Grant, Ingrid Bergman, Claude Rains, Louis Calhern, Mme. (Leopoldine) Konstantin, Reinhold Schunzel, Moroni Olsen, and Alfred Hitchcock as a guest at the party given by the Sebastian spies.
Triple play and certain fortune: collaboration on the screenplay, production and direction for Hitchcock! Selznik was originally taken aback by the idea of uranium in a bottle of Pommard, did not believe in the movie, so sold the whole thing to RKO. Hitch set himself up as producer. The film

cost $2.3 million and grossed $7.1 million. It was also the first time Edith Head, responsible for Ingrid Bergman's wardrobe (and who would before long be dressing Eva Marie Saint, Grace Kelly, Tippi Hedren, and Kim Novak), worked on a film with Hitchcock. After her marriage to Sebastian (Claude Rains), Bergman, a slovenly alcoholic, becomes a superb-looking fashion figure clad in long, flowing gowns, which add to her endangered fragility as well as to the enamored aestheticism of the man who dresses her in this way: the spy Sebastian.

1947

The Paradine Case

Screenplay: David O. Selznick. Adaptation: Alma Reville, James Bridie. Dialogues: Ben Hecht. Production: David O. Selznick. With Gregory Peck, Ann Todd, Charles Laughton, Charles Coburn, Louis Jourdan, Alida Valli, Leo G. Carroll, and Alfred Hitchcock, encumbered by a cello.

A great courtroom film but also a counterpart to *Rebecca*. However, behind the on-screen justice (three cameras on the set during the long Old Bailey sequence so as to continually follow each protagonist and prepare a very fast-paced montage), is the decline of a gentleman, Gregory Peck. As in *Rebecca*, everything was meant to be fiercely British. The large pictures of Colonel Paradine, poisoned, above the piano, and of Lady Paradine (Alida Valli) in her bedroom, call to mind the "deceased" in *Rebecca*. Hitchcock gave Gregory Peck an English speech coach, Philip Friend, who made him listen for hours to speeches by Anthony Eden, then His Majesty's Prime Minister. The film was not well received. The story of this lawyer (Peck) who falls in love with his client (Alida Valli), a murderess, railing against her valet (Louis Jourdan) because he was undoubtedly her lover, the fury of the judge (Charles Laughton) against the lawyer whose wife (Ann Todd, the film's blonde) he desires, in a memorable scene where her dress reveals a bare shoulder, all this jolted British "morality", as well as the Puritan WASP class in the United States. A slight xenophobia also wafts from the film with the presence of Alida Valli (Italian) and Louis Jourdan (French): two émigrés suspected of murder. The suspense does not come from the fact that Lady Paradine may or not be hanged, or Jourdan wrongly sentenced, but from the failure and disapproval rained down upon the elegant Gregory Peck who, confused by his passion for his client, has to abandon his defense and leave the court, in front of the exuberant triumph of a judge (Laughton), exhilarated not only by the death sentence (Hitchcock let it be known that he would have liked to be a "hanging judge") but also by the defeat of the man whose wife he coveted. Perversity in justice!

1948

Rope

Screenplay: Arthur Laurents, Hume Cronyn, and Ben Hecht, based on a play by Patrick Hamilton. Produced by: Alfred Hitchcock and Sidney Bernstein for Transatlantic Pictures. With James Stewart, John Dall, Farley Granger, Joan Chandler, Sir Cedric Hardwicke, Constance Collier, and Edith Evanson.

It was not possible for Hitchcock to play a passer-by in the cramped space of a bachelor pad at the top of a skyscraper—so he appears as a silhouette, the way he often drew it to sign off his letters, in the neon lights forming the signs of the buildings glimpsed through the glass window. *Rope*, a long one shot realized without editing, was Hitch's first film in color.

1949

Under Capricorn

Screenplay: James Bridie (and Peter Ustinov), based on the play by John Colton and Margaret Linden, adapted from

a novel by Helen Simpson. Produced by: Alfred Hitchcock and Sidney Bernstein. With Ingrid Bergman, Joseph Cotten, Michael Wilding, Margaret Leighton, Cecil Parker, and Alfred Hitchcock appearing as a guest at the governor's ball.

Another film in color, shot exclusively for Ingrid Bergman's sake. After playing an alcoholic (*Notorious*) and a frigid shrink (*Spellbound*), here she is as a Lady "falling apart for love" (Hitch) and still drinking! Despite Bergman's extremely elegant dresses, and Joseph Cotten's class—Hitch found him too refined, and had thought of Burt Lancaster for the role—the shimmering colors belie a somber, troubling movie, and the mummified head that Bergman finds on her bed foretells the head of Anthony Perkins' "mummy" in *Psycho*.

1950

Stage Fright

Screenplay: Whitfield Cook, based on the novel by Selwyn Jepson. Adaptation: Alma Reville. Costumes: Christian Dior (for Marlene Dietrich) and Milo Anderson (for Jane Wyman). Produced by: Alfred Hitchcock for Warner Bros.
With Jane Wyman, Marlene Dietrich, Michael Wilding, Richard Todd, Alastair Sim, Patricia Hitchcock, and Alfred Hitchcock who turns with curiosity to look as Jane Wyman goes past.

Pat Hitchcock had just a small part using the nickname "Chubby," which caused her to quip: "That's nice! So that's what my father thinks of me!" And she was a stand-in for Jane Wyman in some of the car scenes. Women do a lot of driving in Hitchcock's films—Janet Leigh, Grace Kelly, and others. And they drive too fast! He will regret that the bad guy in this film was not "classy" enough: "I made another mistake: in this film it's the bad guys who are scared!"

1951

Strangers on a Train

Screenplay: Raymond Chandler and Czenzi Ormonde (plus Alfred Hitchcock and Alma Reville), based on a story by Patricia Highsmith. Music: Dimitri Tiomkin. Produced by: Alfred Hitchcock and Barbara Keon for Warner Bros.
With Farley Granger, Ruth Roman, Robert Walker, Leo G. Carroll, Patricia Hitchcock, and Alfred Hitchcock who gets on board the train with a double bass.

The choice of Farley Granger plays off a memory: he was one of the two gay murderers in *Rope*. Playing opposite Robert Walker here, the memory of that earlier part left a whiff of sexual ambiguity wafting over his relationship with the real bad guy. For once, Hitch did not get a blonde actress, for Warner forced him to use Ruth Roman in the role of Granger's fiancée. He will make her the sister of his daughter Patricia—and scale down her part! Patricia should also have been one of Walker's victims! She will get her revenge by criticizing the end of the film, pronouncing it "awful, so moralistic, so conventional! As if bad guys were always punished in real life."

1953

I Confess

Screenplay: George Tabori and William Archibald, based on the play by Paul Anthelme. Music: Dimitri Tiomkin. Produced by: Alfred Hitchcock and Barbara Keon for Warner Bros.
With Montgomery Clift, Anne Baxter, Brian Aherne, Karl Malden, O.E. Hasse, Roger Dann, Dolly Haas, Charles Andre, Ovila Légaré, and Alfred Hitchcock on the grand stairway between Quebec's Upper Town and Old Lower Town.

The first human to appear is Alfred Hitchcock himself on the steps.

The film was a flop because American audiences did not know about the Catholic rule of secrecy at the confessional, and therefore failed to understand why the priest, Montgomery

Clift, was prepared to let himself be found guilty of a murder that he had not committed, when the actual murderer had confessed to his crime. At the same time, the love story between Clift and Anne Baxter (before he took the cloth and became a priest) leaves a shadow of guilt hanging over the innocent man. What is more, the murder suited them!

1954

Dial M for Murder
Screenplay: Frederick Knott from his play. Music: Dimitri Tiomkin. Produced by: Alfred Hitchcock for Warner Bros. With Ray Milland, Grace Kelly, Robert Cummings, John Williams, Anthony Dawson, and Alfred Hitchcock who appears in an old school photo.
Hitch was always interested in technical advances, and shot this film in 3-D, forcing audiences to wear specially made, two-toned glasses to watch the film. A knowing friendship was instantly struck up between Hitch and Grace Kelly. She would make many suggestions to her director, and he complied. That she should be (scantily) clad in a negligee for the murder scene, and not wearing a dress, as Hitch had planned, is one example. And even at this early stage, Hitch paid very close attention to the clothes worn by the woman who would always be his favorite actress. Attention which will achieve perfection, thanks to Edith Head.

Rear Window
Screenplay: John Michael Haye, based on a short story by William Irish. Costumes: Edith Head. Sets: Sam Comer and Ray Moyer. Produced by: Alfred Hitchcock for Paramount. With James Stewart, Grace Kelly, Wendell Corey, Thelma Ritter, Raymond Burr, Georgine Darcy, Judith Evelyn, and Alfred Hitchcock winding up a grandfather clock in the home of the musician Ross Bagdasarian.
A splendid fashion show (Grace Kelly's wardrobe was designed by Edith Head) at the service of an obsession with a murder. For it is patently obvious that Stewart is really keen for the neighbor opposite to have really killed his wife. Kelly tells him: "We're two of the most frightening ghouls I've ever known. Shouldn't we be a bit happy if this woman is still alive." On the contrary, their pleasure stems from the various clues that all point to murder. A particularly cruel view of humankind. "The only creature in the neighborhood who liked everybody," in the words of one of the characters, is the little dog, who also ends up strangled.

1955

To Catch a Thief
Screenplay: John Michael Haye, from the novel by David Dodge. Costumes: Edith Head. Produced by: Alfred Hitchcock for Paramount. With Cary Grant, Grace Kelly, Jessie Royce Landis, John Williams, Brigitte Auber, Charles Vanel, Jean Martinelli, Georgette Anys, Roland Lesaffre, Rene Blancard, and Alfred Hitchcock sitting beside Cary Grant in the bus.
Grace Kelly again. Plus France and its fine restaurants, plus a convertible car, plus the sumptuous costumes of a masked ball, plus a wrong man (albeit a repentant thief, Cary Grant). It was on this very same corniche road, where she drives far too fast in the film, that Grace Kelly, then Her Serene Highness Princess Grace of Monaco, came to her death in a crash, many years later.

The Trouble with Harry
Screenplay: John Michael Haye, based on the novel by Jack Trevor Story. Music: Bernard Herrmann. Costumes: Edith Head. Produced by: Alfred Hitchcock and Herbert Coleman for Paramount. With Edmund Gwenn, John Forsythe, Shirley MacLaine, Mildred Natwick, Mildred Dunnock, and Alfred Hitchcock walking along the road.
Hitch's avowed aim was to prove that Americans were responsive to British humor—Wrong! Yet the film has a macabre, merry, tender, and undeniable

charm. Hitch's obsession with perfection obliged him to re-create the (beautiful) landscape of Vermont in the studio, because a storm had stripped the trees of their leaves two days before shooting. He had genuine fallen leaves trucked from Vermont to Hollywood. It should be pointed out that the quick pencil sketch John Forsythe makes of the face of the deceased Harry is directly inspired, in technique and composition, from Rouault's *Christ* (one of Hitch's favorite painters). The other works from his hero were made by the painter John Ferren, a friend of Hitchcock.

1956

The Man Who Knew Too Much
Screenplay: John Michael Hayes and Angus McPhail, based on a story by Charles Bennett and D. B. Wyndham Lewis. Music: Bernard Herrmann. Costumes: Edith Head. Produced by: Alfred Hitchcock, Herbert Coleman for Paramount.
With James Stewart, Doris Day, Brenda De Banzie, Bernard Miles, Ralph Truman, Daniel Gelin, Christopher Olsen, Bernard Herrmann (playing the conductor), and Alfred Hitchcock as an onlooker watching acrobats in the market square at Marrakech.
The film's theme song, "Que Sera, Sera," would win the Oscar for best song. And it was Hitch's favorite musician, Bernard Herrmann, who himself conducted the London Symphony Orchestra and the Covent Garden Chorus in the concert hall—Royal Albert Hall—where the assassination will take place. Ever since, cymbals have become threatening objects in the imagination of all audiences. The musical suspense lasts for precisely eight minutes and thirty-six seconds—and Doris Day's scream less than a second!

The Wrong Man
Screenplay: Maxwell Anderson and Angus MacPhail. Music: Bernard Herrmann. Produced by: Alfred Hitchcock and Herbert Coleman for Warner Bros. With Henry Fonda, Vera Miles, Anthony

Quayle, Charles Cooper, John Heldabrand, Esther Minciotti, and Alfred Hitchcock who introduces the prologue.
Hitch does not appear in the film proper, preferring to present it and announce to the audience that the story is a true one. The news item about a New York City musician, Manny Balestero, falsely accused of robbery, almost led to a legal error, which made the headlines in *Life* magazine. This is a real (semi)documentary about an arrest, a man being held in custody, and an imprisonment. Everything is in fact true and carefully researched in the actual places—police station, prison, etc. This realism adds to the dramatic effectiveness and Henry Fonda's mental confinement. But there is no room for the thing that Hitch usually juggles with so much skill—ambiguity.

1958

Vertigo
Screenplay: Alec Coppel and Samuel Taylor, based on the novel by Boileau-Narcejac. Music: Bernard Herrmann. Costumes: Edith Head. Title design: Saul Bass. Design of the dream sequence: John Ferren. Produced by: Alfred Hitchcock and Herbert Coleman for Paramount.
With James Stewart, Kim Novak, Barbara Bel Geddes, Tom Helmore, Henry Jones, and Alfred Hitchcock as a passerby.
One of the most beautiful examples of Saul Bass's credits, spirals fanning out from Stewart's iris as he clings to a roof, and ending on Kim Novak's chignon. All serving Hitch's most macabre of tales. Hitch was obsessed by death during the filming of *Vertigo*: he had been operated on twice that year. In this story about doubles (the woman with two faces, the living woman-dead woman), the only human quality is really introduced by the character of Barbara Bel Geddes, future mother of the family in *Dallas*. Nobody else smiles or jokes in this work, which is dominated by shades of green: Kim Novak's car, the lighting of the hotel, the water far beneath the Golden Gate Bridge, and so on. The

audience's anxiety reigns from the very start of the movie right to the end. And to heighten it, Hitch reveals what's been going on before the film is halfway through. And James Stewart, who is impervious to Barbara Bel Geddes and her efforts to do whatever it takes to please him, seems incapable of loving any woman—unless she's a dead one. For Scottie's nightmare—the second dream sequence after the one from *Spellbound*—Hitchcock hired his friend John Ferren.

1959

North by Northwest

Screenplay: Ernest Lehman. Music: Bernard Herrmann. Set decoration: Henry Grace and Frank R. McKelvey. Title design: Saul Bass. Produced by: Alfred Hitchcock and Herbert Coleman for MGM.
With Cary Grant, Eva Marie Saint, James Mason, Jessie Royce Landis, Leo G. Carroll, Martin Landau, Adam Williams, Robert Ellenstein, and Hitchcock missing his bus.
The shooting title of this movie was *Breathless*, chosen at the very moment when Jean-Luc Godard, in France, was shooting his first feature film, under the very same title. In addition to the joyous malice, not to say cruelty of the script (nothing is what it appears to be), it marks a wonderful return to the fetishism of female blondeness and "class," superbly embodied by Eva Marie Saint. Flawless hair, low-cut gown at the back, bare shoulders, bare feet (in the train and on Mount Rushmore), cigarettes lit for her, and the profile of an ancient cameo. Close-ups on the nape of her neck, on her wrists, and her ankles. A veritable catalogue of male fantasies, preceding the unleashing of Hitchockian fantasies in *Marnie*.

1960

Psycho

Screenplay: Joseph Stefano, based on the novel by Robert Bloch. Set decoration: George Milo. Music: Bernard Herrmann.
Title design: Saul Bass. Produced by: Alfred Hitchcock for Paramount.
With Anthony Perkins, Janet Leigh, Vera Miles, John Gavin, Martin Balsam, Patricia Hitchcock, and Alfred Hitchcock wearing a Texan hat.
Hitch invested $8,000 of his own money in this film, which grossed $13 million. He made $2.5 million. There is no central character to identify with, though this was Hitchcock's golden rule. The murders come thick and fast, among rather slow characters: Janet Leigh strays, and wavers; after her death, the detective and Leigh's sister are just as indecisive and hesitant. This contrast adds to the audience's feeling of uneasiness. Out of a minor news item (which he more or less sticks to), Hitch creates a mythology of voyeurism, "dirty" money, and the Oedipus complex, which was never so well personified on the big screen as by Anthony Perkins. The role of Norman Bates propelled him into the cinematic firmament, and straitjacketed his career in "psychopathic" roles.

1963

The Birds

Screenplay: Evan Hunter, based on a story by Daphne du Maurier. Set decoration: George Milo. Electronic sound: Oskar Sala and Remi Gassman. Consultant for electronic sounds: Bernard Herrmann. Costumes: Edith Head (for Tippi Hedren) and Rita Riggs. Produced by: Alfred Hitchcock for Universal.
With Tippi Hedren, Rod Taylor, Jessica Tandy, Suzanne Pleshette, and Alfred Hitchcock leaving a shop with two dogs on a leash—his very own dogs, Geoffrey and Stanley.
After *Psycho*, Hitch ventured into the (pseudo)terror film, and this is his contribution to the annals of fantasy film. No rational explanation is actually provided for the sudden attack of the birds on human beings, and the on-going nature of this war between species.

1964

Marnie

Screenplay: Jay Presson Allen and Ernest Lehman, based on the novel by Winston Graham. Set design: George Milo. Music: Bernard Herrmann. Costumes: Edith Head (for Tippi Hedren) and Diane Baker. Produced by: Alfred Hitchcock for Universal and Geoffrey Stanley Inc. Prod.
With Tippi Hedren, Sean Connery, Diane Baker, Martin Gabel, Louise Latham, Melody Thomas Scott, and Alfred Hitchcock walking down a corridor.

The name of the production company comes from Hitch's dogs, which we saw on a leash at the beginning of *The Birds*. The blonde Tippi on her railway platform, running away after a burglary, seems to be taking part in a fashion show. She walks like a model and is clad in a sublime suit—thanks, needless to say, to Edith Head—and carries in her (ultra-chic) handbag the tools of her kleptomaniac trade, or, more precisely, "art": a (dark brown!) wig, and make-up. The film seems to be like the narrative of a nightmare: the wharf of her childhood with its monstrous secret is deliberately a painted canvas, and the wedding night with Sean Connery a rape. With every character she meets, a danger surges up from her past. The death of her injured horse is a murder or a capital punishment, which, for Hitch, came to be the same thing. The suspense is in the mind: Will she emerge from her madness? Or will she plunge deeper into it? And is the final return to "calm" nothing other than the lobotomy of a woman who is too "free"?

1966

Torn Curtain

Screenplay: Brian Moore. Set design: George Milo. Costumes: Edith Head (for Julie Andrews) and Grady Hunt. Produced by: Alfred Hitchcock for Universal.
With Paul Newman, Julie Andrews, Lila Kedrova, Tamara Toumanova, Wolfgang Kieling, Günter Strack, Ludwig Donath, Carolyn Conwell, and Alfred

Hitchcock holding on his knees a baby who has an accident on his lap.

After the Tippi episode, which very nearly grew into a public scandal, Universal was extremely wary of Hitch's obsessions and dictated who his actors were to be. Hitch was not interested in either Paul Newman or Julie Andrews, and on screen their "couple" desperately lacks charisma. It is as if the director wanted to strip the actors of all their charms, to get back at Universal. Because the star's salaries accounted for two-thirds of the film's budget, Hitch skimped on sets. Needless to say, the murder of Gromek (twenty minutes of sheer horror) remains in audiences' memories, but this film suffers terribly from the fact that Hitch was not happy making it. He himself was under surveillance, just like the pretend spy Paul Newman in the script. Another consequence of this shooting was that Hitch and his composer Bernard Herrmann parted company. Hitch became quite odious and crude, and turned down his old friend's score: that was the end of that.

1969

Topaz

Screenplay: Samuel A. Taylor and Leon Uris, based on his novel. Music: Maurice Jarre. Costumes: Edith Head, Pierre Balmain. Produced by: Alfred Hitchcock and Herbert Coleman for Universal.
With Frederick Stafford, Dany Robin, John Vernon, Karin Dor, Michel Piccoli, Philippe Noiret, Claude Jade, Michel Subor, John Forsythe, and Alfred Hitchcock in a wheelchair at the airport.

After *Torn Curtain*, Hitch had to keep "compromising." The casting was more eclectic than international, and not very believable. He could not even find much inspiration in the beauty of the actresses, except for the death of Karin Dor (a brunette!), who collapses like a broken black flower, opening up before withering. The ending was shot three times, and the final version is nothing more than a botch job.

1972

Frenzy

Screenplay: Anthony Shaffer, based on the novel by Arthur La Bern. Produced by: Alfred Hitchcock and Bill Hill for Universal.
With Jon Finch, Barry Foster, Barbara Leigh-Hunt, Anna Massey, Alec McCowen, and Alfred Hitchcock wearing a bowler hat at the electioneering speech at the beginning of the film.

Hitch rediscovers London: his London, the London of Covent Garden, where his father had had a market stall. With an all-British cast. The audience is in for a surprise: the actors are ugly, and the criminal, invariably so refined in all Hitch's films, is rather repellent. Everything becomes sordid, like the director's own old age. Everything is a tad dreary, with, needless to say, highlights of macabre irony: the corpse that does not really fit into the sack of potatoes and the elaborate meal prepared by the Scotland Yard inspector's wife, while all the inspector dreams of is the simplest of meals.

1976

Family Plot

Screenplay: Ernest Lehman, based on the novel by Victor Canning. Costumes: Edith Head. Produced by: Alfred Hitchcock for Universal.
With Karen Black, Bruce Dern, Barbara Harris, William Devane, Ed Lauter, and Alfred Hitchcock who appears as a shadow play behind the glass door of the registry office.

Patrick Brion emphasizes quite rightly that "Alfred H. filmed *Family Plot* at a moment when Hollywood films were in the process of radical transformation. 1976 was the year of *Rocky, Network, Carrie, All the President's Men,* and *Taxi Driver.*" Which is tantamount to saying that at the age of 77, Hitch is no longer "with it." And he was changing his perspective. In abandoning his sophisticated "bad guys," he told John Russell Taylor: "Bad guys are rather heavy characters. They are unrefined and their motives are down to earth." It goes without saying that his "style" is still there, in bursts. The car stops to let Karen Black cross (she is the only beauty in the movie) in her black suit, wide hat, and dark glasses. Then the camera no longer follows the "heroes," who are in the vehicle, but switches to this pedestrian, like an "apparition," no less, who becomes the new star of the considerably entwined plot. A woman in black, a secret in a cemetery and, in this cemetery, inside an empty grave: a diamond hidden among the pendants of a crystal chandelier, a secret room with walls made of stones of pure cardboard, and disastrous actors. Hitch's Hollywood was dead, or rather, Hitch was dead in the burgeoning new Hollywood of Scorsese and de Palma, who sees himself as his heir, the upcoming Lucas and Spielberg. Is it a sad? He will never make another film.

[PHOTO CREDITS]

[BIBLIOGRAPHY]

[ACKNOWLEDGMENTS]

The books, special issues and magazine articles devoted to the Alfred Hitchcock's work and life are too numerous to allow for an exhaustive listing. Some of them have already been cited in the text of this book. We recall below the most important ones, and the most accessible to the public as well.

Books

Patrick Brion, *Hitchcock*, Paris, La Martinière, 2000.

Claude Chabrol and Éric Rohmer, *Hitchcock*, Paris, Éditions Universitaires, 1957.

Jean Douchet, *Alfred Hitchcock*, Paris, "L'Herne", 1967; in the "Petite Bibliothèque des Cahiers du Cinéma", Paris, 1999.

Bill Krohn, *Hitchcock at Work*, Phaidon Press, London, 2000.

Jean Narboni (editor), *Alfred Hitchcock*, Paris, Éditions de l'Étoile, 1980.

Dominique Païni and Guy Cogeval (editors), *Hitchcock et l'Art : Coïncidences Fatales*, Paris, Centre Georges-Pompidou/Milan, Mazzotta, 2001.

Noël Simsolo, *Alfred Hitchcock*, Paris, Seghers, 1969.

Jane E. Sloan, *Alfred Hitchcock: a Filmography and Bibliography*, Berkeley-Los Angeles-Londres, University of California Press, 1955. Work in which the bibliography is the most complete.

Donald Spoto, *L'Art d'Alfred Hitchcock*, Paris, Édilig, 1986.

Donald Spoto, *The Dark Side of Genius, The Life of Alfred Hitchcock*, New York, Da Capo Press, 1999.

François Truffaut, *Hitchcock (Revised Edition)*, New York, Simon and Schuster, 1985.

Bruno villien, *Hitchcock*, Paris, Editions Colona, 1982.

Articles

J. van Cottom, in *Ciné Revue*, 1978.

Jean-Pierre Dufreigne and Michel Grisolia, "Le Siècle d'Hitchcock", in *L'Express*, Summer 1999.

Ivor Montagu, "Working with Hitchcock", in *Sight & Sound*, 1980.

Gerald Peary, "Hitchcock vu par sa fille", in *Positif*, December 1984.

François Truffaut and Charles Bitch, in *Cahiers du Cinéma*, August-September 1956.

Bruno Villien, in *Cinématographe*, 1983.

CREDITS
This book, *Hitchcock Style*,
edited by *Martine Assouline*,
was written by *Jean-Pierre Dufreigne*,
translated by *Simon Pleasance & Fronza Woods*,
designed by *Mathilde Dupuy d'Angeac*,
with images collected by *Catherine Aygalinc*,
and supervised by *Julie David*.

The publisher would like to thank: Academy of Motion Picture Arts and Sciences (K. Krueger), Adagp (V. Garrigues), AKG (U. Haussen), BIFI (D. Marsaud), Buena Vista Films, Carlton International Media Limited, Cinémathèque française (S. Dabrowski), Centre Georges-Pompidou (D. Païni and M. Dos Santos), Corbis (Fabienne Deltour), Core Production, Gettyimages (A. Baussan), Alfred Hitchcock Collection, Alfred J. Hitchcock Trust, Hoa Qui, Kobal (Anna Barrett), Law Offices of Peter J. Andeson, Magnum (Marie-Christine Biebuyck), Montreal Museum of Fine Arts (Linda-Anne d'Anjou), Paramount Collection, Photofest (D. McKeown), Edward Quinn, RKO Collection, Rue des Archives (C. Terk), Selznick International, Barbara Rix-Sieff, Canal Images Studio, Sunset Boulevard (R. Boyer), TCD (Daniel Bouteiller), Treehouse (S. Bass), Universal Studios, Warner Bros, Bob Willoughby.